Casual Game Design
Designing Play for the Gamer in All of Us

Gregory Trefry

ELSEVIER

AMSTERDAM • BOSTON • HEIDELBERG • LONDON • NEW YORK • OXFORD
• PARIS • SAN DIEGO • SAN FRANCISCO • SINGAPORE • SYDNEY • TOKYO

Morgan Kaufmann Publishers is an imprint of Elsevier

MORGAN
KAUFMANN

Morgan Kaufmann Publishers is an imprint of Elsevier.
30 Corporate Drive, Suite 400, Burlington, MA 01803, USA

This book is printed on acid-free paper.

Notices
Knowledge and best practice in this field are constantly changing. As new research and experience
broaden our understanding, changes in research methods, professional practices, or medical
treatment may become necessary.

Practitioners and researchers must always rely on their own experience and knowledge in
evaluating and using any information, methods, compounds, or experiments described herein.
In using such information or methods they should be mindful of their own safety and the safety
of others, including parties for whom they have a professional responsibility.

To the fullest extent of the law, neither the Publisher nor the authors, contributors, or editors,
assume any liability for any injury and/or damage to persons or property as a matter of products
liability, negligence or otherwise, or from any use or operation of any methods, products, instructions,
or ideas contained in the material herein.

Library of Congress Cataloging-in-Publication Data
Application submitted

British Library Cataloguing-in-Publication Data
A catalogue record for this book is available from the British Library.

ISBN: 978-0-12-374953-6

For information on all Morgan Kaufmann publications,
visit our Web site at www.mkp.com or www.elsevierdirect.com

Printed in the United States of America

10 11 12 13 14 5 4 3 2 1

Working together to grow
libraries in developing countries

www.elsevier.com | www.bookaid.org | www.sabre.org

ELSEVIER BOOK AID
International Sabre Foundation

Morgan Kaufmann Game Design Books

Better Game Characters by Design (9781558609211)
Katherine Isbister

Game Design Workshop, Second Edition (9780240809748)
Tracy Fullerton

The Art of Game Design (9780123694966)
Jesse Schell

Game Usability (9780123744470)
Katherine Isbister & Noah Schaffer (Eds.)

Game Feel (9780123743282)
Steve Swink

Pervasive Games (9780123748539)
Markus Montola & Jaakko Stenros

The IGDA "Stamp of Approval"

The International Game Developer's Association is the largest non-profit membership organization serving individuals that create video games. The mission of the IGDA is to advance the careers and enhance the lives of game developers by connecting members with their peers, promoting professional development, and advocating on issues that affect the developer community.

A big part of the IGDA's mission is to arm game developers with the information they need to succeed in the industry. With this in mind, there are great synergies between the work that the IGDA does and the work that Morgan Kaufmann (an imprint of Elsevier, Inc.) does, as the leading publisher in the areas of game development and game design. IGDA and Morgan Kaufmann are proud to work together to present these game development and design titles to you, in the hopes of advancing your career within the game industry.

All of the proposals in the game series have been reviewed and vetted by relevant IGDA community leaders and volunteers to ensure top quality and relevance. We are proud to offer the IGDA sponsored Morgan Kaufmann game development and design books for your trusted library.

For more information on the IGDA and to become more deeply engaged with the game development community, check out www.igda.org.

For G & Y

TABLE OF CONTENTS

Chapter 3. Play Is the Thing 51

ACKNOWLEDGMENTS

I would like to thank the following people.

Ginger Gray-Trefry, your advice and support through the writing of this book were invaluable. There's no one whose opinion I value more. I simply couldn't have written it without you.

Mattia Romeo, our work together and conversations about games, mechanics, play, fun and art form the foundation of this book. Without those conversations, this book simply wouldn't exist. I think this book is as much yours as it is mine.

Beth Millett, thanks for helping me quickly hammer this book into shape. Your advice, patience and editing were invaluable.

Laura Lewin and Chris Simpson from Focal, thanks for giving me the chance to write this book.

I've had the chance to work with a lot of really amazing game designers, artists, teachers and developers who have all contributed immensely to my view of games and game design. Thanks to each of you, especially: Catherine Herdlick, Nick Fortugno, Peter Lee, Eric Zimmerman, Katie Salen, Frank Lantz, Wade Tinney, Josh DeBonis, Eric Socolofsky, Charles Amis, Naomi Clark, Jesper Juul, Charles Wheeler, Kyron Ramsey, Carolina Moya, Scott Price, Michael Sweet, Bob Wylie, Michelle McDonald, Greg Fields, Jong Woo, Nick Rider, Dauna Jeong, Lana Zhao, Jacqueline Yue, Jiyoun Lee and all the rest of the Gamelab family.

To all the great students I've had the chance to work with over the years: You keep me on my toes and teach me something new every semester.

And thanks to my parents: you guys made all of this possible.

Introduction

This book doesn't offer a grand theory of game design. Rather, it encourages close playing and reading. Not of this book, but of the games it discusses. I am a firm believer that there are two ways to become a better game designer. First, make games and think about why they do or don't work. Second, play other people's games and think about why they do or don't work. Just as you can't become a writer without reading or a film director without watching movies, you can't become a game designer without playing games and trying to pick them apart.

In this book, we will establish some general principles for thinking about play and games. Then we will spend the rest of the time looking closely at a wide variety of games that I think offer interesting insights into casual gameplay. Some of these games are classics. Some aren't. But interesting lessons can be drawn out of all of them.

As we talk about each game, I highly encourage you to go find the game and play it. Explaining a game only does so much good. Games are experiential. You have to play a game—making the decisions and moves it demands—in order to understand it.

From this close reading of games and mechanics, we will begin to assemble some general ideas about how to approach casual game design.

Mechanics

You can think of mechanics multiple ways. First and foremost they are routines, procedures and methods. Mechanics cover everything from running an office to the play of baseball. Individual mechanics combine to create complex game systems.

Mechanics also describes the people who work with those systems, not just tinkering with the procedures and methods, but also designing how new systems fit together.

Mechanics hold the same dual meaning in games.

Game mechanics provide the core of game design. Each game is comprised of a series of game mechanics. These mechanics, from creating matches of three items in a game like *Bejeweled* to sequencing numbers in a game of *Sudoku*, dictate what players do when they play the game. At the heart of any great game is an elegant core mechanic, a mechanic that is both firm enough to provide clear gameplay yet flexible enough to allow players to develop strategies. Understanding the core mechanics of great games helps game designers create games by tweaking, modifying and combining successful mechanics into entirely new game systems. Through

this process of combination and modification, game designers can invent entirely new game mechanics.

And the game designer is herself a game mechanic, breaking out her conceptual toolbox of rules to craft player experience. Sometimes she reuses trusty old rules, like "The player with the most points wins." Sometimes explaining and shaping the core mechanic of her game requires her to write entirely new rules like, "To score points, the player must combine colored gems into crosses comprised of five like-colored gems."

The best way to build new games is to understand the games that already exist, why they work so well and why players can find hours of enjoyment interacting with them. This understanding stems from picking apart and piecing back to together the core mechanic or mechanics of the game. Designers must play the game. Then they must mentally model the system in their heads, modify it and see the results. From this, they will see why the mechanics of the game worked so well, and why with a few changes, the whole game system might have collapsed.

Looking at the mechanics of a game is like looking at the heart of the game. The mechanics are the pump that makes the rest of the game pulse with life.

This book examines an array of mechanics that make up games by looking at a set of well-known games—some classics, some not—and picking apart their core mechanics. It is not a comprehensive list of all mechanics in games, but rather a look at ones I feel hold interesting lessons for casual game designers. This is how I approach game design. This process also informs how many of the game designers I know approach game design. They look at mechanics that worked and ones that didn't. They look at games, toys, Web sites, tools, software—anything that demands interaction—for ideas. Then they figure out how to build a new system appropriate for the game they want to make out of the various mechanics they have seen.

I have divided this book into chapters covering very generalized mechanics. Within those chapters I look at particular games and how game designers used specific mechanics to construct those games.

In 1927, the English novelist and scholar E.M. Forster published *Aspects of the Novel*. The book was collection of lectures Forster delivered at Cambridge University on subjects like "People," "The Plot" and "The Story." In this slim but wonderful book, Forster lays out ways to approach reading the novel and ways to approach writing the novel. *Aspects of the Novel* is far from a how-to guide to writing a novel. Its value is far greater. Forster offers the reader key ways to understand the novel by looking at characters, plots, stories and sentences from a wide array of books. Through *Aspects of the Novel*, Forster helps you understand why certain plots are great while others fall flat. He gets you to start thinking about the essentials of novels that, as a writer, you will need to construct.

While I have no illusions that I can match Forster's level of crystalline wit and observation, I do want this book to serve a similar function. This book is not a how-to guide to making video games. Instead, it offers a way to approach the design of games, from casual video games to sports. It does this by undertaking a similar mission to the one Forster embarked on in *Aspects of the Novel*: it points aspiring

designers, practicing designers and interested players toward the key elements of games and says, "Look at that mechanic! What an ingenious idea! Let's figure out why that mechanic worked so well so we can figure out how to use it ourselves."

I am a casual game designer. This is both my profession and my mission. I like games that are quick to play and accessible. It is in this realm of casual game-play that I think games have the greatest growth potential and the greatest ability to reach a wide audience. So this book will focus on game mechanics that I've explored in relation to my work in casual game design. These are by no means the only mechanics for casual games. Nor am I saying mechanics found in hardcore games can't be casual. After all, hardcore first-person shooters like *Quake* have at their core the same basic mechanic found in seek-and-find games: pointing. It's all a matter of how the mechanic is applied in the game.

The game designer Marc LeBlanc developed a methodology to examine games he called MDA. MDA stands for mechanics, dynamics and aesthetics. LeBlanc argues that mechanics are the basic elements of games. These mechanics combine to form dynamic systems which then lead to a certain aesthetic. The game designer selects or develops mechanics for the game and combines them into a system. As players interact with the system, they have an aesthetic experience. Mechanics that limit a player's moves—like the swapping mechanic in *Bejeweled*—can engender a sense of claustrophobia. Mechanics that force a player to furiously click around the screen, tending to small emergencies—like the spinning plates mechanic in *Diner Dash*—can create a sense of harried frenzy in players. The game designer must pick out the proper mechanics and combine them in a way that creates the desired aesthetic and experience for the player.

The Issue of "Fun"

This book will generally focus on fun. Fun is a loaded word. My idea of fun may be your idea of torture. Fun is almost as slippery and subjective as pornography. But like pornography, you generally know it when you see it. And as a game designer, a big part of your job is learning to recognize the potential for fun and amplify it. Some people derive immense pleasure from sorting their sock drawer. What's to be done with them? Well, for starters you could make a game that replicates the pleasure of progressively organizing objects, be they socks or gems, and give those people something even more fun than their sock drawer.

And while I believe games can exist without fun, this is not a book about making those games. I have played and greatly admired games that provoked in me more anger, sadness and frustration than joy. Art games like Joson Rohrer's *Passage* have beautiful concepts, though I think they lack a general accessibility that making popular casual games demands. They are experimental. And while casual games often experiment with innovative mechanics, their focus is to entertain a broad audience. In this book, I focus on games that offer short, but intense blasts of fun. Sometimes that fun will be sustainable. Sometimes that joy will quickly fade. But I believe casual games need to strive to deliver some element of fun.

The following are some general strategies for casual game design. We will touch on these issues again as we look at specific games.

Know Your Audience

As with any product you want to sell, you must know your audience. A fantasy game about elves and orcs presents a harder sell to middle-aged women than a game about cooking. We don't want to stereotype, but you do need to develop a sense of your audience's interests, because a lot of successful casual games build off of an established interest.

Piggyback on Neuroses

Sometimes nothing makes a better game mechanic than an established obsessive-compulsive behavior. Often these behaviors, like not stepping on cracks, organizing record collections or cleaning up kitchens, already have play-like qualities. When we engage in these behaviors we generally follow certain rules we lay out for ourselves: don't step on cracks, organize your music collection by mood, or clean all the dishes in less than 15 minutes. With a little bit of work, these simple activities can be given goals that make them into full-blown games. Sometimes these games can then be transferred into video games.

Delivery Is Everything

Knowing your audience also means knowing where they want to play games. Do they want to play games on their computer during a coffee break at work? Do they want to stand in front of their television and pretend to play tennis? Are they more likely to play games on their cell phone during their commute? Games can take so many forms, and can be played in so many places, that it's almost mind-boggling. Games are no longer limited to PCs and game consoles. Cell phones, iPhones, and handhelds like the Nintendo DS and Sony PSP make games portable. They also enable games to fit into new interstices of our days. Different audiences have unique moments of free time. Tailor your games to these moments and you can break through the competition for attention.

Conceiving and Iterating

Generating concepts trips up a lot of people. To some, generating ideas comes easily, while the birthing process is much harder for others. Fortunately, there are a number of smart tools we can use to help us brainstorm game ideas, approaching the game from different angles, from story to audience to theme. We must also learn

to tackle the hardest game brainstorming task: conceiving new game mechanics. Fortunately, many of the best mechanics grow out of established ones. Sometimes it's an unlikely combination of two mechanics, as when *Puzzle Quest* married RPG leveling up to *Bejeweled*-like gem swapping. By looking in depth at a number of game types and mechanics, we'll hopefully be able to see new possibilities emerge.

While coming up with a new and unique game idea is certainly important, too many people think the hard work stops there. In fact, that's just where it starts. We all have loads of game ideas rattling around the back of our heads. Many of them might make great games. That is, if they're well-implemented. Ideas are easy. Implementation is hard.

Most likely, your first attempt to turn your idea into a game will go poorly. Few games are fun right off the bat. If it is easy, you're probably just re-skinning an existing mechanic. In fact, I would argue that making a first-person shooter fun is a lot easier than inventing a whole new casual game mechanic at this point. The first-person shooter mechanic has been polished to a sheen by hundreds of designers working on hundreds of different games.

Making a game requires moving an idea from paper prototype to digital prototype to full production. Each step along this path requires the designer to constantly revisit and analyze the state of the game, to see if the actual player experience is getting close to what they envision.

To do this, the designer will no doubt add features to the game in an attempt to make it more robust. At some point, designers must step back from their games and think about what they can strip away. We are talking about casual games, after all. It is imperative that the experience be clean and streamlined.

The Promise of Casual Games

Finally, this book will be about the promise and potential of casual game design. Casual games radically changed the landscape of games. Now anyone can make a game. Unlike hardcore console games, you don't need a team of hundreds to develop a small casual game. A team of three or four can churn out a casual downloadable title. And one industrious individual can put together a Web-based Flash game all on their own.

The Internet enables you to find an audience and distribute your game. You may have to fund the development yourself, but the generally modest scale of most casual games (compared with a console title) makes this possible. From casual downloadable portals like Real Arcade and Shockwave to Flash game sites like Addicting Games and Kongregate, there are multiple venues for your game that can even help you monetize your game.

But best of all, there are millions of players for your game. This makes designing casual games exciting. They've not only opened up the audience and reach of games, they've democratized the development playing field. As it becomes easier to develop and distribute games, we'll hear from an ever-wider range of voices. This

will lead to a wealth of innovative new games and mechanics for designers and players to explore.

The Value of Thinking Casual

The value of thinking like a casual game extends beyond designing casual games. The same lessons about clear and concise goals and guiding players apply to all game design, whether you're making a casual downloadable, creating a new sport or designing levels for new console game.

The lessons of casual game design can also be applied outside of games, to general user experience design. Social networking sites like Facebook and LinkedIn already rely on game-like experiences, from building a profile (i.e., character) to collecting friends (i.e., leveling up). As sites like these continue to compete for attention, many are relying on game like experiences to draw in users. Casual game design offers valuable lessons on how to craft those experiences from getting users on achiever cycles to quickly drawing in users with gentle learning curves.

Casual game design has the potential to radically influence both games and software. But first we need to look at how casual games engage players. That means starting with their mechanics.

CHAPTER ONE

What Is Casual Gaming?

Over the past several years, the term "casual game" has been bandied about quite a bit. It gets used to describe so many different types of games that the definition has become rather blurred. But if we look at all of the ways that "casual" gets used, we can begin to tease out common elements that inform the design of these games:

- Rules and goals must be clear.
- Players need to be able to quickly reach proficiency.
- Casual game play adapts to a player's life and schedule.
- Game concepts borrow familiar content and themes from life.

While all game design should take these issues into account, these elements are of particular importance if you want to reach a broad audience beyond traditional gamers. This book will look at elements that a wide array of casual games share and draw out common lessons for approaching game design. Hopefully it will be of use not just to casual game designers, but to all game designers and even general experience designers as well.

Everywhere you look these days, you see impact of casual games. More than 200 million people play casual games on the Internet, according to the Casual Games Association. This audience generated revenues in excess of $2.25 billion in 2007.[1] This may seem meager compared to the $41 billion posted by the entire game industry worldwide,[2] but casual games currently rank as one of the fastest growing sectors of the game industry. As growth in the rest of the industry stagnated, the casual downloadable market barreled ahead. Web games are turning from mild diversions into serious revenue earners (and major time suckers). Even the game console industry has been invaded by the ethos of casual gameplay. Nintendo, considered by many to be headed for irrelevance several years ago, has ridden the success of its Wii

[1] http://www.casualgamesassociation.org/faq.php#casualgames
[2] http://arstechnica.com/gaming/news/2008/06/gaming-expected-to-be-a-68-billion-business-by-2012.ars

console back to the top of the game industry. They staked their future on capturing a broad audience with a brand of casual gameplay accessible to anyone. And it turned out to be a good bet. Other popular console titles with casual gameplay mechanics, like *Guitar Hero* and *Rock Band,* have captured the public imagination.

So, what could a downloadable PC game like *Diner Dash,* a viral web game like *Desktop Tower Defense,* and a console title like *Rock Band* possibly have in common? More than you might first think. While they have many differences, from audience to scope to platform, they share some key fundamental elements within their game design. Each has accessible content that helps players understand the gameplay. Each of these games can be picked up and enjoyed by novices within minutes. Each focuses on one clear game mechanic and polishes it to a shine.

But perhaps to better understand what we mean by "casual game," we need to take a short walk through history.

It Started in Solitude

You could say casual gaming began in 1990 when Microsoft started bundling *Windows Solitaire* with Windows. The mouse had only been introduced in 1981 and didn't really start achieving widespread use until the late '80s. Many people were still getting used to the idea of pointing and clicking to navigate their way through a graphical user interface. As Microsoft prepared Windows 3.0, executives were looking for an application that would help train people to use the mouse and literally "to soothe people intimidated by the operating system."[3] They found it in *Windows Solitaire* (Figure 1.1), which can now legitimately claim to be the most played video game in the world. In terms of number of plays, hours consumed and numbers of players, *Windows Solitaire* dwarfs every other game, from *Doom* to *Grand Theft Auto.* According to the engineer responsible for building a new version of the game for Windows Vista, *Windows Solitaire* is the most-used Windows application.

Of course, video games existed long before Microsoft unleashed *Windows Solitaire* on the world, but they never reached such a wide audience, an audience that didn't even know it was looking for something to play. The version you find on your computer is a stripped down game, copying the rules of card-based *Klondike Solitaire,* but with the several added benefits that have defined casual games ever since. First, it's dead-simple to use. You don't have to install anything. It's already on your computer and when you call it up from the Windows menu, it starts nearly instantaneously.

Ease of use is an essential ingredient in casual games. The audience for casual games is a broad and general audience. They typically have no patience for juggling their way through eight different CDs to install a game only to confront confusing menus and options screens. They want to play, but they want to do it when the mood strikes them. So from the very get go, the game must be easy to get into, and this includes the installation. With *Windows Solitaire,* the deck is

[3]http://www.slate.com/id/2191295/pagenum/all

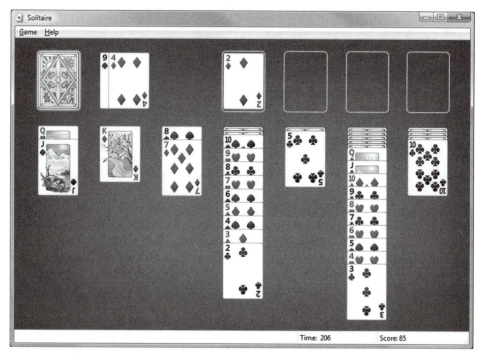

FIGURE
1.1

The simple interface of *Windows Solitaire* **is now a video game classic. (Microsoft product screen shots reprinted with permission from Microsoft Corporation)**

already shuffled and the cards laid out for you. Your first interaction in the application is actually playing the game.

Secondly, since you most likely already know the rules to *Klondike Solitaire*, the game has about a 10-second learning curve to reach proficient play. Even users unfamiliar with how to use a mouse in 1990 could understand the basic interaction scheme in a matter of seconds. So before you know it, you're cruising your way through your first game. This short time to proficient play is a crucial aspect of casual games. Players are not necessarily looking for a long, deep play experience. More likely, they simply want something to divert their attention or offer a few moments of relaxation. So games with familiar mechanics and rules often win out over deeper more complex games, as they are the easiest to learn. Games with new interaction schemes and mechanics can succeed, but they still need to offer some element of familiarity to the player, be it in content or theme.

A game of *Windows Solitaire* may take you anywhere between three to five minutes. You can start a new game at any time if you're frustrated or stuck. In fact, *Windows Solitaire* removes entirely the most frustrating part of card-based *Klondike Solitaire*: the shuffling. In the card-based version, you might take 10 minutes just to shuffle and lay out the cards, only to find you're entirely screwed within five moves. The computer obliterates that problem. What was before a ritualistic game—as much

3

about shuffling and set-up as it was about play—becomes a fast-paced game of sorting on the computer. You can play over and over and over, all while eating your lunch with your free hand. This bite-sized chunk of play allows you to fit in a game between meetings or as a quick palette cleansing between filing TPS reports. The low requirements on your concentration enable you to play the game on a boring conference call or while listening with one ear to your friend drone on about his day. (Granted, your replies will no doubt take on that cold, glassy sound of divided attention.)

Windows Solitaire fits into your life when you want to play. You don't have to dedicate an entire weekend and go without showering to finish a game. You simply pick it up and play when you are bored. Since *Windows Solitaire*, casual games have served as salves against boredom. Initially, the game isn't really a focus. Only the most elegant and addictive casual games worm their way into players' brains and become obsessions. Most players don't follow release schedules, eagerly anticipating new casual games. Rather, they stumble upon them and become addicted. Casual games start out as curiosities and wind up habits.

Where *Windows Solitaire* for Windows differed from the original card game, it did so brilliantly. Anyone who has suffered through hand after hand to finally catch a winning spread knows what I'm talking about: the incredibly cathartic cascade of bouncing and shattering cards unleashed by the placement of the final king (Figure 1.2). This is the money shot after the power-moment of realizing you will win the game. The game is austere and almost entirely devoid of life other than this final animation. So when it happens, you feel that you've earned it. To this day, I still watch the entire animation play out, never clicking through it. Casual games are often spare, small games, but they know how to deploy the bling. Just look at PopCap's brilliant *Peggle*, a game that comprised almost entirely of sparkles. Each game ends with Beethoven's *Ninth Symphony*, rainbows and fireworks making you feel like the greatest player on Earth.

So in many ways, casual game developers all live in the long shadow cast by a simple port of a card game programmed by Microsoft intern Wes Cherry in 1989. Not only did it establish many of the tropes of casual play, it also served as a gateway drug for people who would never consider themselves gamers. These players would never have dreamed of picking up an SNES controller in 1990 and working through a 40-hour game, but they would fiendishly play *Solitaire,* racking up hours of gameplay in small chunks throughout their day or week. Eventually, many *Solitaire* players moved on to *Minesweeper* and *Freecell* to *Bejeweled* and *Diner Dash* and eventually even to *Wii Tennis* and *Guitar Hero*, without ever considering themselves gamers. And as they did, casual games evolved with them, rising to meet their new interests, skills and level of engagement.

Bedazzled

Eleven years after *Solitaire* invaded our consciousness, another game came along and helped redefine the casual games: *Diamond Mine*, or, as you more likely

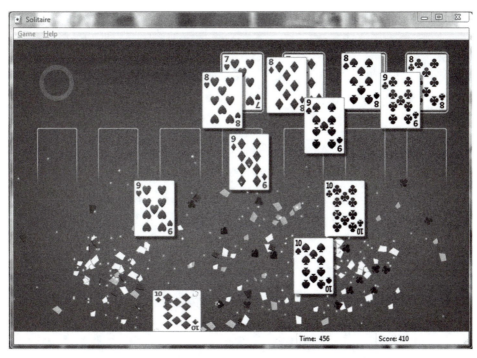

FIGURE
1.2

The incredibly cathartic release of a win after countless hands of failed *Solitaire*. **(Microsoft product screen shots reprinted with permission from Microsoft Corporation)**

know it, *Bejeweled* (Figure 1.3). In 2000, game designers Brian Fiete, John Vechey and former pogo.com producer Jason Kapalka founded the game development company PopCap. Their first project was such a monster hit that it's easy to forget they've continued turning out best-selling and innovative casual games ever since. They originally launched *Bejeweled* as a Web-based Flash game, licensing it to game portals like Microsoft's Zone.

Bejeweled is an incredibly simple, yet elegant game. It presents players with a grid of colored gems. Players swap adjacent gems to form vertical and horizontal matches of three or more with the same color. Matched gems score and disappear in explosions of sparkles, and new gems drop in from the top of the screen. You score bonus points if you match more than three gems or if gems drop into new matches as they fall. Players can progress through levels by reaching goal scores. Or they can race against the clock, matching gems to keep pace with a timer. The game also includes an untimed mode with less pressure.

Initially some of the distributors that PopCap approached balked at the untimed mode, believing it held no challenge. PopCap, however, stuck to its vision. As Kapalka put it in an interview with Gamezebo, "We were having fun playing it and my mom was having fun playing it," he said. "Our theory was, if my mom, who

FIGURE
1.3

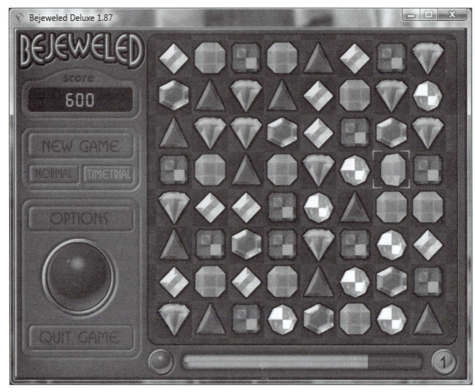

The incredibly simple, yet elegant *Bejeweled* **game board belies an extremely addictive experience. (Reproduced by permission of PopCap Games)**

doesn't normally like games, likes it, there must be something there. She may not know good game design, but she knows what she likes."[4]

Bejeweled was a hit as a Web game, but PopCap had no way to monetize the game. The bottom dropped out of Web advertising in 2001 as the dot-com bubble burst. So PopCap decided to create a deluxe version of the game, with better art, more sounds and new modes, and sell it online. Many people were still getting used the idea of buying goods online in 2001, especially intangible things like download-able games. There wasn't yet a firmly established market for downloadable games.

They priced the game at $20, a price even PopCap initially believed was too high. But it proved a sweet price and helped establish the market for casual download-able games. Like *Windows Solitaire* easing PC users into the idea of the mouse, *Bejeweled* and other casual games helped ease many people into the idea of online purchases. Seven years later, players have bought more that 10 million copies of the

[4]http://www.gamezebo.com/features/special-editorials/behind-game-bejeweled

game, downloaded it more than 150 million times[5] and spent roughly $300 million on the game.[6]

So what makes *Bejeweled* so incredibly addictive? Well, in part people really like to match and sort stuff. There is immense satisfaction to be had by turning chaos into order. Like *Windows Solitaire*, your progress in the game is largely based on chance, but players still feel a great deal of agency. That's because, unlike a game of pure chance that relies on a roll of the dice, your moves in *Windows Solitaire* and *Bejeweled* feel like your own. You choose the card to place and jewels to swap. This gives the player a vital feeling of control. Again, the game allows for almost instant mastery. *Bejeweled*'s untimed mode enables the players to scale their level of involvement at any moment. Without time pressure, your job is just to keep looking until you find a match. You can perform this search at your leisure.

By charging for the game, PopCap helped establish casual games as commodities. Suddenly casual game players who previously played free games on their computer or the Web found themselves actually buying games.

Looking at it today, it can be hard to see *Bejeweled* for the innovative game that it was. The casual download market has been flooded with clones that copied every aspect of *Bejeweled* from the matching to the swapping to the gems. The mechanics of the game are now almost as familiar as *Windows Solitaire*. But at the time, *Bejeweled* felt like a new mechanic, albeit one that felt eerily familiar. With *Bejeweled*, casual players were willing to move beyond mechanics borrowed from card and board games and to embrace a game native to video games.

PopCap has pushed their flagship game onto multiple platforms, from PCs to consoles to cell phones. The game proved extremely adaptable to these different venues, particularly cell phones, showing again that people want games that slot into their lives at the moments they choose. Suddenly, subway cars and waiting rooms were alive with the tinkling sounds of jewels swapping and scoring.

The Next Swing in Casual Gaming

Nintendo took the next big step in casual games with *Wii Sports*. The game's release accompanied the launch of Nintendo's new gaming console, the Wii, in 2006. As of September 2008, the game had sold 30.87 million copies, including those bundled with the console.[7]

As Sony, Microsoft and Nintendo began developing the next generation of consoles, everyone thought the major attraction of the new machines would be improved graphics and more powerful processors. This is the tack that Sony and Microsoft took with their machines, crafting them to push ever more pixels. Nintendo, however, followed a very different course.

[5]http://news.bbc.co.uk/2/hi/technology/7301374.stm
[6]http://www.wired.com/gaming/gamingreviews/magazine/16-11/pl_games
[7]http://www.nintendo.co.jp/ir/pdf/2008/081031e.pdf#page=6

At the time, Nintendo's sales had fallen far behind Sony's Playstation and even Microsoft's Xbox. Many analysts were writing off the company. Nintendo realized that to grow their audience and market share, they needed to bring in new players. Instead of trying to take a bigger piece of the gamer pie, Nintendo decided to make the whole pie bigger. And who did they focus on? Casual gamers. These people weren't wowed by higher resolution graphics. Like Windows 3.0 users discovering *Windows Solitaire* for the first time, many probably didn't even realize they were interested in playing games. But when presented with the Wii's surprisingly intuitive magic wand and the play it enabled, they were intrigued. With a clever marketing scheme and great word of mouth, the Wii became a phenomenon largely on the back of the title *Wii Sports*. The public was enthralled with the idea that you swung the almost magical Wiimote just like you would a real tennis racket to play *Wii Tennis*. Suddenly casual gamers who would have never bought a console were lining up to get hold of a Wii.

Wii Sports was designed as a flagship game, bundled with the Wii to demonstrate the capabilities of the Wiimote. Nintendo wanted to make a game that leveled the playing field between casual players and hardcore gamers. By introducing a simplified controller with a unique, but intuitive, control scheme, Nintendo put all players on the same footing. Nintendo producer Katsuya Eguchi, the man in charge of *Wii Sports*, said, "Initially, our goal was to create something very simple that anyone could just pick up and play, and because everyone knows sports, we thought that would probably be the best setting."[8]

Wii Sports capitalized on the widespread popularity and familiarity of sports. The designers chose five games they could intuitively simulate with the Wiimote. This meant the games needed to have clear and familiar arm-motions like swinging and punching. They then stripped those games of much of their complexity, boiling them down to one core interaction. So with *Wii Tennis*, the player swings the Wiimote to whack the virtual ball across the net. You do not even need to correctly position the avatar to return the ball. The game largely removes the spatial complexity of tennis, boiling it down instead to a timing game. It's tennis, with no running, only swinging. Said Eguchi, "Our goal with *Tennis* wasn't to create a game that was really, really challenging. We wanted to stay with a simple, pick-up-and-play idea. If we added the need for the player to run to the ball, that would add a level of complexity that we think would be an obstacle." We will see this same move—boiling a game down to its elemental mechanic—over and over again as we look deeper into casual game design.

Nintendo also went casual with the game's visual aesthetics. Nintendo initially thought they would use Mario characters in the game, but ended up populating the game with Miis, simple characters that resemble traditional Japanese wooden dolls. User testing revealed that players preferred the more abstract Miis to the Mario characters. This move probably helped contribute to the success of the game. It

[8]http://wii.ign.com/articles/709/709218p1.html

made the game much more palatable to non-gamers. Even if the gameplay had been exactly the same, the inclusion of Mario characters would have suggested to players the need for some prior knowledge or familiarity with the world of Nintendo games. It took something simpler and more elemental to fully grab the attention of the general populace and convert them into new casual gamers.

The Wii and *Wii Sports* were instantly a huge commercial hit. The game system and *Wii Sports* crossed over in to the public imagination in ways that few games do. Adults and kids alike began holding "Wii" parties, inviting friends over to play together. The game even made an appearance at the 80th Annual Academy Awards, when host Jon Stewart and actor Jamia Simone Nash were caught playing *Wii Tennis* on one of the shows mammoth projection screens as part of a skit. *Wii Sports* was suddenly the game everyone, young and old, casual and gamer alike could get into playing (Figure 1.4).

With *Wii Sports*, casual gaming fully came into its own. *Windows Solitaire* showed that, if given a simple, free game, people will play—a lot. *Bejeweled* and the casual downloadable industry proved that audiences beyond hardcore gamers existed and would be willing to pay for games. The Wii finally showed that those new players might be lured into more serious investments if offered the right type of game. Now casual forms of gameplay have become a force within the game industry. Publishers and developers alike are racing to figure out how to capitalize on this new audience, which makes it a very exciting time to be thinking about casual game design. Examples of new innovations in casual gaming keep cropping

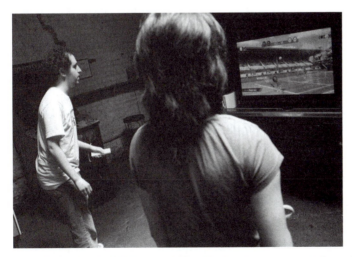

FIGURE
1.4

Participants in the 2008 annual Wiimbledon Tournament at Barcade in Brooklyn, NY. (Photo by Getty Images North America[9])

[9]http://www.zimbio.com/pictures/fEI3SbNemIz/Brooklyn+Bar+Holds+Wiimbledon+Video+Game+Tennis/W4m2kpvoHn0

up. Game designers experiment with new ideas and forms, failing and succeeding. The audience grows and changes with each new successful mechanic and title.

Casual Queens versus Genre Kings

So why casual and why now? What's wrong with a good old fashioned first person shooters (FPS) full of screeching aliens and thick-necked space marines? Nothing. That is, if you're a gamer. But if you haven't spent the last 20 years playing video games or don't have 15 hours to dedicate to gaming every week, you will find them pretty darn confounding. Over the course of their development, video games have grown increasingly complex and hard to use. Just look at an Xbox 360 controller next to an NES controller. Or better yet, next to an old-fashioned Atari joystick. The array of shoulder buttons, thumbsticks and d-pads on an Xbox controller make the d-pad and A & B buttons on the NES controller look positively quaint.

Worse yet, whole games rely on the player starting off with a deep-seated knowledge of genre conventions and mechanics. If you pick up a modern FPS role-playing game like *Fallout 3*, you are confronted with a complex world and inventory system with little to no explanation. If you have experience with shooters and role-playing games, you realize the game operates along fairly standard lines. But if you don't have that knowledge base, you might spend several hours just learning to look around, walk, aim and shoot. Never mind that once you have figured out the basics of movement, you must still master the inventory system and dialogue trees. I'm a fairly decent gamer and it still took me 20 minutes to figure out how to switch weapons in the game. That's about 15 minutes longer than most people have to dedicate to playing a game, and about 19 minutes longer than the patience a casual gamer has for learning a new control mechanic.

Now, *Fallout 3* is a great game, full of exciting story, interesting challenges and beautiful environments to explore. But easy and intuitive it is not. *Fallout 3* is what designer and writer Danc (of the insightful game design blog *Lost Garden*) would call a genre king.[10] *Fallout 3* stands at the end of a long line of games that use similar mechanics. Each new game release makes small adjustments and additions to that mechanic, adding new complexity to the gameplay. Each game within a genre must add some new challenge to the gameplay or risk being dismissed as too easy by fans of the genre. At a fundamental level, games are about learning and mastery. You poke and prod a game system until you master it. This learning process makes games fun. Once you completely master a game, it becomes less exciting. Raph Koster explored this topic at length in his excellent book, *A Theory of Fun*.

So to continue offering fun challenge to players, designers have had to make games harder and harder over the years. The change is not necessarily noticeable from one FPS to the next. But when you make the leap forward over 15 years of a genre and all the gradual changes made to a mechanic, the difference in difficulty becomes very apparent. Essentially, hardcore video games have kept barreling forward, towards a

[10] http://www.lostgarden.com/2005/09/nintendos-genre-innovation-strategy.html

destination only the truly skilled and dedicated can reach. This has left a lot of people potentially interested in playing a game standing by the wayside.

Casual games reset this difficulty curve and invite in unskilled players.

Why Now?

Evolving demographics, the Internet and general comfort levels with technology—not to mention the deep marketing pockets of Nintendo—have all contributed to the rise of casual games.

First off, gamers are getting older. According to a 2006 survey conducted by the Entertainment Software Association (ESA), the average age of a gamer is now 33. Of all gamers, 31 percent are under 18 years of age, while 44 percent are between the ages of 18 and 49. A full 25 percent of gamers are 50 years or older.[11] This means the audience for games is much more diverse than the stereotype of the teenage gamer. As the average gamers have gotten older, they have also found they have less time to play games. These players now have wives, husbands, kids, jobs, DirectTV and housework all competing for their attention. Fitting in a 15-hour marathon of *Civilization* gets harder and harder. But they still want to play something, just in shorter sessions. They need to slot gameplay into their lives, not the other way around. Casual gameplay—with its short play times—meets that need.

These statistics also suggest the audience of games is much wider than normally assumed, and growing wider all the time. The stereotypical image of a gamer—the anti-social, nerdy teenage boy—is quickly disintegrating. This broad audience is bound to have a wide range of tastes. Quite unexpected to many is the fact that women make up 38 percent of the gaming population.

The Internet is probably the biggest driver behind the growth of casual gameplay. We're all spending more time online. Much of that time is probably spent looking for something to do. And games often fill that need. More and more gamers are playing online. The same 2006 ESA study found that 44 percent of frequent gamers play online, versus just 19 percent in 2000. So what games are they playing? More than half of all games played online are puzzle/board/game show/trivia or card games, all squarely within casual genres. This dwarfs the 22 percent playing action/sports games.

Casual gameplay is particularly suited to the Internet. We consume content in small chunks, from two- to three-minute YouTube videos to blog posts, as we jump back and forth between our e-mail and work. As a result of playing games in Web browsers with Gmail beckoning us from another tab, games need to make low-attention demands and offer quick rewards. It's very hard for a game (or anything really) to capture our full attention. This "continuous partial attention," as the writer Linda Stone terms it, prevents us from devoting our full attention to any one thing for very long.[12] This makes it very hard to play a hardcore game like

[11]http://www.gamasutra.com/php-bin/news_index.php?story=9342
[12]http://www.lindastone.net

Fallout 3, which requires full attention for an extended period. But it makes playing a round of *Bejeweled* for five minutes quite easy. Casual games don't demand full attention right off. They are easy to start playing, pause and come back to. The best ones ramp up their demands on attention over time so the players barely notice how fully they have been drawn in.

The Internet also allows for the quick spread of new games. Games like the Flash application *Desktop Tower Defense* can be launched, go viral and find an audience of millions in weeks. Without the Internet, all of those casual gamers might be stuck playing *Windows Solitaire* and *Freecell*.

As the audience grows wider, new people are playing games, from grandmothers to 30-somethings who thought gamers were for kids to Internet savvy teens to lapsed gamers returning to the fold. Casual game design is about designing games for all of these people.

Summary

Casual games now take up more than half of all games played, and have introduced a much wider population to gaming, from senior citizens to working moms. While casual games use a wide variety of mechanics to appeal to the different interests and limitations, there are four key elements to any casual game:

- Rules and goals must be clear.
- Players need to be able to quickly reach proficiency.
- Casual gameplay adapts to a player's life and schedule.
- Game concepts borrow familiar content and themes from life.

CHAPTER TWO

The Game Mechanic at Work

The game designer has a number of responsibilities in the game development process. The game designer directs the creative vision of the game from conception through to launch. Like the director of a film, the game designer is responsible for creating and maintaining the creative direction of the game, working with the artists, programmers and producers to bring the game to life. This includes a wide range of specific responsibilities from brainstorming concepts to writing rules to crafting levels for the game.

The Role of the Game Designer

People have been designing games for thousands of years. In the 1920s, Sir Leonard Woolley unearthed a board game in the Royal Tombs of Ur in what is now southern Iraq. *The Royal Game of Ur*, dating back to 2,600 B.C., is probably the world's oldest intact board game (Figure 2.1). The Egyptian game *Senet* is even older. Historians have found evidence dating *Senet* back to 3500 B.C. But we can confidently say games are far older than that. As long as leisure time has existed, we've had play and games to help fill those spare minutes. And as long as there have been games, there have been game designers, picking out stones, crafting boards and prescribing rules to govern play.

And while the tools of implementation may have changed—we now push pixels instead of round stones—the basic idea is still the same: Craft a set of rules that governs play. As an author strings words together into sentences and builds them up into stories, a game designer combines rules into mechanics and assembles those mechanics into games.

We all have some experience with game design. As children, we work with our friends to turn our play into games. On the playground, bored with simple tag, we conspire to add new rules to the basic mechanic of tag, building up new games, from *Freeze Tag* to *Television Tag* to *Zombie Tag*, gradually making the game more complex and interesting. Just think of the common refrain echoing from kids playing

FIGURE
2.1

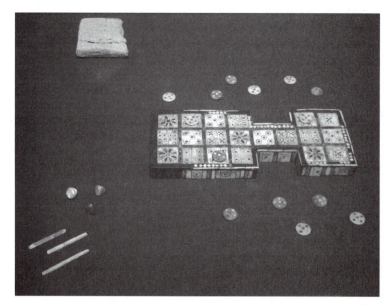

The *Royal Game of Ur* on view at the British Museum. (WikiCommons[1])

tag, "No tag backs! You gotta wait at least 10 seconds." These kids have instantly recognized a flaw in tag that often devolves the game into a stand-off. One simple rule tweak fixes the game: After being tagged, you must wait at least 10 seconds before you can tag the same player back.

The practice of adjusting games continues into adulthood. Pick-up basketball players adjust the rules of games like 21 or three-on-three to suit the players at their local court. They change rules that dictate courting the ball, committing fouls and even points per basket. Friends gathering to play board games like *Trivial Pursuit* or *Monopoly* add house rule variations to deal with perceived weaknesses with the game. For example, a common *Monopoly* house rule says landing on Free Parking pays out to the player all cash accumulated from Chance and Community Chest cards. Playing a game forces us into an intimate relationship with the rules and naturally leads us to adjust them to improve the experience of playing (or sometimes, more devilishly, to strengthen our own hand).

It's almost natural, then, that the job of game designer is somewhat overlooked. We take for granted that games exist. Many of the games most familiar to us—like tag—seem so elemental that you cannot imagine them not existing. Games have an active and rich folk tradition that we regularly interact with. Like ghost stories, it is often assumed that folk games like tag or hide and seek do not have authors. Games are one of the few media that still have such an active

[1]http://commons.wikimedia.org/wiki/File:Royal_game_of_Ur,at_the_British_Museum.jpg, User: Zzztriple2000

folk tradition. It can seem as if they've always existed. Even popular board games like *Monopoly* have been around long enough that we take their existence as a given. But *Monopoly* was designed by someone, Charles Darrow, in fact. His game is a descendant of *The Landlord's Game* designed by Elizabeth Magie Phillips, a Quaker follower of the economist Henry George, who created her game to help explain George's single tax theory.

As video games came to dominate the game industry, people have become more familiar with the profession of game development. However, misconceptions still abound. The software and art are the most tangible parts of a video game. Video games fill the screen with lush graphics, moving around, responding to your input. Unlike a board game, you rarely sit down and read the rules to a video game. Those rules exist, but they are baked into the code. As a consequence, the general population equates game design with programming or 3D graphic design. Tell most people you work in game design, and they'll ask if you are a programmer or an artist. Both of those jobs are absolutely integral to video game development. But there are some other vital roles that need to be filled to bring a video game to market.

The same people doing game design may also be programming and drawing characters, but they are all separate arts requiring different training. In the independent development scene, with small teams, team members may find themselves conscripted into handling multiple facets of game development. This can be good. A healthy knowledge of programming and art creation is indispensable when designing games. That background gives the game designer a better sense of what is possible and the cost of implementing ideas. But in the end they are all separate tasks.

And it all starts with the game designer. Game design is the art of creating the system and experience of the game. The game designer generates the concept that underlies the game. She says, "This game is going to be about matching sets of three adjacent objects." This concept gives the game a basic shape and direction. The Game designer defines the space of the game: "The game will take place on a 10-by 10-grid with a red, blue, yellow, green or purple block in each square." After that, the game designer must sketch out the gameplay: "The player will make matches by swapping adjacent blocks to create sets of three." This begins to define how the player will go about making those matches of three. Once they have the initial concept, the game designer fleshes out this system, crafting the nature of the experience by adding rules. She adds a rule, "The player can only swap two adjacent blocks if one of the swapped blocks will wind up in a matching set of three or more." This prevents the player from swapping any two blocks, and adds a level of challenge to the game. Slowly, through the accumulation of rules, the game is constructed. Finally, you wind up with something like the system behind *Bejeweled*.

This doesn't all happen at once, and it certainly doesn't happen in a vacuum. The development of the game design is a living process that responds and changes as the game is built and the mechanics are tested. The game designer works in partnership with other team members to build the essential elements of the game. The game designer makes an initial guess at what will make a good game and then the team finds a way to prototype that idea and test it through play. The game

15

The patent application for *The Landlord's Game* shows a game that evolved into Monopoly as different designers adapted and refined the mechanics. (WikiCommons[2])

[2]http://commons.wikimedia.org/wiki/File:BoardGamePatentMagie.png, User: Zzztriple2000

designer then refines the game idea, adding or removing elements and playtests the game again.

As the game progresses and grows more complicated, the game designers must keep the game clear and focused. Clarity is important in any game, but it is of the utmost importance in casual games. The game designer is an advocate for the player and must focus on delivering the smoothest experience possible.

Video Game Designers

These days, "game designer" seems synonymous with "video game designer" in the popular imagination. This means the job is part game design and part software developer.

A video game development team can generally be broken down along the following lines:

- Producers manage the development budget and team, helping organize the team and providing the necessary support so each team member can do his or her job.

- Game designers are responsible for the concept and vision of the game. If you were to equate the role to movies, the game designer would be the director. He or she works with the artists and the programmers, helping guide the implementation of the game from the overall visual tone to the bounciness of the physics engine.

- Visual artists produce the art assets for the game, be they hand-drawn animations or 3D models. The field of visual arts in game development is huge and encompasses a number of different specialties, from user-interface design to character design to animation.

- Audio artists create the sound effects and music for the game.

- Programmers write the software code that brings the game to life. They take the specifications and rules and turn them in to code. This is the heavy lifting in video game development.

- The Quality Assurance team puts the game through the paces, writing test plans and thoroughly testing every aspect of the game. QA is often a good entry job into the game industry, as it familiarizes you with all aspects of development, forcing you to work with producers, artists, game designers and programmers.

Board Game Designers

Video games get all of the attention and steal the headlines. But casual gamers are just as likely to play board games as video games. Fortunately, a number of talented game designers dedicate their energies to board games. Board game designers have many of the same responsibilities as video game designers. They conceive the

game, write the rules, work with artists, and continually iterate and refine the game. However, when creating board games, designers cannot rely on programmers and the software to do all of their heavy calculations. So they must pay close attention to balancing the game and the probabilities of different moves and actions.

The Responsibilities of the Game Designer

On a high level, the game designer is responsible for the concept and vision of the game. But what does that boil down to on a day-to-day basis? In practice, the game designer's job looks something like this:

- Work as part of the team
- Generate the concept
- Craft the rules
- Write game and software specifications
- Guide the implementation
- Playtest the game
- Refine the concept
- Design the levels

Work as Part of the Team

Good game development is a team effort, requiring the input of individuals with different skills and knowledge. The game designer has specific knowledge and skills relating to how the game system should work. But programmers and artists have very specialized knowledge that greatly influences the game. The game designer must communicate the structure and tone of the game to the other team members. The more effectively he or she can share the vision, the more the other members of the team can contribute ideas and suggestions that draw on their specialized knowledge. If the idea and requirements of the game are clear, the programmers will be able to suggest everything from an appropriate game engine to the variables they can expose to the game designer. A working grasp of programming is extremely useful for any game designer. It helps give you an idea of possibilities and makes communicating software needs easier.

The game designer also needs to speak the language of visual and audio artists. Artists will produce the art and audio assets that go into the game. But they will look to the game designer for guidance on the overall tone and direction of the game. The art should be in service of the gameplay, so the designer and the artist will need to be on the same page. Like programming, visual art has its own special language. The designer saying, "Make it happier," is not helpful and will leave the artist with

insufficient direction. But being able to say, "We need to lighten the color palette and increase the line weight to give the characters a more round, cartoonish feel" will go much further in helping the artist know how to make the game "happier." The same holds true for audio artists.

If you don't already have a knowledge of these disciplines, you should work on developing one. Pay attention to the way artists and programmers talk about their work. Work with these members of your team to develop a rapport. Ask them to teach you about their work and, in turn, share your knowledge of game design.

Through all of this, the game designer must work in partnership with the producer to make sure the game stays on track. The producer is responsible for keeping the game on schedule and budget. But the game designer must help him or her do that. The game designer must recognize when to cut features to save time and when to push hard for a feature that will greatly improve gameplay and the player experience. This can lead to some back and forth between the producer and the game designer. Maintaining a relationship of respect is vital. In the end, if both the producer and game designer are clearly communicating, the two will develop a close relationship which will help keep development focused.

Each studio will have its own variation on team structure. At very small developers, the same person may fill multiple roles, from designing the game to programming to drawing the art. At large console developers, the development team will consist of dozens of people, each one responsible for some small aspect within one of the production silos. But no matter what, the game designer needs to be the consummate team player. He or she needs to help everyone else on the team do their jobs better.

Generate the Concept

The game designer is involved from the very outset in generating the concept for the game. External forces will often provide certain constraints for the game. Commercial interests may dictate subject matter or a general game type. The game platform will push the gameplay in directions that suit the controls of the system. For example, console controllers are ill-suited for complex strategy games. The need for a keyboard and mouse tends to push strategy games onto PCs. Most importantly, your intended audience will drive certain gameplay decisions. But in any of these cases, the game designer needs to be there to help define the mechanic at the core of the game. The rest of the game, from the story to the art, should grow from the core mechanic.

At the outset of a project, the game designer will brainstorm initial concepts for the game. Some designers generate many wildly different concepts. Other designers quickly settle on one general idea and come up with variations. It is up to you to find a method that best fits with your way of generating ideas.

The easiest way to begin thinking about a game is to start with a game mechanic or interaction you know works. Many games are built on top of other games. It's

important that game designers play other games and closely analyze which mechanics work and which don't and why. Game designers may play a game and see new potential in a game mechanic. Perhaps you will see a way to reuse the mechanic with different content. Or you may envision a way to modify the mechanic and make a new game. What if you mixed *Solitaire* with *Scrabble* so you played with a deck of cards marked by letters, and your goal was to spell specific words, not just get cards in numerical order? There are millions of ways to modify and build new games. You just have to look around.

Some game studios will spend time prototyping mechanics. A game designer may mock up ideas in paper prototype form or work with a programmer to put together a small digital prototype. This prototype should demonstrate a game mechanic or interaction scheme or perhaps even just a possible visual content direction. When it comes time to develop a new game, the team can draw on these prototypes and pick and choose the prototypes they feel work the best. Spending time prototyping mechanics can be difficult for a studio to maintain. It ties up resources on work that doesn't immediately generate revenue. But it can prove invaluable in the long run, as it gives new game concept generation a set of departure points.

If the project you're working on calls for a fresh concept, you may have to start with pure brainstorming to find a game concept and mechanic. This sort of open-ended assignment can be daunting. In order to reach a set of interesting and viable ideas, it's important to give your brainstorming some structure. First off, when brainstorming game ideas from scratch, define some parameters for the game before you begin, such as your goals for the game, the platform and audience. Blue sky brainstorms where you can head in any direction are often unproductive.

Before you come up with game concepts, it is important that you have an idea of what you want players to get out of the game. Are you aiming for commercial success or do you prefer to use your game to make an artistic statement? Do you want players to have a quick, intense, five-minute experience? If so, your game idea doesn't need to be as deep and strategic as a game that must hold a player's attention over 80 hours. Instead, you can focus on a novel or interesting interaction scheme. If you want players to engage with the game for hours on end over multiple weeks, then you will need to design a game with structures that draw players back again and again. You might decide to do this through a complex and strategic game. Or you might make the game about a persistent identity that players nurture by collecting items and experience points so they can level up the character. You'll generate concepts in the brainstorm, but it's important that you have an idea of how people will play your game before you start brainstorming. That way you can focus on ideas that meet these goals.

4 Minutes and 33 Seconds of Uniqueness is a beautiful little game created by Petri Purho. The only way to the win the game is to be the only person in the world playing it for four minutes and 33 seconds. During the game all you see is a black window (Figure 2.3). The game constantly checks with a server to see if anyone else anywhere in the world has started the game. If they have, the game simply closes and you lose. The game is a clever little idea, but hardly commercially viable. But that's okay, because the game is more of an art project than a commercial game,

FIGURE
2.3

4 Minutes and 33 Seconds of Uniqueness. **(Reproduced by permission of Petri Purho, Heather Kelley and Jonatan Söderström)**

and Purho knew that when he set about making the game. The game was actually inspired by the piece *4'33"* which is sometimes referred to as "Four minutes and thirty-three seconds of silence" by the avant-garde composer John Cage. There is a large audience of people interested in exploring games as art, and this game strikes a chord. Knowing your intended audience will help you know what you can and cannot do in your game—how to craft it to satisfy your players.

Knowing who you are making the game for will suggest the level of complexity and engagement the game should offer. If you are making a game for the casual audience, it's important to keep the game simple and focused on the core mechanic. A casual game cannot demand players dedicate an hour to every play session. The game should be playable in small, discrete chunks. This will help the game match the amount of time casual game players can give to it.

Determining your audience can also help suggest content directions for the game. Attractive content often helps entice players to try the game. You want to find content that will draw players in, not turn them off. This doesn't mean that all content needs to be bland and market-tested. Instead, you just need to be aware of how your audience perceives your game. The audience for Web games on Kongregate has different taste than the players who download casual downloadable PC games from the portal Big Fish Games. Kongregate attracts more kids with greater taste for typical gamer tropes than a downloadable portal like Big Fish will. The downloadable portals attract a large number of adult women. You can make a zombie game for that market, but it will probably be more successful if the zombies look like the cute-cartoon zombies of *Plants vs. Zombies* (Figure 2.4) than if the zombies display the ghoulish gore of the zombies in the hardcore console title *Left 4 Dead* (Figure 2.5).

21

FIGURE
2.4

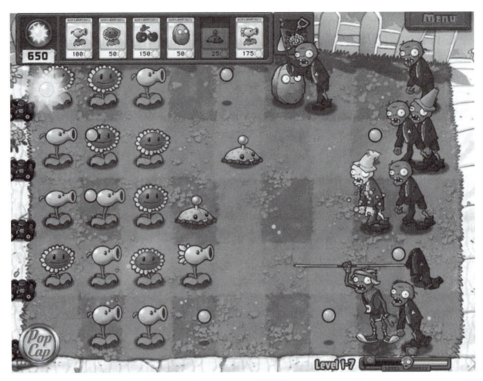

Plants vs. Zombies **has been a big hit in the casual market despite the undead content. PopCap made the content palatable by using a cartoonish style that made the zombies almost as endearing as the flowers. (Reproduced by permission of PopCap Games)**

Similarly, determining the platform will help you hone in on your audience, as well as highlight technical limitations for your game. Distributing your game on Xbox Live versus downloadable portals will put your game in front of very different people. Get familiar with the types of games on different platforms and portals. Play each outlet's games, look through the popular games and any user profile information you can find. Keep abreast of these outlets by revisiting them. The audience can shift and change over time. This will give you a greater idea about the length of game and depth of gameplay the audience will be expecting. Use this information in your brainstorming. If you've decided to make a Web game for Addicting Games, you probably don't want to make a strategy game that takes hours to play. Instead, you probably want to make a small game with a simple, yet repeatable, mechanic that may only take a few minutes or even seconds to play.

Each platform will have technical limitations to contend with. If you make a game for Xbox Live or PlayStation Home, you'll need a control scheme that works well with a joystick controller. As a general rule of thumb, PC downloadables should be playable with just the mouse. And if you want to be really safe, your downloadable

FIGURE
2.5

The zombies in Valve's *Left 4 Dead* aren't nearly as endearing as the undead in *Plants vs. Zombies*. They made the game a hit in the hardcore market, but it's hard to imagine these gruesome zombies striking a chord with casual gamers. (© Valve Software)

game should probably just use the left mouse button. This will no doubt change over time as casual downloadable players become more advanced. But it will still be a while before casual players are using WASD-keys and the mouse in combination to control games. If you develop games for an iPhone, a player's finger may operate much like a mouse, but it will obscure part of the screen in the way a mouse will not. Ninja Kiwi's port of their popular web game *Bloons* to the iPhone is marred by this very limitation. Touching your finger down to aim your shot obscures your aiming arrow, making it much harder to shoot accurately than when you play the game on the computer and you can use a mouse (Figure 2.6).

Meanwhile, *Gigaputt* (developed by my company, Gigantic Mechanic) takes advantage of the special abilities of the iPhone (Figure 2.7). In the golf game, you swing the phone like a golf club and knock the virtual ball over a Google Map of your surrounding neighborhood. The phone leverages the GPS and the accelerometer built into the phone to enable the gameplay. This is an example of a game where the specific constraints and abilities of the platform inspire the gameplay and mechanics.

The point designers should heed is clear: look into the technical and control limitations imposed by your platform and use these as parameters when you start brainstorming concepts. These constraints will actually help spark ideas, not limit them.

FIGURE
2.6

When you play the Web-version of *Bloons* on the PC the mouse does not obscure the game-playing area. The experience on the iPhone is flawed because the designers didn't properly account for the touch control scheme of the iPhone and how it would obscure the game area. (© Ninja Kiwi)

Once you have determined your audience and platform and researched what they entail, you should have a nice set of reference points and constraints to inform your brainstorming. You can add additional constraints if you like to further focus your idea generation.

Gigaputt **uses the iPhone GPS and the accelerometer as key components of the gameplay. (Reproduced by permission of Gigantic Mechanic)**

After you and your team feel that you have produced a healthy basket of ideas, you need to trim and organize your ideas. The game designer should classify the ideas, looking for similarities and trends. Organize them by content ideas and game mechanic ideas. This doesn't necessarily need to be done in a group, as it could take some time. At this point, you should go through all of the ideas once to cut ideas which seem out of scope for the project or just plain impossible. With the remaining ideas, you can spend some time fleshing out the most viable ideas, imagining how the idea would look and play as a full game. At this stage, it's important that you recognize intriguing gameplay possibilities. When you are designing casual games, it's also important to keep the idea simple. At this point, it can be very tempting to start tacking features, goals and strategies on to the game. You certainly want to imagine a robust game, but be wary of going too far before testing the main interaction at the core of your game idea.

Once you have settled on a few ideas you like, the game designer should conduct some competitive analysis to see what other similar games exist. This includes looking for similar games, and researching how well they've sold. Envision how your game will fit into the market. Just because a similar game already exists doesn't mean that you should not pursue an idea. But you do need to think about how your game will differ and surprise players to stand out among the crowd.

25

If you are working for a publisher or client, you will need to pitch your ideas to them as well. Sometimes, they will want to see a playable prototype, while other times a well-written pitch document will suffice—more likely if you already have a proven track record making successful games. Your game pitch should be concise, describing the game as succinctly as possible. Include art mock-ups that help describe the gameplay and general look and feel of the game. Pictures always help convey abstract game system ideas.

With your team and client, settle on the game that best meets your objectives, audience expectations and platform requirements.

Craft the Rules

Rules provide the skeletal framework for your game. They give your game structure and solidity. They tell the players what they can and cannot do.

Once the team has settled on a concept, the designer writes the rules and fleshes out the game. It may seem silly to write rules for a video game, but it's still an important exercise. It often seems like video games don't have rules so much as interfaces. The software simply defines what the player can and can't do, so the player doesn't need to know the rules. It's true, the game guides the player, but the software still follows rules. As the game designer, you must define the behavior so you can write the software specifications for the programmer. Writing out the actual rules to the game serves as a good starting point for thinking about the software specifications.

There is no one perfect way to write rules for a game, but there are lots of ways to wind up with a confusing set of rules. Before you write your rules, make sure you have a clear idea of how the game plays and what experience you want the players to have. Then craft your rules accordingly. Keep your audience in mind. For example, hardcore board gamers are much more willing to pore through and study a long booklet of rules than most casual gamers. In my experience, most people want to get going with the game as soon as possible. They view rules as an unfortunate impediment to playing, not as the intricate and careful crafting of experience that game designers do. As always, it's best to give your audience what they want, not necessarily what you want.

Some general guidelines for writing rules:

- Be concise and exact
- Be firm
- Can't vs. must
- Instructions are rules too
- Avoid too many special cases
- State the game's goal upfront
- Tell the rules like a story

- Give examples
- Organize play into phases

Be Concise and Exact

Be as concise and exact as possible. Clearly state what will happen when a game event occurs. Unclear rules confuse and frustrate players. Many players will simply abandon a game before even starting if the rules are unclear. In addition, be careful not to contradict yourself with rules.

If you say a player has power-up, define exactly how many rounds or seconds the player can use the power-up. If someone loses or gains points, define exactly how many points. If you generalize by saying, "When you place the paint bomb, it changes the color of a bunch of the gems," players will have no idea how many gems change color, nor what color they take on. It is much better to say, "When you place the paint bomb, it changes the color of all gems in horizontally and vertically adjacent squares to a color of the player's choosing." This way, the outcome is clearly defined.

Be Firm

Your rules should not leave room for argument. The game system governs the game. It dictates to players how to play. People expect that of rules. Deliver that.

Use strong language like "will" instead of "may." This will become increasingly important when you begin to write specifications for your game.

In addition, you don't want players to have to interpret your rules during play. They'll wind up arguing with each other, sucking the life out of your game. You want them to stay lodged in the game system you create. Stepping out to argue about rules snaps players out of the game. It's like seeing the boom mike dip into the frame of a movie—it ruins the illusion of the game.

Can't vs. Must

It's easy to think of rules as just a list of "Can't Dos." Pawns can't move backwards; you can't touch the ball with your hands; you can't move while holding the basketball unless you dribble. While you will certainly need to have a number of Can't Dos in your list of rules, if you have too many, it may feel claustrophobic to players. Can't Do rules also do a poor job of telling the player what he or she can do, how he or she should actually be playing the game. Rather than simply thinking of Can't Dos, structure your rules as Musts. So instead of saying, "You can't move while holding the basketball, unless you dribble," try, "To move with the basketball, you must dribble." This makes the rule more affirmative and begins to help the player see what type of actions the game wants him or her to take.

Instructions Are Rules Too

There can sometimes be questions about what constitutes a rule. A rule is any information the player needs to play the game. At its core, each rule should reflect an element of the game system. However, when written, they may look more like instructions. That's because instructions describe how to interact with the game system. So the rule might be, "The number of spaces a player can move is determined by the roll of a six-sided die." But the rule as instructions may read "Roll the dice to determine how many spaces you can move."

Avoid Too Many Special Cases

You want your game to have an overall systematic consistency. Rules and the effects they dictate should naturally flow from one to the other. Special cases are instances where one particular element of the game behaves unlike all of the other elements, breaking the system's consistency. You know you're headed for a special case when you have to write, "You always do this, EXCEPT when this ONE thing occurs. Then you do this other thing instead." For example, it would be inconsistent game design if the rules of basketball were changed to say, "To move with the basketball, you must dribble, unless you have just scored a three-point basket." Not only does that rule not make any sense given the context of the game, it would also break up the action of the game and make playing much choppier as players began to behave in different ways based on specific events. Some special cases are necessary. But if you lard your games with them, players have a hard time keeping track of what they should do. In board games, they will be forced to constantly refer back to the rules. In video games, they will likely just be confused by constantly changing behaviors.

State the Game's Goal Upfront

Before you plunge players into lengthy descriptions of what they must do and what they can't, tell them what their overall goal is. Tell them how they win. This can be as simple as, "The goal is to score the most points." This puts all of the rest of the rules into context. Players can read the rules and situate them in their minds in relation to that goal. A rule might help a player earn points or might cost him or her points. If players have a clear idea of the game goal in their minds, they know immediately if that rule helps push them closer to winning or might cost them the game.

Tell the Rules Like a Story

Where you can, it helps to narrativize your rules. Don't just spit out rules in a long list. Put them into a natural flow that reflects the gameplay. Introduce high-level rules that frame the action of the game first. Then introduce rules in an order that reflects how players will encounter them in the game. Craft your set of rules into a walkthrough of the game, from set up to standard moves to the end game. This gives players a sense of the arc of the play experience so they will know where they are in

the game. Think of it like telling a story. You introduce the players to the setting, run them through the action and finally move on to the climax of the game. This method can enable players to begin playing the game before knowing all of the rules, letting them learn some of the rules by playing. Rules learned while playing usually make more sense because the player now has a feel for the game and its constraints.

Give Examples

Help players understand a rule by providing a description of the rule in action. Say someone was having a hard time understanding the rule, "To move with the basketball you must dribble," you could clear it up with a simple example, "If you catch the ball you can no longer move as freely. To move, you must dribble the ball. You can also shoot or pass the ball to another player. Once you get rid of the ball, you can move freely again."

Organize Play into Phases

Your game should have a natural rhythm to it. Each move should sensibly lead to the next action. This will help players move smoothly through the game. This doesn't mean each move needs to be one simple click or roll of the dice. If your game requires more complex interaction patterns, consider breaking each turn into phases. A lot of complex board games do this. This helps players chunk rules and instructions into more understandable moments. For example, the excellent board game *Settlers of Catan* breaks the game into a number of different phases, each with a set of instructions. Each turn a player takes is broken into three different phases: the Raw Material Production Phase, the Trade Phase and the Build Phase. Each phase has unique actions associated with it and involves each player in the game in different ways. By breaking each turn into these three phases, players can develop a rhythm to their play. Players know when to pay attention and when they can tune out.

It also makes reading the rules easier. The player can digest each phase in turn, rather than trying to understand, all at once, all of the rules about collecting materials, trading with others and building new resources.

This sort of organization can be valuable in video games as well. A game with a several step process can benefit by laying out each move as a series of steps or phases. This will help players internalize the structure of the game and navigate through the UI. The easier it is to understand and make moves, the more effort the player can expend on strategy and gameplay.

Write Game and Software Specifications

Before the programmers and artists can begin working on the game, the game designer will need to provide a software specification document. The spec, as it's often called, serves as the blueprint for the game. Spec documents can run to hundreds of pages

for large games, as they need to outline all of the functionality in the game. For small teams using agile project management methodologies, the documents will be much smaller, but grow over time as the game evolves. In this document, the game designer lays out all of the functions the game will need to perform and the variables the game designers will need to access to balance the game. The document should be detailed, but not so verbose that programmers refuse to read it.

Included in this document should be rough wireframes for the game's user interface, or UI, as it's commonly called. The specifications should also include notes on the visual direction for the artists. This can include everything from rough sketches to written descriptions to sample images from games, books, comics, photos and movies that capture the desired look.

Writing good, clear specifications is an art in itself. Game designers new to writing specs tend to underwrite them, which leaves big holes in the logic of the game that the programmer will then need to fill with his or her own assumptions. This will frustrate many programmers, especially if the game designer later asks for changes because the assumptions didn't match what the designer had in mind. It's best to think out the logic of the game as thoroughly as possible and then document it, so the programmers don't have to make guesses as to how the game should work. Another common mistake is overwriting the specs, putting in so much detail that the programmers feel they can't make key decisions about how to implement features.

Probably the best thing you can do before writing a specification document is talk with your team to fully understand how they want you to structure and write the spec. They are the ones who have to read and interpret the document, so you want to craft it for them. Some programmers may want very detailed specifications that list every possible iteration of a function. Others may prefer just a high-level sentence or two that describes the functionality. Still other programmers may prefer lots of pictures and wireframes showing how the game moves from state to state. Similarly, work with the artists to decide the best way to agree on an art style. Once your team has given you an idea of how they want to receive specifications you can set about crafting the document in this model.

The game designer will lay out the initial design document, but other members of the team may contribute to it as well, adding information about the narrative, art, UI and technology. The game designer will own the design document, but they maintain it to help facilitate conversation and to keep a record of creative decisions for the game.

Specs must be clear enough to convey the essential ideas, but concise enough that readers are not bogged down. Effective organization of your design document is key. Each game is different and will require a different structure. I recommend breaking your document into several key sections:

General Summary

State the purpose of the document and a very high-level view of the game. This is to orient anyone picking up the document and helps him or her know what to expect.

- Table of contents
- Story/theme information
- General look and feel
- Summary of gameplay
- Information architecture
- Specifications for specific features

Table of Contents

As the document grows in detail and length, a table of contents will be an invaluable tool to help readers find specific information buried within the document.

Story/Theme Information

Set the narrative stage for the game. You want everything in your game to feel consistent, from the art to the gameplay to the user interface. Describing the narrative universe of the game will help get artists, programmers, audio designers and UI artists on the same page. If your game has a detailed story, give an overview. This section is still valuable, even if your game is an abstract game with no particular story. Even abstract games have a theme. Lay out that theme.

As the document grows, you may start to include more details about the narrative. If the story is short, you may include the actual script in the design document. For longer narratives, it may be easier to create a separate script document so you don't bloat your design document.

General Look and Feel

In this section, you'll begin to establish the art style for the game. The designer may do this by simply describing the art style he or she feels will work within the game. So you might say, "The game takes place in the world of high fashion and the art should reflect that. It should borrow the look and feel of fashion magazines like *Vogue* mixed with the fashion illustrations of Antonio Lopez and David Downton."

Ideally, your descriptions should be accompanied by some visual research, such as pictures that exemplify the general style you are envisioning. But don't go overboard—the game art director will want to more fully establish the style. The direction you suggest should be the result of conversations with the team about what styles the team thinks will work. Once a general art style is set, the game's art director will look for more comparable art to round out the visual research. Again, this information can be stored in the design document or housed in a separate file, depending on the volume.

Summary of Gameplay

You should provide a line-by-line description of the gameplay, from starting the game and picking a level to the moment-to-moment interaction within the game to beating a level and moving on to the next level. Looking at the experience as a whole will help you think about how the overall experience is crafted. It's very tempting to only think about the game as independent chunks. This will lead you to concentrate on the game screen interactions. This is necessary. You want that section to be well thought out, but you also want to view the game as a whole, taking into account how well the whole experience coheres together. This summary, along with the screen flow, will serve as the roadmap for features that need to be specified.

When describing the gameplay, describe the interaction hit upon the key beats within your game. You want to provide a procedural description of how to play the game.

I often find it helpful to use this summary to lay out basic terminology for the game that you will use later when you spec a feature.

Here's an example of an initial gameplay description for a simple video game version of *Solitaire*:

- Game Loads
 - When the game loads, the **Main Deck** is in the upper left corner.
 - **Foundations** appear as four ghosted rectangles in the upper right corner.
 - **Cards** will be dealt into the **Tableau** underneath the Main Deck and the Foundations.
- Dealing Sequence
 - The **Dealing Sequence** commences as soon as the level loads.
 - During the Dealing Sequence, cards are dealt from the Main Deck to seven **Piles**.
 - When the Dealing Sequence is complete, the player has:
 - Seven Piles of cards in a Tableau with the top card on each Pile face up.
 - Four empty slots on the Foundation.
 - The Main Deck placed face down.
- Play Begins
 - Player begins organizing cards.
 - The player organizes cards on the Tableau by placing face-up cards on top of one another. Cards are organized from the king down to the ace, alternating **Suit** colors on each card.
 - A sequence of organized cards can start with any card, but must proceed down from that point.
 - When a player moves a face-up card, revealing a face-down card, the face-down card is turned face up.

- The player organizes as many cards as they can.
- Stacks of face-up cards can be moved on top of other face-up cards if they maintain the proper sequence.
- Playing off the Main Deck
 - If the player has no moves left to make on the Tableau or Foundation, he or she can click the Main Deck, flipping over the top card and placing it in the **Main Deck Active Pile**.
 - Cards can be drawn off of the Main Deck Active Pile and placed on the Tableau or Foundation, if they are in the proper sequence.
- Playing on the Foundations
 - To win the game, the player must sort all of the cards by Suit into four separate stacks on the Foundation rectangles.
 - The Foundation stacks proceed from ace to king.
 - Once all four Foundation Stacks are complete, the player wins.
- Win Animation
 - When the player wins the game by completing all four Foundation stacks, the **Win Animation** plays.
 - After the Win Animation completes, the **New Game Dialog** appears and asks if the player wants to play again.

It can be very useful to include hyperlinks to key sections in your game design document. Using these hyperlinks, your team members can jump to a section where they will get more detail about a function or element of the game. This way, you can avoid cluttering your description with too many details about specific functions that don't concern the overall experience and gameplay. In the description above, each of the bolded words would be hyperlinks that link to a section with more detail about that element. As the game grows and you add features to your game, you can come back and add them to your initial gameplay description.

Information Architecture

Once you have your initial description of the gameplay, you should start working on the information architecture for the game. This includes a screenflow diagram that shows how all of the screens and processes in the game are connected. Once you have that screenflow, you can begin creating wireframes for each screen.

Screenflows can be laid out in programs dedicated to information architecture, like Visio, or pieced together in Illustrator or Photoshop. I've found that Microsoft Word has enough tools to create adequate screenflow diagrams for games.

Let's imagine our *Solitaire* video game is composed of a series of levels you have to play through. Each level is a specific assortment of *Solitaire* cards you must complete before moving on to the next level. Figure 2.8 is an example of a screenflow diagram for that level-based version of *Solitaire*.

FIGURE
2.8

A screenflow shows the process of the game and the various decisions made at each key point in navigating the software of the game.

Screenflows can become very complex very quickly, even for simple games. You can always break them up into multiple, smaller screenflows that cover specific interactions.

Once you have this screenflow, it gives you a good idea of what screens you need to wireframe and build in your game. It also provides a good map of the overall experience for other team members.

Wireframes are skeletal versions of each screen in your game. The wireframe should indicate all of the necessary elements for the screen. This includes buttons, score meters and gameplay elements. The wireframe does not indicate the final look and feel of the UI or even the exact layout; rather, it determines the weight and importance of each element. By looking at the wireframe, the artists should be able to see that the Pause button is smaller and lower than the Play button. That means Pause is less important than Play. The wireframe should also lay out the basic elements of the gameplay, illustrating how the pieces should generally be organized on the screen.

The amount of detail in a wireframe depends on how much you need to communicate and the roles on your team. Traditionally, a UI expert would be in charge of

producing wireframes for each screen. The first pass the game designer makes can be relatively bare. However, on small teams, the game designer may also be doing a fair amount of information architecture and layout, in which case he or she may need to make more detailed wireframes. There is a definite trade-off in making bare bones wireframes versus detailed interface mock-ups. Stripped-down wireframes are easy to change around and don't get locked down by the game "theme." They can be divorced from the art. However, this stripped-down approach means the artists will have to do more work to really make sure all of the elements you spec out actually fit on screen in a legible format.

Wireframes can be as simple as Figure 2.9. Adding more detail to the wireframes makes them more attractive and enables you to begin to explore exact layouts versus theoretical layouts. You can begin to see if the button will actually be large enough to be legible and clickable. This is very useful, but can add a lot of time to production. More detail also makes the wireframes harder to change, should the theme change. Beware when showing detailed screens to others. When people see art assets which look relatively polished, even if they are part of a mock-up, they begin to think of that asset as final. The more detailed your wireframe images, the more comments you will have to contend with about the "look" of them. This can be useful in some circumstances (say, if you're going to produce the art yourself), but it can also be a waste of time if the art is going to be entirely redone.

It's important to note—great UI is really hard. Like gameplay, you never get it exactly right on the first attempt. It requires refining as you see how players interact with it. Your wireframes and user interface will inevitably undergo revisions as you watch players stumble over certain interaction schemes you have designed.

Specifications for Specific Features

Once you have outlined the basic gameplay, you need to go into more detail on specific features. The specifications for each feature should walk through all of the behavior that surrounds the feature. This includes each possible state of the feature. So if this is a move in the game, what happens if the move is correct, what happens if the move is wrong, what happens if the move fails and what happens if the move collides with another move? You will need to do this for each feature. This is also your chance to define variables for features like the avatar, power-ups and enemies.

Defining the Main Deck Active Feature from our *Solitaire* game might look something like this:

Main Deck Active Pile

When a player clicks on the **Main Deck Face Down** pile, the program flips over X cards and lays them face up on the **Main Deck Active Pile**. The cards should be spaced out slightly so that the player can view the number and suit of each card. The player can only interact with the top card. The player can pick up the **Card** and place it on a **Foundation Pile** or a **Tableau Pile** if there is an available slot (see **Tableau Pile Sorting Method** and **Foundation Piles**

FIGURE
2.9

A basic wireframe for *Solitaire*.

Sorting Method). If a user successfully moves a card off of the **Main Deck Active Pile**, the next card in the stack becomes the top card.

Variables

Cards to Flip = X (this variable should be set in the level configuration. The range of possibilities is from 1 to 5.).

As you craft your game design document, you may find you need other sections not listed here. That's entirely possible, if not likely. Remember the game design document is a living document that changes and evolves with your game. It serves as a record of important design decisions. It should also be thorough enough that you could hand it off to another group to implement if for some reason you become unavailable to work on the project. It is the blueprint for the game.

Guide the Implementation

As development gets under way, the game designer must stay in constant contact with the rest of the team. The game designer will need to work with the team to sort

through issues as they arise. This means brainstorming creative solutions with programmers and artists. Games never progress the way you think they will. Even with a thorough specification document, unforeseen issues will arise as you playtest the game. These issues will require effort from the whole team to resolve. It's up to the game designer to see that the team solves the problems and makes the game better.

Be careful about the features you request. If the designer is constantly requesting features, variables and art they never uses, other team members may get frustrated and balk at future requests. Only request features you believe will truly make the game better. If you begin describing a feature by saying, "Maybe it would be cool if we could have the game do this . . ." that's a sure way to lose the faith of the programmer or artists. Be decisive. If you believe a feature is truly necessary and will make the game better, make the case for it. Help the rest of the team see why it really is an integral feature of the game.

The game designer should not seek to simply impose his or her vision on the game and the rest of the team. Instead, the designer should seek out the opinion of other team members. Use the expertise of your teammates to solve problems.

But at the end of the day, the decision about what direction to take often comes down to the game designer. The designer must have enough confidence in the game design to make a decisive decision.

Playtest the Game

The game designer must continuously play the game as it moves through each iteration. By the time the game launches, you won't be able stand playing the game anymore. But you will have an almost innate understanding of the game system. As the game designer, you must also watch others play the game and learn from their play. You take notes on where they succeed and where they fail, where they have fun and where they grow bored. You must do all of this with lips sealed. You'll desperately want to give the players hints on how to play the game, but you shouldn't. In the end, when the game ships, you won't be there to provide strategic hints to every player. The game must teach the player without your help. To produce a game that effectively teaches players requires playtesting, tweaks to the UI, gameplay and tutorials and more playtesting.

Different game companies have vastly different tools for playtesting, depending on their resources. A company like Microsoft working on a triple-A title like *Halo 3* can afford some very cool tools for playtesting, such as videotaping players, creating statistical maps that reveal where players die and running all manner of regression on their data. Other teams must take a more low-budget approach, such as offering pizza to playtesters and tracking player movements with old-fashioned pencil and paper. In both cases, though, the general philosophy and approach are the same. Observe as dispassionately as possible, record moments and places where players falter and get stuck, then turn this analysis into action items to revise in the game. Then do it all again.

It is always important that the game designers help craft and observe at least a portion of playtests. They need to see where the game breaks; they need the first-hand experience of observing players.

Game designers should begin playtesting their game as soon as possible, getting others on the team and at their company to take a spin at the controls of the game. This will give the designer some initial feedback about what needs to be adjusted. However, as everyone at the company becomes familiar with the game, the designer will need to begin playtesting with fresh eyes outside of the company. This has several advantages. First, people outside the company are less invested in the game. They care less about whether the game succeeds or fails. Your development colleagues are as invested in the game succeeding as you are. This makes their opinion somewhat suspect. They are more likely to see fun because they know how the game is supposed to work and want the game to be a success.

Getting outside opinions also enables you to approach players who are more likely to be in your intended audience. Like it or not, most game companies are not producing games for their employees. If you make games, you are most likely a relatively serious gamer, probably more so than the average casual gamer. Your taste in gameplay will probably run to the more complex and challenging. This makes it very important that you find some actual casual gamers to test your game. You should find your game fun, but you don't necessarily want to design it for yourself. You want a large, broad audience to find it fun.

In your initial brainstorming and concept development, you should have identified the key audience segments for your game. When you have a workable prototype of the game, reach out to members of your audience and ask them to playtest. Bribe them with pizza, cajole them with free games, flatter them with compliments. If you're making a casual game, reach out to your friends who don't devotedly play games. Then reach out to your friends' friends. The further removed from you the playtesters are, the more honest their feedback will likely be.

Before you begin your playtest, write out a script detailing the instructions you will give and the questions you will ask. Your script should introduce the players to the game, explaining what you will be doing, thanking the playtesters for participating and letting them know how long the session will last. Tell them they are free to stop playing at any time or to play as long as they want, but that you will be focusing on a specific aspect which will cover X amount of time. If your game is in the early stages of development, you may need to give people a sheet of paper with instructions on how to play. You can also simply read them the instructions. Use the playtest as an opportunity to test your tutorial text. Following a script formalizes the playtest and makes sure that each player gets the same information.

Before you start the playtest, it usually behooves the designer to have a short interview with each tester. Ask the playtesters what type of games they normally like to play and how often they play. Ask if they have ever played games similar to yours. You want to gather a little information about your playtesters to give some context to their play and comments. If a playtester claims she absolutely loves to play real-time strategy games like *StarCraft*, you can assume she is a hardcore player

well-versed in using the computer to perform complex operations. If he reports playing *Bejeweled* for three hours a day, you are probably dealing with a different breed of player. And if players say they don't play many games because they aren't comfortable with computers, then you'll be able to observe their interactions with the game system in that particular light.

After getting acquainted, sit the players down in front of the computer. Preface the session by telling your playtesters that you want to get their unadulterated feedback. There are no right or wrong answers. You'll be observing their play, and you will not give them much help. You'll largely be an impassive viewer and, in some cases, you may not even answer their questions. Give them as little instruction about the actual game as you can to get them started. With early prototypes missing key features and pieces of the user-interface, it may be necessary to set the stage for the game, giving players some key instructions about how to start up the executable. But ideally, tell them as little as possible. You don't want to taint your playtesting results by telling players how to avoid specific problems or by teaching them aspects of the game that the game should be teaching.

With early prototypes, it can be very helpful to structure the playtest to answer one specific question about the game mechanics, rather than try to address all aspects of the game. Your test could ask whether the main interaction—such as sorting cards—is intuitive or whether players feel comfortable clicking and moving cards with their mouse. As the game advances and UI and art get added to the game, your playtests can begin to test the overall game scheme. In each case, however, keep your remarks to a minimum and let the game do the talking.

Once you have your playtesters playing the game, you'll want to sit back at a vantage where you can observe their play, facial expressions and body language without making them uncomfortable. Sitting off to the side and back a few feet should give you a view to their play. As the playtesters make their way through the game, note moments where they get confused and what is onscreen at the time.

The playtester will no doubt ask questions about specific features, "What does this do?" or "How do I do this?" Don't give the answer. You can keep mum or respond politely, "What do you think it does?" This may entail watching players struggle in certain parts as they try to figure out how to start a level or beat a complex part of the game. Let the playtesters work through it and see if they can solve it. Often, the player will figure it out through trial and error. It's up to you as the designer to decide if finding the solution took a little too much trial and resulted in a little too much error. If players get completely stuck, explain to them quickly how to move past. Knowing when to step in and when to stay silent is a judgment call. If you're making casual games, your players won't want to struggle long, but even the simplest game requires a bit of thought, so give them room to do that.

As players move through the game, do not explain strategy to them or tell them the best way to score points. That is something the game must teach the player. Also refrain from making suggestions like, "Oh it's really fun if you do this. . ." That will immediately throw off the playtest results.

In addition to watching what game elements the players interact with, read their body language and facial expressions. Be empathetic. Watch to see when people really look happy, as if they are enjoying themselves. Watch for signs of frustration passing over their face. If they lean forward, intently staring at the screen, it's a good bet they are engaged. If they lean back, play with one hand and sigh a lot, they probably aren't very engaged. Most people aren't that obvious, but the more you playtest, the better sense you'll have of whether people are enjoying themselves.

Determine beforehand how much of the game you want the tester to play through. This may be a few levels if you just want to test interaction with the core mechanic. It might be a few hours if you want to see how well the game holds up over dedicated play. Have them play enough to answer the question you are testing.

During the playtest, it is a good idea to note data about the user's plays. Note the player's scores, how many times a player must attempt a level, and what power-ups are used. These will help with level balancing later.

After they finish playing, ask your playtesters some directed questions. You can let them tell you whether they liked the game and had fun. That's the first piece of info they'll want to share. But be prepared to ask some more pointed questions to really get at their feelings about the game. Generally playtesters will be generous and tell you they thought the game was fun. Often, they are flattered to have been asked to test the game and want the opportunity to do it again. They may be afraid that if they say they hated the game they won't be asked back. Assuage this fear and tell them you want their honest opinion. But then remember to read between the lines. Ask them how long they think they would keep playing. Ask them what parts they specifically liked and didn't like. Ask them about specific moments in the play. Each playtest will lead to different questions, again depending on the question you are trying to answer. If you are testing the UI, ask them to explain what certain buttons do and see if they really internalized the game flow. If you are playtesting levels, ask them which levels they enjoyed and which they didn't and why.

You can also ask what features or changes they might like to see to the game. But take all feature requests with a grain of salt. Players will often want features that might make the game easier or harder. It's up to the designer to decide if these requests would really improve the game. But if playtesters ask for the same feature, you should give it some serious consideration. There may be something about your game that demands this feature.

Remember that each playtester represents only one data point. You want to collect as many data points as possible so you don't have to put all of your faith in the taste or experience of a few players.

The key to good playtesting is remaining impartial and analytical. This can be very hard. Developers spend a lot of time trying to get a game just right and really want people to enjoy the game. It's tempting to get mad or dismiss players who don't seem to fall in love with the game. But you can actually learn more from people who get frustrated with your game than from testers who blindly adore it.

Refine the Concept

No good game is born fully formed. Every concept and game needs refinement to reach its full potential. The game designer must listen to the concerns of playtesters, team members and publishers and then synthesize all of their comments. From all of this feedback, the game designer must lay out a path for changing the game if necessary. Often, prototypes will show that what you thought would be fun isn't. Instead, some minor feature actually provides the joy in the game. In these cases, the designer must be willing to adapt his or her vision to the realities of the prototype. You'll make dozens of false starts. But if you're willing to quickly prototype, refine and throw out ideas that don't work, you'll eventually come to something great.

At other times, the game designer will need to stay the course if he or she believes the game is on the right path and will become fun with the implementation of certain features. This means the game designer must not just play the actual prototype, but be able to extrapolate and play the imagined game in his or her head. This can be very hard, but it's essential for you to be able to look at a game and begin to play out the possibilities in your head.

This is the sort of skill that requires a fair amount of practice and experience. When designers start out, they tend to be inflexible about their designs. The more you work with your team on different games, the more you will come to trust and utilize the opinions of others.

Just remember that your game and concept will need revision. No book reads perfectly on first draft. The rough cut of a movie is often a complete mess in dire need of editing. Games are the same way, possibly more so. They require an iterative process to build. A game is an interactive conversation between the game system and the player. The two sides need to react and dialogue with each other. During development, the designer needs to dip into the part of the game system for that conversation, listening to what the player has to say and responding with the appropriate refinements.

Design the Levels

Once the game system has been laid out, the game designer will need to build levels. Level design is the meat and potatoes of game design, where the designer crafts the moment-to-moment user experience. In level design, the game designer finally starts using all of the knobs and variables they asked the programmers to build. Tweaking these variables in different combinations, the game designer hopes to make a fun experience with just the right amount of challenge. The game designer must be willing to make levels with only a partial set of tools while waiting for the game to be fleshed out. Often these levels must be trashed later as new features become available. But constantly exploring the potential and limitations of the game system as it is built will help keep the game on track and focused on the most important features—those that actually make the game fun.

As the features are fully built out the game designer will craft the arc of the player experience. This means taking into account player learning curves. This can be particularly tricky with casual games, as the audience is very broad and has a wide range of abilities. As the designer, you'll need to design a path through the game to suit all types of players, from expert gamers to the first-time player uncomfortable with even using a mouse.

Level design is an art unto itself, to which you could no doubt dedicate an entire book. Here are some general guidelines and approaches for designing levels:

- Be empathetic
- If you can't beat your level, then it's waaaaaaaay too hard
- Design for the general audience, not the hardcore
- Ease players into the game
- Don't forget to challenge players
- Build levels around a central concept
- Teach players to play the level
- Give players room to explore
- Occasionally break your own rules (carefully)
- Create a plan
- Vary your levels
- Refine, play and refine
- Playtest

Be Empathetic

When first time designers sit down to try their hand at level design, they almost always produce incredibly complex, punishing levels. If all you had to go by were levels crafted by beginner designers, you would conclude game design was a blood sport. First-time designers mistakenly take level design as a contest between player and designer. The ethos seems to be, "But can you beat this!?" This is the wrong approach. Level design should not be a struggle between designer and player. No, the game designer should offer a helping hand to guide the players through the level, leading them toward enjoyment. At times this means giving the player challenge. But at other times it means letting the player succeed. You want the player to have a good time, not simply a hard time.

So how do you know if they are having a good time? That's a much harder thing to measure than success and failure rates. You need to employ your sense of empathy. You need be able to put yourself in the position of the players and see the game through their eyes. They don't know all of the tricks and secrets hidden in the level. The game designer creates the basic concept of the level. But then you must ask yourself, what would the players like to do? What will make them enjoy the level?

Players want to be challenged, but they don't want to be punished. They want to feel successful. They want to win. Your challenge is letting players do that without letting them see that you let them win.

If You Can't Beat Your Level, then It's Waaaaaaaay Too Hard

On multiple occasions, I've had new level designers tell me they cannot beat their own levels. That's unacceptable. Designers know every surprise the level will throw at the player. They know by heart where to step, what aliens will pop out, what gems to swap, the order in which customers should be served. They have mental access to all of the hidden information of the game. So if you can't beat the level, imagine how long it will take your average player to beat it. The average player will be totally out of his or her depth. Players can only discover this hidden information by the arduous process of trial and error.

As a general rule of thumb for casual games, I feel a designer should be able to beat early levels in a game with one arm tied behind his or her back. As the game progresses and gets more difficult, perhaps some concentration is required. But unless you are designing the boss levels in a hardcore console triple-A title, you really shouldn't be losing all that much. And even then, you need to be able to beat it to ensure that it is beatable. It's entirely possible to design a level that is unwinnable by setting a goal score too high or a jump too far. You have to be able to play through your level from beginning to end and prove it's winnable.

You designed the level. You know where all of the bombs and traps are hidden. For this reason, the level is easier for you than anyone else. Don't tune the level for your own enjoyment. Tune it for the player's enjoyment.

Design for the General Audience, not the Hardcore

The hardcore players always have the loudest voices. They are the ones on forums complaining a game is too easy. They clamor for greater and greater challenge. But you have to remember: they are a minority. Granted, they are a vocal minority, but a minority just the same. You need to take their demands into consideration, but like democracy, you need to answer the majority's needs first. The large majority of your casual games audience is not hardcore. They want challenge on the order of an invigorating hike, maybe some light scrambling over rocks. They don't want to scale a 1,000-foot cliff. Covered with ice.

Design your levels to please and thrill the general audience with intermediate skill levels. This is the audience that will make your game a success. You want them to be happy.

Ease Players into the Game

Starting any game represents a big challenge. You have to learn the rules. You have to suss out how to control the game. You have to take in the game narrative and

world, all while navigating a user interface tailored to the specific game. This puts a lot of cognitive demands on a new player. If you have super-challenging gameplay on the first level, you'll likely scare players off.

Ease players into the game. Introduce one element at a time. If your game has a lot of power-ups, dole them out one at a time. The same goes for enemies. If your control scheme is particularly complex, break it into pieces to enable players to master the different components. You want to make getting into the game as smooth as possible. Since players must spend so much energy learning the game in the first few levels, don't overwhelm them by making them learn tricky levels too. Let them get their feet under them before swiping them out.

Don't Forget to Challenge Players

While it's crucial to ease players into a game with a gentle initial learning curve, don't forget to challenge your players. Without a bit of challenge, the game will lose all sense of vitality, devolving to no more than an exercise with some very idiosyncratic constraints. Sometimes challenge means actually making players lose a level, just to remind them they are playing a game and keep them on their toes.

Wade Tinney, the co-founder of Large Animal Games, once related a story about how they used dynamic difficulty adjustment in one of their games. The game's algorithm monitored how many levels a player won in a row and modified the difficulty accordingly. If the player won several levels in a row, the game would make the next level harder, making it quite likely the player would lose the next level. After a loss, though, the game would adjust and make the game a bit easier again. In playtesting, they found this kept players intrigued and playing the game. If they won every level, they tended to stop playing sooner.

Build Levels Around a Central Concept

Before you start laying out all of the variables in a level, spend some time thinking about what concept underlies the level. The best levels are concise and clean. They focus on one central idea, running through different elaborations on that idea. In a color-matching game, the core idea of a level might be managing a preponderance of one color. A puzzle platformer might require a series of similar jumps.

A level is like a great pop song. It has a central melody that you can build variations around, but underlying the whole level is one catchy hook or idea. This gives your levels clarity and focus. Focusing on one idea will help you find the core element of fun in the level and let you polish that to a shine.

Teach Players to Play the Level

A level should offer signals to the player that indicate how to approach the level. You want to guide the player into the experience. If your level is all about a particular type of move, give your players space to try out the move and learn to master

it before placing them squarely into danger. So if your level requires wall jumps, give the players a safe place to try out wall jumps before you have them do those wall jumps over spikes or bombs. Otherwise they will repeatedly die and get frustrated.

Set up general patterns and rules that players can learn to "read." If your game requires a particular type of wall jump, set up similar structures for the wall jumps in the easy and hard parts. In this way players will begin to recognize what action they should perform to pass difficult spots. Players will begin to read the level and understand what actions to deploy.

Give Players Room to Explore

Levels that introduce a new feature should focus on teaching the player the basics of using the feature. Completing the level should require the player to interact with the new feature in some basic and straightforward way. You want the players to see the basic utility of the item, be it a power-up or new move. Forcing them to use it will help push them to use the feature and break them out of their established playing pattern.

In the next level, use the feature again, but open the play up to let the players explore other aspects of the feature. If it's a power-up, give them the chance to explore the different facets and ways they could use the power-up. The first interaction teaches them the basics; the second teaches them to creatively apply their new tools.

Occasionally Break Your Own Rules (With Care)

Once you have set up patterns in your game, you can break your own rules. Do this with care. You don't want to call into doubt the entire system of meaning you have created for players. But the occasional shift in the patterns of the game can surprise and delight your player. It keeps the gameplay fresh and enables the players to feel they have creatively applied the mechanics of the game.

Breaking your own rules should be done with care. You don't want the game to seem arbitrary. You still want it to read like there is a logic to the game.

Create a Plan

Just as you would outline a novel or screenplay, it's crucial to outline your level structure. Lay out where you think you will introduce different concepts, power-ups, enemies and content to the game. Make sure this level plan fits with the overall narrative and goals of the game. Make a big spreadsheet or list with an entry for every level in the game, detailing what elements will be used. Outlining the whole game helps you craft the overall experience of the game, progressing the game in complexity and difficulty. It will also help you see which elements you are using too often and which you are ignoring.

Vary Your Levels

This may seem obvious, but it's not easy to do. It's very easy to fall into a pattern you repeat over and over. As you produce levels, establishing consistency between levels is important. You can get a lot of mileage out of creating levels that are variations on a theme. However, you don't want those variations to feel repetitious.

Where possible, get multiple designers to contribute levels to the game. Different designers inject fresh perspectives into the game, with each designer finding new ways to use the level variable tools to create a slightly different experience. If you do use multiple designers, though, one lead designer should set some basic parameters and target goals for the all levels that the individual level designers follow. This lead designer must also play through all of the final levels to make sure they are balanced and consistent.

Refine, Play and Refine

Lay out the basics of the level. Play it. Make refinements. Play it again. Make more refinements. Play it again. Keep this up until you have polished the experience of the level. It will take a while. No one gets it right on the first stab. Like an author reworking a paragraph to get just the right syntax, a level designer reworks and plays a level to craft just the right experience. This is the most important part of level design. Sometimes this will require you take a break from the level for a day or so then come back to it and try it again. A little distance can you give you some much needed perspective on your work.

Playtest

Playtest, playtest, playtest. You can play and refine your level until you're sick to death of it. But you'll never be able to capture the fresh perspective of a new player without playtesting it with others. Get outsiders to look at it and carefully note how they play it, where they have fun and where they don't. Then modify the level to draw out the fun parts and reduce the not-so-fun parts.

Becoming a Game Designer

There are many ways to become a game designer, though no sure path. Programs exist that teach people the fundamentals of game design and developing video games. These range from pre-professional programs like Full Sail to more arts-oriented programs like University of Southern California's Interactive Media programs. However, like film schools, these programs can train you in the fundamentals of game design, but it's up to each person to put what they've learned into practice. And in the end, practice is the most important part. If you want to be a game designer, you have to start making games however you can.

Use available game engines and level editors to make maps for your friends. This teaches you to work with game design tools and tweak variables while trying to

build a fun experience. Again, level design is an essential skill for any aspiring game designer. Creating your own levels is also a good way to start building a portfolio that shows off your design chops. Many employers looking for game designers ask applicants to build sample levels using one of the company's own level editors. This gives employers a good view into the type of game designer the applicant will make. Will they punish the player with impossibly hard levels, mistaking difficulty for fun? Will they make levels that are too easy and do not offer any challenge? Will they nurture the player along with levels that offer compelling and creative challenges?

Practice designing games nonstop. Play games, then imagine how you would modify them to make them better (or worse). Start practicing with board games. Read the rules to board games and consider how the game designers framed the game for you with their written description and rules. Contemplate a change you would like to make to the game and then modify or add rules that you think will produce that result. For example you might try to make a game go faster. Consider what rules you would have to change. Can you shorten each player's turn? Can players take turns simultaneously?

Also try taking out key rules to see where the game breaks. This can be very informative. Games are like buildings framed by rules. Sometimes taking out just one beam causes the whole thing to collapse. Other times, the game can withstand the removal of a number of rules before it ceases to be playable. Take soccer (or football, as the civilized world likes to call it) for example. On their Web site, the Fédération Internationale de Football Association (FIFA) offers a document that spells out the official "Laws of the Game." This document is 138 pages and covers everything from the size of the field to the duration of the game to player equipment.[3] How much of all of that, though, is really essential to soccer? How many rules can you strip away and still call the game you're playing soccer? Does offsides really matter? Does the number of players? Probably not. Does prohibiting the use of your hands when touching the ball? Most definitely. The game would cease to be football if every player could use their hands to carry the ball. Taking out rules will teach you to boil a game down to its primary core mechanic. This is an essential skill for casual game design.

Don't stop with games though. Try giving goals and rules to different activities to see how you might make them into games. We already treat a lot of activities like games. How quickly can you chop three carrots for your salad? Can you walk to work without stepping on any cracks? How quickly can you sort all of your e-mail into folders? Why? It teaches you to look for obvious rules and play structures. The more obvious and intuitive your rules, the better casual games they will make. Plus, some of these activities may even make good video games. A lot of casual games, like *Cooking Mama* and *Snapshot Adventures,* are reinterpretations of familiar activities. *Cooking Mama* (Figure 2.10) has built a hit franchise around preparing meals.[4] *Snapshot Adventures* (Figure 2.11) makes a game out of bird watching and taking photographs.[5] And even if you don't make any of your daily activities into video games, you will learn to look for fun in unusual places.

[3]http://www.fifa.com/mm/document/affederation/federation/81/42/36/lotg_en.pdf
[4]http://www.cookingmamacookoff.com
[5]http://www.largeanimal.com/games/deluxe/snapshot-adventures-secret-of-bird-island

FIGURE
2.10

Cooking Mama **transforms cooking into a game. (© Majesco Entertainment)**

FIGURE
2.11

Snapshot Adventures **recognizes the implicit game like qualities of bird spotting. (Created by Large Animal Games. Published by iWin)**

Beyond these exercises, start making your own paper games. Many games start their lives as prototypes sketched out with pen and paper. Paper prototyping enables you to quickly test ideas to see if the general mechanic is fun. Building non-digital games, from board games to card games to new sports, exercises your game design muscles and forces you to confront general problems that you'll encounter again and again in game design, from creating core mechanics to closing player exploits to balancing statistics.

If you want to be a game designer, you have to make games. You can't be a rock star without practicing the guitar, and you can't become a writer without sitting down and actually typing out stories. The same is true of games. Like most arts, game design is one part inspiration and nine parts implementation. Build a portfolio that shows you understand games in all their aspects. Design levels, board games, card games and make up new sports. Each game project will teach you something new about designing games.

Becoming a Professional Game Designer

Traditionally, playtesting has been a way into the game development industry. All video game companies need people to play their games and test them not only for bugs, but for playability. For this, they hire playtesters. This helps people get their foot in the door and gives them the chance to work with programmers, artists, producers and game designers. Some of these playtesters go on to become producers or game designers.

Experience with software production in general can be a good way into the video game industry. At its core, making video games is just software development. The product just happens to be really fun. Working as a project manager or producer in software development gives you many of the same skills you will need to bring to games—from conceiving and specing projects to working with programmers and UI designers.

However, the best way to become a game designer is to start making your own games. One of the great things about developing casual games is the low barrier to entry. Not only can an individual or a small team make a Web game, but they can also find an audience on the Internet. In this sense, becoming a game designer is not unlike hanging your shingle: make a game and put it on the Internet. Monetizing your work can be hard. But there are some good channels, from Kongregate to the iPhone to the portals, that make self-publishing possible.

Why Be a Casual Game Designer?

So why do game designers work in casual games? Wouldn't they all rather be making big budget console games? After all, most game designers are likely gamers used to playing console games. No doubt, some casual game designers do long to make big-budget AAA console games. But there are many who prefer working in casual games. A number of things make creating casual games attractive.

First, casual games are small. They can take anywhere from a week to a year to develop. This is a stark contrast to the multiple years necessary to develop a console game. The short development time for casual games gives you the opportunity to work on more games. This prevents you from getting as burned out on a game. New projects offer fresh challenges and the chance to try out new ideas.

Designing casual games for a broad audience also means your friends and family may actually enjoy playing your game, even if they are not hardcore gamers. Casual games have the chance to reach a really broad audience in the way that only the best-selling hardcore games do. So while the *Grand Theft Auto* franchise has made more money than any casual game, more people have probably played *Bejeweled* than *Grand Theft Auto*. Casual games with core mechanics designed specifically to appeal to as many people as possible have the chance to become genuine pop culture phenomenon, spreading virally over the Internet and gossiped about around the water-cooler. That potential to reach a mass audience excites designers.

Casual games also offer more opportunity for innovation. Because they are small and less expensive to make, game designers can take more risks. They can try out strange new mechanics or base the game around off-beat themes and art. Casual games have their tropes and limitations, but the landscape often seems far more open than the console market. Even console games hailed for their innovation, like *Halo*, mostly just refine known mechanics. *Halo* very cleverly improved upon the health meter and inventory system, but in the end it hews very closely to first-person shooter conventions. The game designers innovated within an established genre. Contrast that to the puzzle game *Crayon Physics*, in which the player draws objects which are transformed into physical objects within the game.[6] *Crayon Physics* was created by the one-man development "team" Petri Purho, who designed, programmed and created the art for the game. The game grew out of a series of game design experiments by Purho, in which he designed and built a new game every seven days. *Crayon Physics* feels much more experimental and far afield than most any console game. Obviously, a lot of innovation happens on console games, but the conventions of established genres and the cost of doing business make it very risky. Smaller teams and budgets allow for more quick experimentation.

Summary

You want to be a game designer? Well, you've probably already taken the initial steps. Start with paper games, card games and physical games—things you can do all on your own. Then move on to video games. Game designers appreciate good design, whether it is in a card game or a video game. The art of game design is not about pixels or programming after all. It's about crafting fun experiences out of rules. The rest is practice and implementation. Like any art, to become a game designer you must design games. You must make games.

[6]http://www.crayonphysics.com

CHAPTER THREE

Play Is the Thing

A firm grasp of games starts with a good understanding of play. If you don't understand the attraction and enjoyment of play, it can be hard to fathom the attraction of games. Even more importantly for a burgeoning game designer, it will be hard to create activities with which people want to engage. The playful activity is the elemental building block of games. Almost all games have at their heart an activity which you could describe as playing. This playful activity often resides beneath the level of core mechanic. It supports and animates the core mechanic. In a game like *Bejeweled*, it's the playful activity of matching, which is then structured by a match-three game mechanic. In a sport like soccer, it's the kicking around of an object that supports the mechanic of kicking the ball into goals. Aspiring game designers must be able to identify these playful activities, pick out the fun ones and build games around them.

Play is the act through which we experience not only games, but much of the world around us. As children we use play to explore the world, sussing out everything from basic physics (if I throw a ball up in the air, it will inevitably come back down) to social relations (if I call that girl a name, she won't like me). Through play, we test the limits of our own actions and their impact on the world. This behavior continues into adulthood, though it may be less apparent and we may call it by a different name. There are obvious ways adults continue to play. They play golf; they get together with friends to play poker; they hold *Wii Tennis* tournaments. Then there are less obvious ways. Flirting is a form of play. Rough-housing with your son, painting your face orange and blue and rooting for the Mets, wildly cheering and calling out for "Freebird" at a concert are all forms of play. Even spinning your wedding ring on the conference room table during a meeting is play.

New parents engage in a form of mutual play with their infants, in which both baby and parent poke and prod at each other, exploring and establishing the ways in which they can interact. A father picks up his infant daughter. The baby kicks her legs wildly about, flailing below her father's arms and whimpers. The father repositions his daughter on his hip to try and get the girl to stop kicking. He swings her around and bounces her on his knee. They both look at each other with a moment of incertitude, as if asking, "Is this right? Have we reached a moment of mutual comfort and happiness?" The father tickles the girl and smiles. The girl smiles back

and the two reach a moment of attunement. She flaps her arms in excitement and he hoists her up above his head. The father makes note that next time his daughter is unhappy he should place her on his knee, bounce her and maybe throw in a few tickles. Through this playful interaction, both father and daughter begin to establish a grammar for interacting.

The Dutch anthropologist Johann Huizinga opened *Homo Ludens*, his seminal book on play, by declaring, "Play is older than culture, for culture, however inadequately defined, always presupposes human society, and animals have not waited for man to teach them their playing."[1] Huizinga points out that you can see all of the same elements of human play in the playful nipping of dogs or the rough-housing of lions. In these interactions, Huizinga saw play taking a place of primacy. He argued for play as an elemental form of interaction and a contributor to culture. He saw lions and boys alike playfully wrestling their brothers and sisters as a means of experimentation and socialization.

Play is semi-structured. There are no explicit rules to play. You can't write down the rules to rough-housing with your siblings. But most people develop a good sense for when the lines are crossed. They develop this sense through multiple play sessions, poking and prodding others to see what is acceptable and what isn't. When you wrestle your brother and twist his arm and he yelps in pain or shouts angrily, "Okay get offa me!" we cache that response and alter our mental guidelines for the play activity. Instead of rules, play operates along general guidelines that define how participants should interact and behave. Play is in some part defined by etiquette that develops out of repeated play sessions. The more formalized that etiquette and those guidelines become, the closer play inches toward structured games.

This makes play an incredibly fundamental part of our lives, one that we never escape. If you were to ask a group of adults if they "play," I imagine many would respond in the negative. Or they might admit to playing a few specific games, but few would declare they routinely engage in unstructured play. But most likely they play much more often than they realize. We all have favorite activities we rely on to kill time. Tapping feet on the subway, spinning pens around our fingers during meetings, counting cars as we walk, flirting with a co-worker. We just don't think of them as play. Perhaps we call them killing time, or possibly the activity is so natural that we don't even realize when we start doing it. The need to play is innate. Understanding how to tap into that primal urge to play gives game designers powerful tools with which to engage players.

The Liminal Moment

So play is ubiquitous and informs learning. How does that impact game designers? Most forms of play grow stale after a while. How long can you keep stacking up blocks just to watch them fall? Kicking a ball back and forth can get boring pretty

[1] Johann Huizinga, *Homo Ludens,* Beacon Press, 1971, p. 1

quickly. That's where games come in. If you give yourself the goal to build the highest tower you possibly can out of your blocks, the activity suddenly takes on new directed shape. You have something to strive for and something to measure yourself against. Every time the blocks tumble back to the floor, you know what you need to do next: Add at least one more block to your next stack. Even this slight goal and loose structure stretches out the entertainment that can be found in playing with blocks.

There is a liminal moment in play when a playful activity transforms into a game. The play provides the spark of fun. The game provides the framework for long-term interaction. It's the game designer's job to usher the player through these liminal moments, to transform moments of free play into structured games. Designers do this by providing the rules and goals that define the game. In doing so, they build a system that supports repeat play.

This moment of transformation should be of particular interest to game designers. For hardcore game designers, play can be buried under an accumulation of rules. For game designers looking to build casual game experiences, the closer they can keep their game to that liminal moment, the better. Many casual games hover close to the playful activity that inspired the game.

The Rush to Complexity

Hardcore players expect complexity and depth from their games. They play a lot of games. They have learned the basic rules and interactions that govern most games. Their familiarity with basic mechanics means that new games must offer fresh complexities to provide a real challenge. Video games are dominated by genres that rely on familiar mechanics. Just think about how many games for consoles are first-person or third-person shooters. Hardcore players are familiar with the mechanics, so the game must either provide a new mechanic or add other elements of complexity on top of the original mechanic. To meet the ever-increasing abilities of hardcore players, game designers must add new features to the game play. Sometimes this takes the form of a new game mechanic. Sometimes it manifests itself as more resources to manage.

For example, consider the difference in complexity between a game like *Doom* and *Ghost Recon: Advanced Warfighter* (*GRAW*). *Doom* is one of the seminal first-person shooter games. It helped establish many of the conventions of the first-person shooter, from the point of view of the player to the practice of navigating a large open space. At the time, *Doom* was quite complex. It required the player to quickly navigate the semblance of a three-dimensional space with one hand and to take aim at oncoming enemies with the other. All the while, you managed your remaining health, as well as various weapons and ammunition. But at the same time, the game was incredibly intuitive. The core mechanics of pointing at things and shooting felt familiar from the first play, as if the game tapped directly into our memories of childhood water gun battles. In some ways, *Doom* fulfilled a long-held desire among gamers: The video game would actually put you in the position of the

hero pointing the gun at the bad guys. These navigation and inventory challenges combined with the popular shooting mechanic made *Doom* a megahit in the 1990s. But play *Doom* today and the game feels incredibly simple next to modern first-person shooters. Next to *GRAW*, *Doom* looks almost, well, casual.

FIGURE
3.1

***Doom* taps into the basic playful activity of pointing and shooting. (Doom® © 1993 id Software LLC, a ZeniMax Media company. DOOM, ID, and ZeniMax are registered trademarks owned by ZeniMax Media Inc. All Rights Reserved)**

The lineage is obvious. They both offer the same perspective and core mechanic of moving, aiming and shooting. But *GRAW* greatly increases the complexity. In *GRAW*, the player has greater camera control, enabling the player to look up and down. This alone greatly increases the complexity of the game, making it feel more like a full 3D space. *Doom* is limited to one plane.

Everything about *GRAW* is bigger. The maps and levels in *GRAW* are bigger, sprawling over vast areas. The player can pick any number of paths through the space. The inventory of weapons and ammunition the player must manage is larger and more varied. These larger spaces and inventories mean the players must constantly sort through more options as they play.

On top of these complications to the basic first-person shooter gameplay, *GRAW* stacks squad management. In *Doom*, you are simply responsible for your lone,

nameless space marine as he battles his way through an alien-infested space station on one of the moons of Mars. In *GRAW*, you guide an entire squad of soldiers. You have your own avatar you control. But on top of that character, you also give orders to other characters, picking out locations and targets for them to reach and attack. In effect, you play a first-person shooter with a strategy and resource management game layered over the FPS action.

FIGURE
3.2

GRAW **layers tactical strategy and resource management on top of the FPS mechanic, making the game more complex. (WikiCommons[2] © Ubisoft)**

This combination of game mechanics places greater demands on the player, making the game more challenging. It adds depth to the game. The game takes longer to master because there are more systems to learn and control. There are more opportunities for decisions and a greater array of strategies to choose from. The players can barge into a firefight and try to pick off everyone. Or they can send members of their squad to take care of the action.

This added complexity also pushes the game further away from the base element of play. As the FPS game has gotten more complex, the new functions have served to bury that original playful element of *Doom*, aiming and shooting. Pointing and shooting is, of course, still very much at the heart of *GRAW*, but there is an abundance of other stuff the player must also manage. This added complexity and depth delights hardcore players. But very often it just obfuscates the fun for casual players. Casual players tend to be attracted to the base element of play—that element of play the game initially promises to deliver.

[2] http://commons.wikimedia.org/wiki/File:GRAW5.jpg

The Push toward Simplicity

Casual games grow out of a philosophical approach to game design. Unlike games that can claim a common game mechanic, like the first-person shooter, there is no definitive game from which all casual games have sprouted. Instead, games wind up being considered casual games in one of two ways. The first path explains why a game like *Doom* which used to seem hardcore now feels almost casual. Games evolve and yesterday's hardcore game begins to seem awfully simple and casual next to today's newer more complex fare. The casualness versus hardcore nature of a game is entirely contextual and changes as players evolve and grow more skilled. The other way is more intentional. Game designers look at the state of games, play and player skill and attempt to craft a game with a simple, understandable game mechanic at its core. She pushes her game toward simplicity and the core element of play in the game mechanic.

Casual games eschew complexity in favor of simplicity. The game is simple and boiled down. Sometimes, casual games barely cross that fine line between play and game. Instead of asking the player to navigate a complex set of rules, the game focuses primarily on delivering the promise of play initially held out by the game. When creating a casual game, the designer should focus on delivering the pointing and shooting, as opposed to the pointing and shooting with resource management and strategy game laid on top of it. The casual game should be closer to the activity of kicking the ball back and forth than the game of professional soccer laid out in 138 pages by FIFA.

Every game has a fundamental element of play. If you strip away all of the rules, you'll find it. You'll get back to the moment where the game transforms back into simple play. At that moment, you can see where the game most likely originated. What was the impulse that sparked the game? Basketball, with all of its complexities and strategies, with its bouncing balls, dunks and three-pointers, basically boils down to the impulse to throw an object into another object. Take away the jumping and the geometry, and checkers is about gobbling up your opponent's pieces. Chess is about cornering your opponent. How you accomplish this feat is complicated by all of the individualized movement patterns of each piece. At its core, a game like *Doom* is about pointing and shooting. In many ways, the pleasure and attraction of the game stems directly from playing cops and robbers as children, of putting your hands together like a gun and yelling "bang" as your friend walks through your sites.

This is the sort of straightforward, almost elemental play that most people seek when they decide to play a casual game. This is true of both self-identifying casual players and dedicated gamers electing to play a casual game. They want a short, pure burst of play. They want something they can learn and play quickly—a game with simple, stripped down core mechanics. Playful activities exist without the hindrance of complex rule sets. In their lack of complex rules, they must by definition be relatively simple and straightforward. To add complexity, you must add rules. This in turn makes the game harder to learn and master. Of course, if these players

really like the game and get better at it, they too may demand more depth and complexity. Eventually they may demand that the casual game evolve in complexity to match their growing skill and understanding of the game. But at this point they will be looking for a hardcore version of the casual game they started playing.

Patterns of Play

Casual game designers must walk the fine line between play and games. To effectively straddle that line, they must understand play. Play only seems unstructured at first glance. Upon closer examination, we can see definite patterns of play emerge. A number of scholars have dedicated themselves to examining the different manifestations of play. Huizinga got the conversation started, and scholars, academics and game designers alike have continually found new ground to probe.

The National Institute for Play takes play very seriously. They believe play has transformative qualities for children and adults. This non-profit is comprised of a number of psychologists and researchers looking at the effects of play on cognitive and social development.

They outline seven main types of play in an effort to create a holistic framework for studying play.[3]

- Attunement play: This very simple interaction produces measurable brain activity and powerful emotional connections. A mother makes eye contact with her child, and the child smiles. The mother smiles back, reinforcing the baby's smile and bringing the two into attunement.

- Body play and movement: We understand much of the world through our own bodies. From babies flailing their arms as they learn motor control, to kids tossing snowballs at each other, to adults learning the foxtrot, we explore our world and simultaneously entertain ourselves and explore our limits through movement.

- Object play: Much of our play is inspired by objects. We pick them up, shake them, turn them over, spin them, throw them. Through these interactions, we explore the limits of the object. How much stress can it take before it breaks? How far will it fly with a good heave? Babies do it. Grown-ups do it. Object play can also lead to problem solving as you learn to take apart an object and put it back together.

- Social play: Social play runs the gamut from rough-housing to more complex rituals like the Dozens, in which participants trade ribald insults. Animals also engage in social play. This play serves important socialization and cultural functions.

- Imaginative and pretend play: Playing house and other games of pretend may seem like child's play, but it does wonders for our creativity, at a young age and even later in life. It also helps kids build their own mental models of the world.

- Storytelling-narrative play: Stories are one of the atomic units through which we organize our understanding of the world around us. We group our lives and our

[3] http://www.nifplay.org/states_play.html

days into stories about the characters and events of our lives. Shaping them into stories helps give them meaning and lets us make sense of the random events of life. We largely learn to create those stories through play. We take on roles, we make up tall tales and we share them with each other.

- Transformative-integrative and creative play: We use our fantasy play to spark creativity and imagine new possibilities for our play. We imagine all of the different things we might do with a ball and test them out. Sometimes we use these ideas in our lives outside of play as well. Group brainstorming often takes on elements of creative play.

And the National Institute for Play isn't alone in categorizing and studying play. Scholar Brian Sutton-Smith has written very eloquently about play and games. In his book, *The Ambiguity of Play*, Sutton-Smith examines the role and perception of play in culture. Like many, Sutton-Smith acknowledges that play is hard to define, that play is often ambiguous and variable. Playful behavior can be found in many of our daily activities, from traveling to gossiping to reading. We may infuse these activities with playful competition, comparing who has been more places. In gossiping, we cheekily denigrate people behind their back. Or we may simply go through the imaginative exercise of envisioning and identifying with fictional characters, playing out their lives in our heads.[4]

At the outset, Sutton-Smith presents a list of activities he considers to be play and categorizes them into groups not unlike those presented by the National Institute for Play. Sutton-Smith lists broadly recognizable categories. But it is the activities and behaviors that he includes in each category that really provoke interest. He takes a broad view of play and sees playful behavior in an incredibly diverse set of our everyday activities. Many of them you might not consider play at first. But when grouped together with other similar activities, you can see how each does indeed possess elements of play.

Sutton-Smith's categories of play and a few of the examples he includes:

- Mind or subjective play: Here he gives the example of daydreaming, fantasizing and similar activities.

- Solitary play: hobbies, collecting, reading, building models

- Playful behaviors: playing tricks, playing by the rules, playing at something

- Informal social play: partying, joking, getting laid, babysitting, intimacy, amusement parks, speech play like riddles, gossip and jokes

- Vicarious audience play: watching television, films, Renaissance fairs, spectator sports

- Performance play: playing music, playacting

- Celebrations and festivals: birthdays, roasts, weddings, balls, masquerades

[4] Brian Sutton-Smith, *The Ambiguity of Play*, Harvard University Press, 2001, p. 3

- Contests (games and sports): athletics, golf, gambling, board games, card games, martial arts
- Risky or deep play: caving, hang-gliding, sky jumping, sport climbing

Tapping Play for Games

Thinking about different categories of play can be useful for game designers. It can give you a starting point for a new game. Looking at activities that already engender playful characteristics can spark directions for new games. This is true for everything from physical games to card games to video games.

There are obviously many different ways to categorize play. But these are some useful categories for starting to think about game design:

- Physical play
- Playing with others
- Playing with things
- Playacting
- Daredevilry or pushing your luck

Physical Play

Obviously many of our sports grow out of activities such as running, jumping, throwing, hitting and spinning, from simple games like the 100-meter dash to more complex games like American football. But these sorts of activities also inform smaller casual games, like arm-wrestling and thumb-wrestling. They also inspire the focus of video games from platformers like *Super Mario Bros.* to fighting games like *Tekken*. Mario's name was originally Jumpman, after all.

These activities have an immediacy that stems from their primacy. As children, we first explore ourselves and the world through physical play, making many of these activities intimately familiar. This makes building games out of them relatively easy as everyone already understands what they need to do. They are enjoyable, satisfying activities in and of themselves. Game designers can use them as building blocks and combine them into new structures. For players, the fun and challenge comes in mastering the actions in the new contexts.

One of the great advantages of physical play is quantifiable outcomes. You can measure how fast someone runs, how hard they hits and how high they jumps. This makes building a game around the activity easier because you can keep score easily.

Physical activities do present problems for game designers though. The games are quickly limited by the physical abilities of the players. For all of your hard work balancing the game to make it fair to all players, some people will excel at the game based simply on physical prowess. This is especially true of games that hew closely

to the original physical activity. This does not break the game, but it can present some players with advantages and discourage others from participating.

Game designers can compensate for the dominance of physical ability by creating a system of rules to balance out the game and add more strategy. By offering over-lapping strategies and multiple paths to victory, the game should theoretically allow for greater range of player abilities. The trade-off is complexity. Casual game design-ers must again be aware of this trade-off as they construct their game. The simpler the game, the faster players will understand and get into the game. However, simple games will likely be dominated by players with particular abilities that match the game's core mechanic.

FIGURE
3.3

Run straight and run fast. Jesse Owens running the 200-meter dash at the 1936 Olympics. (WikiCommons[5])

Compare the 100-meter dash with American football. Anyone can immediately understand the 100-meter dash. There's really only one rule: be the first to cross the finish line. This simplicity and lack of complex strategies mean that 9 times out of 10, the faster runner will win the sprint. Contrast this with American football with

[5] http://commons.wikimedia.org/wiki/File:Jesse_Owens.jpg

its almost byzantine rule system governing ball control, downs, yards and ways to score. It's no wonder uninitiated viewers find themselves bewildered upon watching their first football game. But the complex rules of football allow for a wider range of strategies and outcomes. Yes, more physically adept players will generally be better at football, but players need not all be physically adept in the same way. There is no one trait that will always win out in football. A faster player may be outwitted by a clever player with agile feet. A stronger player may be avoided by a faster player. Football's complex rule system allows for different strategies and variable outcomes. However, you cannot explain football as quickly to a new player as you could the 100-meter dash. It is an extremely complex game, and the time necessary to master the rule system precludes it from meeting our definition of a casual game.

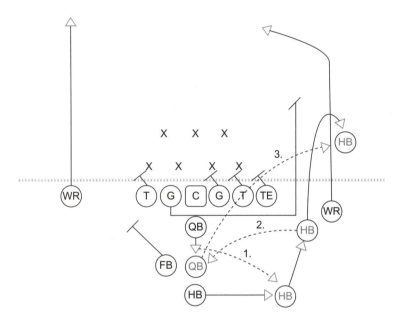

FIGURE
3.4

A diagram of the flea flicker play in football shows off the geometrical and strategic complexity of the game. (WikiCommons[6])

In Chapter 8, Hitting, we'll look at how tapping into primal physical actions can provide the basis for entire games. Games like *Whac-a-mole* and *Wii Tennis* rely heavily on physical sensation, giving them a place of primacy in the game over strategy or complexity. Then in Chapter 11, Bouncing, Tossing, Rolling and Stacking, we'll look at how physics systems can be modeled to emulate physical play and all the variability that accompanies objects careening through space.

[6] http://commons.wikimedia.org/wiki/File:FleaFlicker.png, User: Jeffness

Playing with Others

Far more amorphous than physical play, but equally compelling, social play (talking, lying, accusing, betting, bluffing, bidding, joking, gossiping, comparing, copying, repeating, guessing, swarming) offers many activities which provide the roots for games. Lying, guessing and accusing form the basis for social games like *Mafia* and *Werewolf*. Card games like poker are as much about reading the tells of other players and calling their bluffs as the probability of building the right sets.

As Sutton-Smith points out in *Ambiguity of Play*, social play can include simple behaviors like comparing how many U.S. states you and your friend have each visited. This very impulse to compare/compete with your friends drives many of the applications on social networking sites like Facebook. Take the Facebook applications *Cities I've Visited* (Figure 3.5). The entire purpose of the application is to broadcast

FIGURE
3.5

Applications like *Cities I've Visited* allow users to display how well-heeled they are while comparing their moves against their friends. This application is just shy of being an actual game. (Cities I've Visited ® is the registered trademark of TripAdvisor LLC. The screenshot is ©2009 TripAdvisor LLC. Used with permission)

how many places you've traveled to, while comparing your tally with your friends. This sort of social play manifests itself in many ways. People can find hours of fun in comparing their rental histories on services like Netflix. There is inherent competition in naming what movies you have seen and enjoyed.

Tapping into these behaviors offers game designers a rich palette of interaction. By making the social interactions between players a key part of the game, you can leverage the unpredictability of human behavior. There is inherent complexity in reading and reacting to others. Just figuring out if someone is telling the truth contains an implicit goal; figuring out the answer and calling them out can be incredibly satisfying. Adding rules and game structure can amplify the tension and excitement.

However, it also poses risks to the consistency of the game. The more the game relies on social interactions, the more dependent it becomes on the players and their ability and willingness to relate to one another. As opposed to physical play with hard quantifiable outcomes, social play can feel a bit squishy and subjective. Designers can address the subjectivity and the reluctance of players to fully engage socially by adding more structured rules. However, as the game becomes more formalized, the designer loses some of the spontaneity of true social interactions.

In Chapter 12, Socializing, we'll look at several games and how they use rules to craft social interactions. The card game *Apples to Apples* uses several simple rules to turn the arbitrary judgments of players into binding resolutions. Simply looking at the rules this dynamic might seem too loose and random. But in the context of the game it works quite effectively, given that players are willing to engage each other socially. *What to Wear*, a Facebook game about fashion, also uses the arbitrary judgments of other players to power a scoring system. In this game, the designers create a system to emulate the social milieu of fashion by harnessing the opinions of thousands of users.

Playing with Things

Little kids aren't the only ones with toys. From animals to kids to adults, we all occasionally find hours of enjoyment in simply playing with some object, spinning, bouncing, counting, sorting, matching and rolling it. Cats love paper bags, dashing in and out of them. Kids can be entertained by a good bag for hours too, even if the bag was originally used to deliver an expensive new toy. Heck, adults can find plenty of uses for a paper bag too, blowing them up and popping them behind an unsuspecting spouse. We use the object as a nexus or centerpiece for our play. Something in the physical characteristics of the object sparks our interest. We find that a ball bounces right back to our hand when thrown a certain way into the corner; or that a cell phone will spin for 10 revolutions on our desk. We explore and play with the cheapest of objects, reveling in our discoveries about how it behaves. Of course, as we get older, our taste for playful objects sometimes gets more expensive, running from fancy blenders to sports cars. There's joy to be had everywhere, even in flicking open menus with your thumb on an iPhone just to watch the little bounce it gives.

Object play is often mixed with physical play. What do you do with a ball? Kick it. Then there is object-based play that combines social play, like the always dangerous

party game *Spin-the-Bottle*. Other times, playing with objects requires more mental acumen than physical, as you struggle to make matches from memory or sort out sets.

As with other sorts of play, games sit just a few simple rules away. Turning this sort of play into a game can be as simple as seeing how long you can get the object to spin or how many catches you can make in a row.

Sorting and matching also falls into the category of object play. Humans seem to have a natural tendency to sort. Spread an array of different colored paper clips on a conference room table before a meeting, and I bet you by the end of the meeting, a significant portion of those paper clips will be grouped by color or strung into chains. We seem to have an almost subconscious need to produce order from chaos. Thousands of games have grown out of just this desire to sort and create sets. From the set creation in Poker to the split second group sorting of *Pit* to the color matching of *Snood*, countless games find real pleasure in making order of randomness.

Tapping into these activities offers fertile grounds for game designers. Games like *Memory* are bare bones games that rely primarily on the characteristics of the object. By building a game around play with an object, designers can take advantage of familiar interactions that already show an element of fun. The dart game cricket does exactly this. It provides a structure of rules and scoring to go with the joy of hurling sharp objects at a target. When you hold a dart in your hand, it's pretty obvious what you should do with it: throw the sharp end at anything you think it will stick into, preferably a dart board and not your brother. Simply throwing darts

FIGURE
3.6

In Cricket, players must close out sections of the dart board by hitting them. The wide distribution of target areas ensures some amount of success, especially early in the game. (WikiCommons[7])

[7] http://commons.wikimedia.org/wiki/File:Darts_in_a_dartboard.jpg

and trying to hit the bull's eye is fun, but ultimately tiring over time. Unless you're quite practiced, you're not likely to hit the bull's eye very often, so your success to failure ratio will be pretty low. Cricket, on the other hand, demands that you hit regions all across the dart board. Players must close out regions of the dart board, like the area of the board labeled 19. You close the section by landing three darts in the wedge. The first team to close all of the sections in play wins. (You can also play Cricket where you begin to score points after closing a wedge.) Cricket gives players a range of new goals at which to take aim. Direct competition to close out scoring areas spurs players forward imbuing each throw with great meaning.

A game like *Guitar Hero* is an excellent example of a video game centered on an object. The designers at Harmonix, the original makers of *Guitar Hero*, had long dreamed of making a rhythm action game with a guitar controller. However, getting funding to make an expensive peripheral for a video game was no easy trick. So they cut their teeth developing rhythm games like *FreQuency* and *Amplitude*. These games were popular with players and game critics. But it wasn't until they were finally able to combine their stellar gameplay with a guitar-shaped controller designed in collaboration with Red Octane that they started winning over a whole new audience of players. The gameplay of their games *Amplitude* and *FreQuency* in many ways isn't that different from the main mechanic of *Guitar Hero*, but the little plastic guitar distributed with *Guitar Hero* makes all the difference. It immediately draws the player into the game because it's simply fun to play with. It's also familiar.

FIGURE
3.7

Much of the fun of *Guitar Hero* stems from rocking out on these simple almost silly looking plastic guitars. The object ties the game together. As soon as you pick it up you know how to hold it and you feel like a guitarist. (WikiCommons[8])

[8] http://commons.wikimedia.org/wiki/File:Guitar_Hero_series_controllers.jpg

Mentally mapping the activity of hitting streaming notes on the screen is much easier with an object that looks like a guitar than with a normal video game controller. The shape and feel of the object tells the players much of what they need to do.

The disadvantage of object play is, well, it requires you own the object and a specific set-up that accommodates play. This can limit the accessibility of the game. The more limited the accessibility, the more limited its chances for adoption.

In Chapter 4, Matching, and Chapter 5, Sorting, we'll look at how games like *Solitaire* and *Bejeweled* use the characteristics of objects to structure gameplay. The designers of these games create mechanics which highlight the features of the objects and force the player to interact with those features. Chapter 11, Bouncing, will look at games like *Bowman* that take the playful act of shooting an arrow and shape it into a simple goal-directed game that utilizes the physical properties of an arrow in flight.

Playacting

Any time we play, we playact to a greater or lesser degree. The roles we assume help guide our play and provide a thrust for our actions and unwritten rules for our behavior. Little kids playing cops and robbers take on the roles of heroes and villains in their play. They do not necessarily provide elaborate backstories and deep-seated motivations for these characters ("I'm a divorced cop with a serious authority problem and two mortgages on my house"). Instead, the roles simply provide a general behavioral framework that they use as departure points. Everyone knows the cops really want to catch the bad guys and will chase them down at all costs. So the kids playing the cops chase the robbers and yell, "Halt! Police!" Robbers, of course, rob. They knock over banks, grab the cash and run away. So kids playing robbers sneak around and then run like mad from the kids playing the cops when they're spotted. The simple sketch provides enough meaty roles for most childhood play. The action of play provides the forum to act out the roles.

Role-playing seems to have garnered a bad reputation. People often associate it with Renaissance fairs and live-action role-playing. But these are instances of role-playing taken to extremes. There are many more subtle ways in which we enact characters.

From improv games to role-playing games to even video games we continue to adopt roles and characters to inform our actions. When we play a video game, we take cues from the character in the game. Depending on the type of game and the richness of the character, this will lead the player to inhabit the character and make decisions as that character. A game like *Diner Dash*, in which the player controls Flo, a former businesswoman who has chucked it all to run her own diner, requires little role-playing. You don't need to think about what it would be like to be Flo, owning your own restaurant and trying to pay your bills and all of the pressure that would entail to play the game. Frankly, the story of the game isn't very concerned with those issues either. Told in short and simple comic strip interstitials, the game story focuses on how Flo gets better and better at serving more and more people. Simply knowing that Flo is a waitress and that she needs to bring patrons their food is enough. The role of Flo gives the player an indication of how to behave.

FIGURE
3.8

Live-action role-playing takes role-playing to the extreme. There are many more subtle ways we enact roles. (WikiCommons[9])

FIGURE
3.9

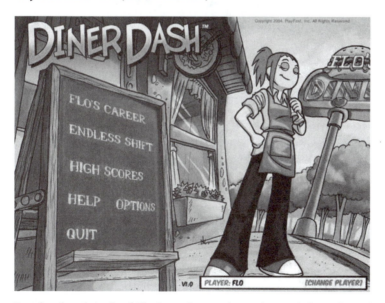

By adopting the role of Flo the waitress, players instantly know how they should behave in levels: they should serve customers. (Copyright © 2003 PlayFirst, Inc. Reproduced by permission of PlayFirst, Inc.)

[9]http://commons.wikimedia.org/wiki/File:LARP_Sternenfeuer_Treffen.JPG

Similarly in a game like *Tom Clancy's Splinter Cell*, the player does some very light playacting. In *Splinter Cell*, the player controls Sam Fisher, a covert operative dropped into places like foreign embassies where you cannot risk detection. The need to sneak around undetected informs all of the player's actions within the game. The game allows for a certain amount of leeway. You can occasionally be seen and still pass the level, but players who take the game seriously will strive to never be seen, even if this makes the game harder to play. In this simple way, they enact the role of a covert operative even when the game does not strictly require it. They may not consider and inhabit Sam Fisher's personal motivations, but they do recognize the primary role of Fisher as a covert operative and enact that.

FIGURE
3.10

In *Splinter Cell*, players adopt the role of the stealthy secret agent. Even in situations where you could jump out, players still make an effort to hide and go undetected. (WikiCommons[10] © Ubisoft)

As our playacting becomes more complex, so does our relationship to it. In some games, playacting not only provides motivations for actions within play, it also becomes a way to explore what it would be like to inhabit another persona. This is especially true of role-playing games, from table-top games like *Dungeons & Dragons* to video game RPGs like BioWare's *Star Wars: Knights of the Old Republic*. In *Dungeons & Dragons*, players craft characters with complicated back stories and a web of motivations. Then they play as those characters and attempt to make decisions consistent with the character's backstory and personality. The play of the game is a process of improvisational storytelling conducted between the Dungeon Master

[10] http://commons.wikimedia.org/wiki/File:Splinter_Cell_Screenshot_vision01.jpg

leading the game and the players enacting the characters in the game. In video game RPGs, players are more constrained by the software and the story embedded in the game. They can improvise and impact the story less. But they can still make significant choices as the character which greatly impact how other characters in the game react to them.

Almost any game with content that involves people, gods or even animals has an element of playacting. These games provide a role which is recognizable to players. The more abstract the game, the less playacting involved. So games like *Bejeweled* and *Tetris* involve next to no playacting. Players simply interact with the game system as the player. *Diner Dash*, with its recognizable, but fairly iconic character, allows for light playacting. The player does not become Flo, but does enact the basic physical actions of Flo. Games like *Dungeons & Dragons*, where the player creates a character and then inhabits the mindset of that character, involves a great deal of role-playing. You cannot really play without inhabiting the character.

Role-playing extends far outside of games and even play. We also apply role-playing and playacting to more serious pursuits, from acting to adopting slightly altered personas to fit different situations. When we answer the phone at work, many of us use an altogether different tone and voice than we do at home. We assume the role of office worker and project a certain persona to meet the situation. While this may not fall under our typical definition of play and fun, it shares similar qualities with playacting.

Basing games around acting and roles can provide powerful motivations for players. It also helps illuminate the context of the game for players. Allowing for playacting and building in opportunities for role-playing can greatly intensify the experience of a game. Games where the player can really get into character and assume a role tend to be more immersive. However, creating the right situations for role-playing can be very difficult. Players are often willing to engage in light playacting. But many players prove quite reluctant to go beyond that to actual role-playing. They are willing to consider and inhabit the role of an iconic spy much more than they are to try and assume the role of a specific spy with specific personal problems and bugaboos. Perhaps this is because of social taboos and social anxiety at the idea of performing. As a result, most players new to role-playing will try to be funny, hamming up the role rather than playing towards a more serious side. Laughter tends to cut the tension and relieve any social awkwardness. Even experienced role-players will tend to play for laughs when they play with strangers.

This reluctance to role-play makes designing games with deep elements of role-playing difficult, especially for casual players. Serious role-players tend to be serious gamers. However, casual gamers are often willing to engage in a bit of playacting. While many casual games like *Solitaire* and *Bejeweled* have quite abstract themes which allow for very little playacting, a number of successful games are beginning to involve more recognizable character and so more playacting. *Diner Dash* not only popularized the time-management mechanic among casual downloadables, it also put a recognizable avatar character that players could identify and playact at the center of the game. The publisher, Playfirst, went on to build an entire franchise

around Flo and even repeated the formula in other games like *Wedding Dash* with the character of the wedding planner Quinn.

How to Host a Murder has been a popular party game for more than 20 years. While it might seem like *How to Host a Murder* is a role-playing game closer to *D&D*, it is actually quite casual. It requires more playacting than it does actual role-playing. Players are assigned iconic roles which they can decide to act out however they choose. The only thing the game requires is that players reveal certain pieces of information at specific points to aid partygoers in solving the murder. You could play the game simply as a deductive logic exercise not unlike *Mastermind* or *Clue*. Of course, you would miss out on some silly, performative fun, but the game would work much the same.

Daredevilry/Push-Your-Luck

The last category of play involves the joy and fascination that comes from pushing limits. These activities are playful exertions that test your abilities and appetite for risk (sneaking, rock-climbing, cliff-diving, sticking your hand near a moving fan-blade, playing "I'm not touching you" with your big brother, ski jumping). In many ways they resemble the physical activities at the center of games. However, unlike those activities—which revolve around the joy of performing a simple action—these activities offer the thrill of seeing just what you can get away with before crashing and burning.

This sort of play naturally provides a visceral thrill. Rules are also naturally embedded in the activity. These rules are partially defined by physical elements, with the moment of failure or consequence serving as an upper bound. The player's goal is simply to get as close to that upper bound as possible without failing.

Jenga is the perfect example of this sort of activity formalized as a game. In *Jenga*, players stack a set of wood sticks, creating a tower. Then players take turns pulling out sticks until finally someone removes a piece that causes the entire mass of blocks to come crashing down. The game has a natural drama which increases with each piece pulled out, leaving all the players in a state of agitated anticipation until finally the crucial block is pulled and the tower collapses. At this point, inevitably a chorus of cheers and screams breaks out as the anxiety is released like a coiled spring.

It's not always easy to simulate daredevilry in video games where the risks are, by definition, lower. Sure you may lose, but you can always start over again with little penalty. But there are ways to do it. And successfully simulating this moment of anticipation and release can imbue the video game with great drama. *Tom Clancy's Splinter Cell* does an excellent job of drawing tension out of its stealth mechanic. Players are required to sneak around embassies avoiding guards, cameras and all manner of surveillance equipment. The player must quietly walk and climb by all of these guards, often passing only inches from them without raising an alarm. The player knows that as soon as they are detected, alarms will sound, more guards will rush in and quite likely the game will be over. This gives the game an interesting dichotomy between coiled silence as the player meticulously avoids detection and

FIGURE
3.11

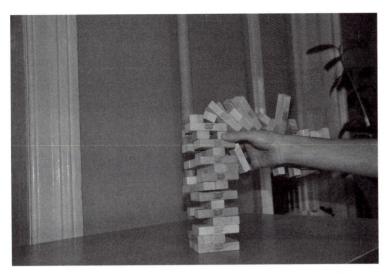

All of *Jenga* builds up to the moment of collapse as players are forced to make increasingly dangerous moves.

frantic scrambling if they do set off the alarm. The player pushes as close as possible to the envelope, increasing the excitement.

Puzzle games like *Tetris* also exhibit similar qualities. Completely filling four lines all at once to form a "tetris" is the ultimate way to score in the puzzle game. To build up a layer of four lines with only a few key blocks missing is dangerous. It is entirely possible that you will never get the one long piece you need to complete the lines. And while you wait, other blocks will stack up and pile closer and closer to the top of the screen. Obsessively trying to score a tetris is a good way to lose the game, but doing so is attractive nonetheless. The reward doesn't necessarily offset the risk in terms of points, but the joy of flaunting the danger and succeeding brings its own psychic rewards.

Building this sort of play into video games often results in push-your-luck mechanics. Players are offered a choice between great penalty and reward if they can complete a complex set of moves that requires great precision. From shooting the moon in *Hearts* to rock climbing, these types of play offset risk, reward and skill. Game designers building this tension into a game benefit from the natural drama and excitement of success. However, they run the risk that this one move will be viewed as the only way to play the game. Shooting the moon in *Hearts* must be balanced out with a more normative way to play the game so that every player isn't constantly trying to shoot the moon on each hand, or simply giving up if the conditions aren't right.

Designers must also weigh whether their players are keen on risk. Casual players often have a strong desire to succeed rather than get hung up on a particular element or level over and over. So if the element of pushing your luck requires too exacting a skill, it will likely frustrate players. This frustration must be offset by easier, but equally valid ways to play and win.

All of these types of play provide game designers with a list of activities that we know engages players. The designer's job is figuring out how to take the basics of play and formalize them into games. This involves finding ways to structure and lengthen those play experiences. A key element to this process is adding goals and rules. As we define games, we'll see that rules will help us give shape to play experiences.

Defining Games

Play and games exist on a spectrum of formality. But that spectrum can sometimes look very broad and all-encompassing. Activities like poker or basketball are clearly games. But what about more ambiguous activities that follow strict rules, like trading stocks? Stock trading would seem to share many qualities with a game: it's rule-based, you have goals, there's a lot of randomness involved. Does that make it a game? Well, that depends on how we define game. And defining games is a favorite pastime of game designers.

The French philosopher Roger Caillois built upon the definition of play laid out by Johann Huizinga in *Homo Ludens*. Huizinga focused largely on play and how it interacted with culture. He saw play in all manner of activity, from rough-housing to politics to war. Caillois meanwhile focused the study of play and honed in on games. In his book *Man, Play and Games*, Caillois offered a definition of play and then provided a system of classification for games. Caillois recognized that games and play existed along a spectrum, with unstructured activities on one end and more formalized games rounding out the other.

Caillois provides the following definition of play:[11]

1. Free: in which playing is not obligatory; if it were, it would at once lose its attractive and joyous quality as diversion;

2. Separate: circumscribed within limits of space and time, defined and fixed in advance;

3. Uncertain: the course of which cannot be determined, nor the result attained beforehand, and some latitude for innovations being left to the player's initiative;

4. Unproductive: creating neither goods, nor wealth, nor new elements of any kind; and, except for the exchange of property among the players, ending in a situation identical to that prevailing at the beginning of the game;

5. Governed by rules: under conventions that suspend ordinary laws, and for the moment establish new legislation, which alone counts;

6. Make-believe: accompanied by a special awareness of a second reality or of a free unreality, as against real-life.

[11] Roger Caillois, *Man, Play and Games*, University of Illinois Press, 2001, pp. 9-10

This definition closely resembles Huizinga's definition of play. And Caillois recognized that play and games existed along a continuous spectrum, with looser play activities on one end and structured, rule-based games on the other. Caillois called the unstructured end of his spectrum "paidia." These activities are closer to the natural root of play where, as he put it, "an almost indivisible principle, common to diversion, turbulence, free improvisation, and carefree gaiety is dominant." The opposite of this freewheeling play he called, "ludus." On the ludus end of the spectrum, conventions and rules have been firmly established, meting out the loose, improvisational nature of paidia activities.

Perhaps Caillois had a penchant for casual game design. He seems to take a dim view of games as they move along the spectrum towards ludus. His view almost sounds negative when he writes, "this frolicsome and impulsive exuberance is almost entirely absorbed or disciplined by a complementary, and in some respects inverse, tendency to its anarchic and capricious nature: there is a growing tendency to bind it with arbitrary, imperative and purposely tedious conventions, to oppose it still more by ceaselessly practicing the most embarrassing chicanery upon it, in order to make it more uncertain of attaining its desired effect."[12] While he by no means dismisses formalized games in favor of play, he does point out the fact that as games become overly formalized and rigid, they lose some of their playful looseness that makes them attractive in the first place.

He recognizes that paidia-like activities will naturally progress towards the ludus end of the spectrum as the players formalizes their interaction with the activity. This mirrors what we know about games progressing towards complexity as you become more skilled.

Caillois went on to divide games into four different categories:

- Agon—games of competition in which players go head-to-head with one another

- Alea—games of chance in which a role of the dice and fate take primacy

- Mimicry—games of simulation dominated by playacting, spectacle and actual theater

- Ilinx—games of vertigo that draw key pleasure from the physical sensation and disorientation

These categories reflect many of the same traits we see in play.

A Designer's Definition

For the purposes of designing games, it can be helpful to lay out a definition for games. At the most basic level, it may help you determine if what you are designing is really a game or more of a toy or experience. That check may seem silly, but it's

[12] Roger Caillois, *Man, Play and Games*, University of Illinois Press, 2001, p. 13

actually more common than you might think. Game design can be applied in many ways, from crafting Web sites to designing toys to making simulations. In designing those experiences, you may intentionally break the definition of formal games and leave off some aspect. If you're making an interactive application, you may find you want the directed experience of games, but not the uncertain outcomes associated with winners and losers. Having a mental model of games serves as a useful sounding board for all interaction design.

Caillois lays out a very helpful definition of play and games. However, I think his definition could be divided into intrinsic and extrinsic qualities. The intrinsic qualities are inherent to the game and its system of rules. They don't speak at all to how people actually interact with it or view it. The extrinsic qualities help us contextualize games and define how it is viewed in a social context. These qualities speak to how we perceive play and games in society. They let us know that we are playing and not working or doing something else.

Intrinsic Qualities

Some of the qualities of games are intrinsic to the game. They are established and defined by the game itself. These are the qualities the game designer has the most control over, because they are the qualities laid out by the actual design of the game.

Governed by Rules

Of the six qualities that Caillois offers, rules are the most important. Rules are the primary characteristic of games. A game is a system of rules that govern behavior. The rules, written down on a piece of paper in a *Monopoly* board game set or explained out loud to a bunch of first-time basketball players, provide the structure for the game. They exist outside of the actual play of the game. Once the game is in play, players interact with the rules and adjust their behavior accordingly. At a base level to qualify as a game and not just play, the rules must encompass an outcome or goal. The rules must include an end state. Whether or not that is considered winning is up to the designer of the game.

Uncertain

Books and movies end the same way every time. No matter how many times you watch *Citizen Kane*, the last shot is always going to be of that darn sled. The fixed nature of a strip of linear film enables directors and writers to tell consistent stories. Games are more variable. Ideally, the outcome of a game is uncertain. You will win or you won't but you won't know which outcome will occur at the start of each game. However, even in games where the outcome is fairly certain—you playing one-on-one basketball against an all-star basketball player like LeBron James, for

instance—there is still a high degree of variability in the game. How many points will LeBron win by? Will he shoot jump shots? Will he dunk? Will he fall for your patented head fake that works so well against your little brother? Games provide differing levels of interaction and choices within them. It is this choice that lends games their possibility space. Simple games have more limited choices and possibility space. Good games offer players more interesting complex choices.

The more tightly a game restricts choices and follows a prescribed script, the more it begins to feel like a movie or a book. If there is no room for any choice for the player in the game, even a simplistic one question choice, then the game ceases to be a game. Games require some level of uncertainty informed by choice.

Extrinsic Qualities

The rest of the qualities that Caillois outlines describe how we perceive the game and are therefore extrinsic qualities to games. They help us understand the game in a cultural context, but they are not intrinsic to the system of rules that govern the actual game. We think of games as voluntary, fun, contained and offering up the possibility for a different winner every time. But none of this is intrinsic to the game. You could easily imagine situations where any one of these qualities could be negated and you would still not deny that you were playing a game.

Voluntary

Games and play are generally voluntary activities. We opt to play the game. This distinguishes it from work where we are required to go. Caillois points to professional athletes and says they are not playing a game, they are going to work. They have to be there to fulfill their job. While this is true—you could consider a professional soccer player an employee or a worker—there is no denying that when on the pitch kicking a ball around, soccer workers are engaged in the game of soccer. Their behavior is being governed by a set of rules. They are playing a game.

Boundaries

Games take place on fields and across boards. They last for several minutes or for several hours. But in that space and during that time, you are playing the game. When the game is over, you step back into the real-world. Huizinga referred to this idea as the "magic circle." Because games are separate, we are safe playing them and we know how to behave while playing them. There is real legitimacy to this claim, though a number of games have attempted to blur the line, from alternate reality games that masquerade as real mysteries to real-world games like *Assassins*.

In *Assassins,* players are given another player as a target. They must find this player and tag or squirt them with a water gun. When they do that player is

eliminated and he must pass on his target. The game may run over several weeks and integrates with your everyday life. You can be assassinated anywhere and any time, from your doorstep to your office desk. The lines of the game, of who is playing and who isn't, begin to blur, instilling a sense of paranoia in players. You could argue that this game blurs the boundaries between the game and the rest of the world. Players know, of course, that they are playing the game, but at times, their awareness may slip and game moves may intrude on their everyday life. Boundaries are important to shape a game, but they are not absolutely intrinsic to the game.

Caillois also says that games must be inherently unproductive. Indeed, most games are unproductive. Most exist simply to bring you some amount of joy while playing, but this does not necessarily preclude games from being productive. For one thing, good games produce joy and fun, which is a value in and of itself. And you could imagine a game that produces some other good as a side-effect. In our culture, games are certainly not designed to be productive, but that doesn't mean they couldn't be. It also ignores the production of fun, which is what most game designers aim for.

Bernard Suits described games quite elegantly when he wrote that games are the "voluntary attempt to overcome unnecessary obstacles."[13] Put more plainly, games take simple activities and make them hard. If we look at the activity behind almost every game, we can see that there is a simpler straight line to success than the game allows. When we talk about game design, these straight lines are considered exploits, and we create rules to prevent players from taking that path. This may seem silly. But it is in the challenge and effort to overcome these self-imposed obstacles that we find fun. Creating the right obstacles and striking the correct balance between your ability to reach your goal and the effort required to get there are the crux of game design.

There are, of course, many ways to look at games and many ways to define them. Designers keep in the back of their head a notion of what they believe they are up to when they make games. All of their work is checked against this mental model. Sometimes they choose to push against that model, imagining games that stretch their personal definition of games by circumventing one of these qualities. Indeed this can be a very productive way to imagine wholly new types of games. Having a mental model of what you are making is an invaluable aid in designing. Your definition can be rigid or loose, long or short, but you need to have an idea of what you are doing.

For novice game designers, it is best to start with a more rigid definition of games. Just like rules help direct a player's efforts toward a game's goal, a definition of games helps direct you towards creating a coherent and whole game. Sticking to the formal elements of games will help you get an idea of how to fulfill the promises of games. Once you understand the qualities of games you can begin to experiment with the form. Picasso may have made some wonderfully abstract paintings that challenged a viewers very notion of art, but he could also create heartbreakingly realist paintings as well. Breaking the rules was intentional.

[13] Bernard Suits, *The Grasshopper: Games, Life and Utopia*, Broadview Press, 2005, p. 55

Summary

Games grow out of play. As a game designer you must look at all manner of playful activities and recognize their potential as games. By girding play with rules and goals we can begin to transform play into games. And by transforming playful activities into games we can lengthen and deepen the experience. In designing casual games it's important to pay attention to this line between play and games. We don't want to overly discipline the frolicsome exuberance of play, as Caillois would say. Instead we want to highlight and enhance the natural playfulness of the activity while shaping it.

Now that we have a general framework for considering play we can look closely at some specific games and see how the designers shaped the experience through the careful application and combination of game-specific mechanics.

CHAPTER FOUR

Matching

We like to pattern match—our brains crave it. Games are essentially complex systems of patterns. Think about it. Games are comprised of pieces that can behave in unique, but prescribed manners. All of the events and moves within a game happen because the rules allow it. They are following set behaviors which form patterns. The patterns are easy to detect in a game like checkers, where the grid makes all of the moves discernible and quantifiable. The patterns in a social party game like *Mafia* are harder to discern, but they exist in everything from the rounds that delineate the game to the patterns of speech adopted by the players. Much of the fun of playing a game comes from figuring out the patterns and mastering them: vault over pawns with your knight, run a pass play on 3rd and long or swap gems into matches of three.

Matching and sorting games provide a very basic form of pattern matching and bring it to the surface of the game. This makes them very accessible and well suited to casual games. If casual games are about accessibility and easy legibility, then it's no wonder sorting and matching games take a seat at the head of the class of casual games. They are explicitly about legibility. Players engage with the game by "reading" the game area and discerning how to chunk the noise into more organized patterns.

Sorting and matching games employ a range of mechanics, but they do share some commonalities. By looking at a few key games we can begin to understand how these games employ different game mechanics and to what effect.

Bejeweled: The Casual Ideal

Bejeweled: such a beautiful little game. It is beloved by casual game fans but scoffed at by hardcore video gamers as suitable only for the most brain-dead casual gamer.

How you can possibly account for the astounding popularity of *Bejeweled* by simply looking at the game? After all, the game isn't much to look at. In fact, you could say it's downright ugly. With a name written in a pink font reminiscent of faux 1950s neon diner signs, perched next to a grid of brightly colored gems, the game could be said to be at best garish (Figure 4.1). And the name makes the game sound like the kissing cousin of the Bedazzler, that 1970s home appliance used to attach rhinestones to denim jackets.

FIGURE
4.1

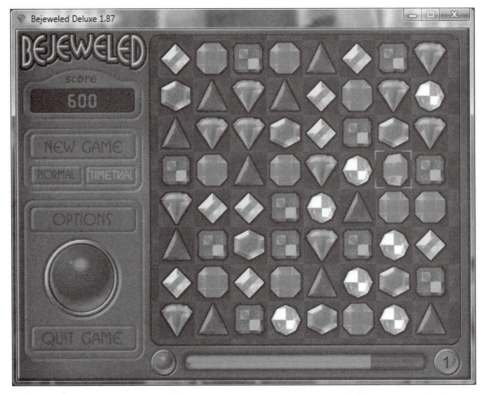

The incredibly simple, yet elegant *Bejeweled* **game board belies an extremely addictive experience. (Reproduced by permission of PopCap Games)**

But *Bejeweled* easily ranks as one of most popular games of the last 10 years. The game's reach extends across almost every imaginable platform from PCs to consoles to phones, not to mention the countless derivatives the game has inspired.

Bejeweled is an incredibly simple, yet elegant game. It presents players with a grid of different colored gems. Players then swap adjacent gems to form vertical and horizontal matches of three or more. Gems in matches score and disappear in explosions of sparkles as new gems drop in from the top of the screen. You score bonus points if you match more than three gems or if gems drop into new matches as they fall. Players progress through levels by reaching goal scores. Or they can race against the clock, matching gems to keep pace with a timer. The game also includes an untimed mode with less pressure.

As sparkly as all of those jewels in the game are, they don't account for *Bejeweled*'s popularity. Looks only carry a game so far. They may spark your initial interest, but to hold your attention, the game mechanics have to really sink their hooks into your brain. *Bejeweled* proves that an ugly game can consume hours of your life if the game mechanic is addictive enough. *Bejeweled* relies almost

solely on its simple, yet engaging, core mechanic and the permutations that the mechanic allows.

The larger meta mechanic of the game is matching. You are given an array of colored gems and must sort them into matches of like colors. There are plenty of games about matching colors that can't claim *Bejeweled*'s level of success. *Bejeweled*'s charm lies deeper down in the specific mechanics that govern how you match.

Bejeweled is dead simple. Practically the only tutorial the game offers is doled out in short instructions before the game starts:[1]

- Swap adjacent gems to align sets of three or more.
- A winning set is three or more gems of the same color.
- Combos and cascades award bonus points.
- Fill the gem meter for a bonus!
- Press spacebar to pause.

After reading these short instructions, you have all the knowledge you need to start playing the game. You're playing a match three game that uses a swapping mechanic to rearrange gems. You move an object by swapping it with an adjacent object.

The rules to the game are slightly more complex, but still wonderfully elegant. Looking at them more closely, we can see what makes *Bejeweled* so special. The original *Bejeweled* offered two modes of play, normal and timed. Normal mode puts no time pressure on you, while the timed mode requires you to stay ahead of a timer to keep the game going. Breaking the game down to a set of approximate rules, the normal mode would look something like this:

Setup:

- The game field is comprised of 64 gems arranged in rows eight across.
- The gems are divided among seven different colors.

Rules:

- The player may swap a gem with an adjacent gem only if the resulting arrangement will result in at least one horizontal or vertical set of three or more matching gems.
- Matching sets of gems score and disappear.
- Gems slide down to fill the newly empty slots.
- If new sets of matches occur when gems fall into their new position, these gems score and disappear.
- The grid is constantly repopulated by new gems falling in at the top of the grid.

[1] http://www.popcap.com/games/free/bejeweled

- The player earns bonus points for matches of four or more.

- The player earns bonus points for "cascades" of gems that drop into additional matches.

- Fill the points meter to reach the next level and reset the game board with new gems.

- Trade points for a hint revealing the location of a match.

- The game ends if no moves can be made for a match.

But really, the spirit of *Bejeweled* is encapsulated in that first rule: the player may swap a gem with an adjacent gem only if the resulting arrangement will result in at least one horizontal or vertical set of three or more matching gems.

This rule lays out the core activity of the game, as well as the main limitation on player movement. All of the rest of the gameplay stems from this rule. It informs not only how you make matches, but the overall pacing and difficulty of the game—the essence of the play experience. Whether you must match three gems or seven isn't as important. Nor is whether you are rewarded with bonuses for cascades. What defines *Bejeweled* is this idea that you cannot move a piece unless you are moving it into a match. This means that every move you make must be successful. It doesn't necessarily have to be the smartest move, but it does have to be valid. This rule imbues *Bejeweled* with both a feeling of immediate claustrophobia, and oddly enough, long-term liberation. You feel cornered, trapped by the requirement to find a swap that will result in a valid match. Finding a match among the array of 64 gems can seem momentarily impossible. It's often easier to see matches that require two swaps rather than matches that require just one, even though those gems are closer together. This produces a feeling of anxiety as you struggle to discover a possible match while also coping with frustration at the limited way you can move gems. So often, the move you really want to make is just out of reach.

But this frustration is gilded with relief. You know there must be a way you can successfully move some gems. If there was no possible match, the game would be over. The simple fact that the game is allowing you to continue playing means that a match exists. This fact offers you a sense of long-term liberation. You will find the match if you look long enough. And when you do find it, you simply have to make it. You needn't worry if it's a particularly good match. *Bejeweled* does not demand long-term strategy the way a real-time strategy game does, or even other casual matching games like *Snood* or *Luxor*. *Bejeweled* absolves you of the need to develop a strategy. You simply play in the anxiety-ridden moment, and you are rewarded with points and a break in that anxiety every time you make a move.

Playing *Bejeweled* forces you to live in the moment and react to the here and now. You match the gems you're dealt as best you can. This ethos pervades casual games, but no where is it more evident than *Bejeweled*.

The normal mode has no timer. You just swap gems when you find them. As you match gems, you collect points and fill the point meter at the bottom of the screen. When the point meter tops out, you receive a handful of bonus points and move

to the next level. If you ever get stuck, you can ask for a hint that will tell you the location of a possible match. Asking for a hint costs you some points, delaying your transition to the next level. Delay filling up the points meter too long and the risk that the board will progress to a point with no possible matches increases.

Despite what some might think, it is definitely possible to play the normal mode *Bejeweled* better or worse. For one, a good player will avoid taking hints, enabling him or her to fill the point meter and refresh the board more quickly. A smart player can also try and plan a few moves in advance to try and drop gems into slots where it will be easier to match them in the future. But the randomness of the new gems the player receives negates excessive planning.

The normal mode of *Bejeweled* is also not without pressures. As you make the obvious matches, finding new matches among the leftover gems can become harder and more frustrating. As you match gems, you sort the board into a state where matches can no longer be made—you use up all of the possible matches. This lends even the normal mode a natural arc from simple discovery towards the rising tension of limited choices. Without this tension, *Bejeweled* would not really feel like a game, but just an activity.

In comparison to the normal mode, the timed mode of *Bejeweled* is rife with tension. In the timed mode, the points meter at the bottom of the screen doubles as a timer. The meter starts each level half full. As seconds tick off, the meter loses points. If the meter reaches zero, the game ends. As you make matches and score points, you refill the meter. If you completely fill the meter, you move to the next level and the board resets. But with each level, the meter drains faster and faster, forcing you into more and more frenetic play.

While the basic activity of normal mode and timed mode are the same, they engender completely different feelings while playing. One simple rule tweak changes the game entirely. The normal mode follows a very gradual arc towards tension. The constant stream of new random gems entering the system alleviates much of the pressure. One matching set on the board can introduce enough new gems for several further moves. The timed mode, however, steadily increases the pressure from the first moments. The two modes of play represent two wildly different player personalities—one who prefers a more casual ambient experience that they can pace themselves and another who wants a game that challenges you to beat it. Traditionally, video games fall into this second camp, but *Bejeweled* shows that the first can be just as compelling.

From a game design perspective, why is the core mechanic of *Bejeweled* so engaging and addictive? Largely because the game fosters success. In *Bejeweled*, you can't do something without doing it right. The game is nothing but casual. There is no long-term strategy. You're not setting up long chains that will only pay off later. Every move pays off at the moment you make it. This gives you a healthy sense of agency. Your moves are your moves. You make it; you see the positive result. You never lose points on a move.

Moreover, you cannot make a wrong move; the game won't let you. This is in stark contrast to almost all other games, in which the number of wrong moves you

can make seems almost limitless. Interestingly, this particular mechanic keeps the game from degenerating into an annoying activity, while at the same time preventing any long-term strategy on the part of the player. If there was no limitation on your movement, *Bejeweled* would cease being a game and simply be a very tedious way to organize colored gems. Instead, the limitation on your moves makes the process of organization even more tedious, but in doing so makes it an engaging game. Arbitrary limitations define games and are a crucial part of game design. As the game designer, you are always looking for new, hopefully natural-feeling arbitrary constraints to impose on activities. Closely analyze any game and you will begin to see that the crux of the game is an arbitrary limitation that defines the moves of the game and therefore the core interaction of the game. Races: get from there to here without going across this area. Soccer: get the ball into the goal, but don't use your hands.

Players must scan the field and quickly weigh which of their possible options scores the most points and which option will lead to an advantageous position for the next move. Players churn through this decision process over and over again in *Bejeweled*. And oddly enough, it's really engaging, because while parsing the color and position of 64 gems is not terribly hard, it's not terribly easy either. It requires just enough mental attention that you have a hard time paying attention to much else while scanning the grid. Sure you can talk to someone else, but you're likely to get that far-off note in your voice, as if you're staring glassy-eyed into the distance. While making the game, PopCap no doubt explored different grid sizes before settling on an eight-by-eight grid. As an experiment, try playing *Bejeweled* and only looking at a four-by-four; five-by-five or six-by-six section of the board (Figure 4.2). The game area becomes much easier to scan, and the challenge drops off precipitously. Conversely, if the board gets much larger than eight by eight, it becomes harder and harder to scan and parse (Figure 4.3). As it is, 64 gems seems to hover just outside your ability to keep a mental map of the entire game board in your head. So you must constantly rescan the board to discover new clumps of like-colored gems for potential matches.

FIGURE
4.2

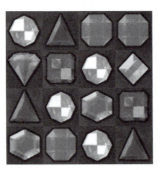

As the grid reduces in size, it becomes easier to scan the board. It also limits your chances at having bigger matches and cascades. The net result is that the experience is flattened. (Reproduced by permission of PopCap Games)

FIGURE
4.3

A larger grid would become significantly harder to scan, making the play feel more random as you have less ability to understand the space as a whole. (Reproduced by permission of PopCap Games)

So why do so many people disdain *Bejeweled*? Again we return to the first rule of *Bejeweled*: The player can swap a gem with an adjacent gem only if the resulting arrangement results in at least one horizontal or vertical set of three or more matching gems.

It is this mechanic that seems to be at the root of so many more hardcore gamers' distaste for *Bejeweled*. The game ensures your mediocre success, while obviating your chances for ultimate failure or success. In normal mode, a *Bejeweled* board may lock up with no moves left ending the game, but you can attribute this failure to the unfortunate array of random gems that the game doled out—or, as it's more

commonly known, bad luck. Conversely, you will find your ability to set up huge scores of jewels relatively limited. You may be able to plan a few moves in advance, but the random noise of the system and the fact that you must actually destroy viable matches of gems to progress prevents you from setting up really big arrays of gems to score at once. It's as if *Bejeweled* takes away your long-term responsibility for success or failure. You are only responsible for finding a match on any given turn (and in some ways, the Hint button removes even that responsibility).

The ire directed at the game by hardcore gamers seems to grow out of a belief there is a moral hazard in removing the responsibility for your actions from players. It's as if hardcore gamers are die-hard capitalists and playing *Bejeweled* is the equivalent of giving yourself over to state-sponsored socialism. Don't worry about planning out your moves, at sweating the math and spatial relations involved in setting up the perfect array of jewels to produce the longest possible cascade of gems. That's out of your hands—the game will give you what it gives you. Instead, player, you are a cog in the system churning through matches. This sticks in the craw of gamers who believe that your ability, your foresight and your hard work should be rewarded. *Bejeweled* is a great equalizer. Even a first-time *Bejeweled* player can largely master the core mechanic in a matter of minutes. This is an anathema to a hardcore gamer who believes mastery should be hard to attain; that it should come at the expense of a great many hours of intense gameplay. They disdain the game because it is the epitome of the casual game which anyone can play.

Compare this four-page strategy guide for *Bejeweled* (www.bejeweled.info/strategy.htm) with the strategy guide and walkthrough for any console title. Console strategy guides can easily run to dozens, even hundreds of pages. Tellingly, the *Bejeweled* strategy guide only offers tips covering scenarios that require one or two moves to set up.

In some ways, *Bejeweled* is like the interactive game equivalent of scratching an itch. You get immediate pleasurable feedback. It's easy to do and requires no real thought. You just interact with it. You swap gems where you find them. And finding them is relatively easy. If you do get stuck, you simply ask for a hint and the game shows you the next place to scratch. You keep doing this for a long time with little consequence. The game never progresses, you never build up much. Yes, you may beat a level and move onto the next one, but it will look almost identical to the one before it. It's the sort of game very well suited to a subway ride or waiting in the doctor's office. You want something to do, something to engage you while you wait, and you've already glanced through the "Celebrities Are Just Like Us" pictures in this month's *US Weekly* and you're just not up for perusing the issue of *Harvard Medical Review* sitting on the stand next to that *US Weekly*. *Bejeweled* offers a little bit of stimulation, but not so much you will strain a muscle.

If you play it in the more relaxed untimed normal mode, you can take as much time as you like to make your next move. You can sit and look through that grid forever. This flies in the face of the common notion of game design that insists players lose if they don't play well. *Bejeweled* seems to be saying to you, "Take your time. We've got all day. Or at least until you reach your subway stop in 10 minutes. If you

haven't made a match by then and you feel like a loser, that's you talking, not me the game."

The downside of this simplicity and lack of progress is that after playing *Bejeweled* for half an hour or so, you can feel rubbed raw and start to regret spending so much time fiercely scratching that itch. In the end, you don't feel like you accomplished much other than killing time. You don't really feel that you got better or progressed.

Bejeweled is a work of genius. It is a game boiled down to almost nothing but a simple core mechanic. The need to develop a strategy in order to win has largely been removed. The gratifying feeling of progress has largely been removed. And yet the game is still largely compelling for significant periods of time.

Why is that?

Clear and direct agency. You make your moves and you see reward for doing so. That, coupled with the fact that humans just seem to like to sort stuff. What's amazing is that *Bejeweled* isn't really a sorting game. *Bejeweled* doesn't progress to a state of sortedness, in the way, say, organizing your sock drawer leaves all of your socks folded neatly together and the orphan socks stuffed together in one corner; or the way alphabetizing your books slowly progresses towards clear order; or the way *Solitaire* ends with four tidy piles of cards sorted by suit. That sort of progression is extremely gratifying. You can see the fruits of your labor and a clear finish line. In *Bejeweled*, on the other hand, as soon as you make a match, more mess just falls in to take its place. All of your sorting is for naught.

So perhaps *Bejeweled* taps into an even more base human desire than sorting: the desire to simply match things? As if it's simply enough to say, "This sock goes with this sock," without progressing to the end state of an organized sock drawer? *Bejeweled* seems to be telling us that sure, people like to sort things. But at the root of that impulse, even further back down the line in our mental evolution process is the impulse simply to match things. We start by matching things. Later we worry about sorting those matches into piles.

PopCap stripped out everything and made the most streamlined game you can possibly imagine. Remove any one element of *Bejeweled* and it would simply collapse and no longer be a game. Without the score meter on the left, the game would become nothing but an interactive grid of gems. Granted, the score right now doesn't necessarily impel the game forward. Rather, it's the game giving a nod and wink toward the player, saying, "See this here score meter? Ostensibly this is why you're here: to score more points, to get a high score. But we both know why you're really here: to match gems. 'Cause I'm just gonna drop more random gems on you as soon as you clear any. Why bother planning ahead?"

Add to the joy of matching a simple slot-machine-like effect that produces cascades of further matches and points and players can begin to derive great pleasure from a simple matching move. This form of outsized reward is one of PopCaps's specialties, one they took to new heights in their game *Peggle*, which ends each level with bursts of sparkles accompanied by Beethoven's *Ninth Symphony*.

Upon occasion, I wonder if *Bejeweled* is too simple for the modern casual game audience. If the game came out now, would it still be as successful? Over the last several years, casual games have grown increasingly complex. They've begun to incorporate more and more elements from traditional "hardcore" games, from role-playing games' leveling up schemes to inventory management. Many of the successful games now incorporate multiple types of gameplay into the same game. For example, *Azada* is theoretically a seek and find game in which the player searches for hidden objects. Yet the game is larded with loads of other little mini-games and mechanics, from sliding puzzles to memory games. The designers of *Azada* seem so perpetually worried about you growing tired of the core gameplay that they've thrown in every puzzle mechanic they could think of. This is both good and bad. What *Azada* lacks in simple core mechanic elegance it makes up for by feeling like an extremely robust game. It offers not only excellent gameplay, but a compelling story. Through a combination of multiple types of gameplay, rich art and integrated story, *Azada* creates the impression of a world within the game. It feels like the sort of place you as a player can open the door to and step in and inhabit. *Bejeweled*, on the other hand, offers only the smallest doormat for you to stand on. You have one thing and one thing only to do and only one way to interpret it. You understand everything there is to know about the game 30 seconds into playing it.

Given that players tend to demand greater and greater complexity the more they play games, it would seem *Bejeweled* would be too simple for the modern player. And yet *Bejeweled* remains successful. If you look at bestsellers on game portals it seems like year after year, *Bejeweled* or some variant thereof remains in the top ten. When a new platform launches, *Bejeweled* is instantly ported and sells well, from the Xbox Live to the iPhone.

Perhaps *Bejeweled*'s continued success stems from the very way we play casual games. Casual games are played in the small interstices of our lives. These are short periods of time, from the 15 minutes spent riding the subway to the few seconds spent waiting for someone to pick up the phone. In these short times, we don't necessarily want to enter into a large game that requires full mental engagement. We simply want to make a few satisfying moves and receive a satisfying reward for those moves. *Bejeweled* allows for that better than almost any other game. And until some other game finds a way to deliver that same powerful combination of simplicity and reward, *Bejeweled* will remain popular.

LEGO Fever and *Luxor*: The Necessity of Constraints

Matching games need constraints. If you can move any piece you want into a match at any time, the conflict and challenge bleed out of the game. You would soon figure out the optimal move, the one that will score you most points for the least amount of effort and then you would make that move over and over. And it wouldn't be any fun because there would be no choice for you to make. Instead, by placing a carefully crafted limitation on your movement, the game designers

increase the fun you can have playing the game. Suddenly there are trade-offs. You can't necessarily do what you want, so you have to do what you believe is best.

I once worked on a game called *LEGO Fever* with a matching mode called Clump that failed to properly constrain player behavior. Players rearranged colored bricks to create matches of at least three like-colored bricks (Figure 4.4). The gameplay was very freeform. You could pick up one brick or clumps of multiple bricks all stuck together. You could set the bricks down anywhere you wanted, as long as they would attach to other bricks. In fact, your biggest worry in moving bricks around and setting them down was whether you would score even if you didn't want to. To heighten the tension, we tried to add difficulty to the game by having blocks randomly grow on top of the clump of bricks.

FIGURE
4.4

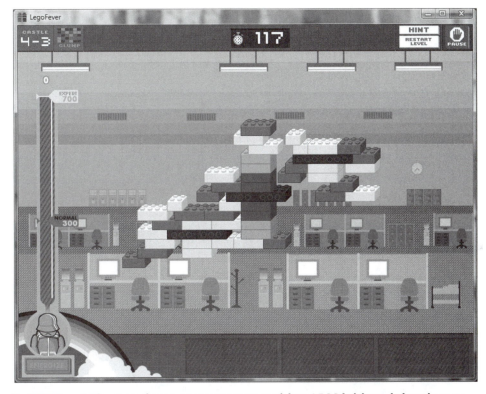

In *LEGO Fever's* Clump mode, you use your mouse to pick up LEGO bricks and place them on other matching bricks to score. The game does little to constrain your movement or to prevent you from making the exact match you want to make. (Executive producer: Peter Hobolt Jensen. Producer: Gabriel Walsh. © The Lego Group. Lego is a trademark of the Lego Group)

You could also score bonus points by creating cascading chains similar to those in *Bejeweled*. However, unlike *Bejeweled*, you could move bricks around freely, picking up bricks and placing them wherever you liked. The game barely constrained your movement, enabling you to create elaborate structures that would

produce huge chains of scores. To maximize your score, you made a stack of bricks in alternating clumps of two like bricks. (See Figure 4.5.) Then you placed this large stack onto a similar stack of alternating colored bricks and they would fall and score all of the bricks in one huge chain.

FIGURE
4.5

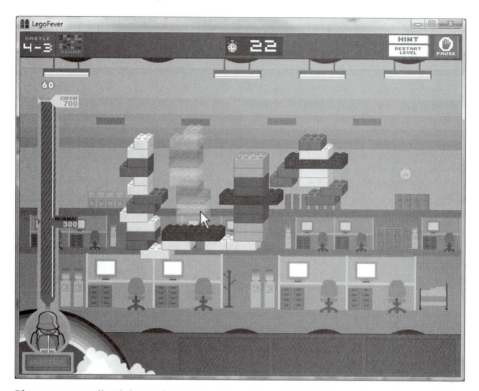

Players soon realized the optimal move is to create stacks of alternating colors and then connect them creating huge scores. By placing the stack of ghosted bricks on the stack on the far left, the player will collect a huge score. (Executive producer: Peter Hobolt Jensen. Producer: Gabriel Walsh. © The Lego Group. Lego is a trademark of the Lego Group)

This was the most effective way to rack up points in the game. It was extremely fun the first time you did it, as you felt like you had beaten the game system. And in essence, you had. You had found the optimal move. From that point on, however, your interest in the mode would wane. Now that you knew the optimal move, the game reduced to the labor of repeating that move over and over. There was little need to survey the game area and make snap judgments about the best move.

What the Clump mode of *LEGO Fever* needed was a constraint that made it harder—not easier—to move pieces. *Luxor,* for example, uses the same matching principles as *LEGO Fever.* You create matches by placing at least three like-colored balls into contact (Figure 4.6). If you are able to carefully lay out a chain of two ball groups in alternating colors, you can be able to achieve the same huge scoring chain

FIGURE
4.6

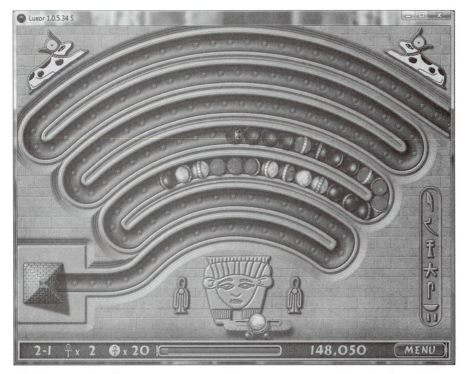

In *Luxor*, the player must fire balls into matches from the bottom of the screen. This adequately constrains your movements to keep the game challenging. (© MumboJumbo)

in *Luxor* that you can in *LEGO Fever*. However, *Luxor* constrains your movements to a greater degree. Instead of freely moving, you must shoot colored balls from a launcher at the bottom of the screen. You can only move the launcher back and forth horizontally. Your placement of balls is complicated by the steady movement of the string of balls along the track. You have no ability to rearrange balls on the track; you can only shoot new ones out. This makes building a huge, game-breaking chain much more difficult and rare. As a result, the game remains engaging longer. You may understand mathematically how to beat the system, but applying that knowledge is much harder. This leaves you in a struggle to find a way to implement your idea or strategy. The game tempts you with the possibility, but limits you with its constraints, keeping you just inches from your ultimate victory. Perverse as it sounds, this keeps players engaged. Once players feel they've entirely won, the game no longer presents a challenge and it loses much of its attractiveness.

After *LEGO Fever* launched, we spent some time working with the mode to see if there was a different game we could mine from the Clump mode by applying the proper constraint to the player's movement. We tried numerous different mechanisms to limit player moves. We tried fusing bricks together once they were

attached. This simply led to frustratingly large blocks of bricks to work with. Players would pick them up, but have nowhere to put them down.

We tried not allowing players to pick up bricks at all, only place them. This was okay, but the random growth and large variation in brick sizes led to a lot of noise and chaotic patterns. In the end, we weren't able to come up with a mechanic that worked better than the original Clump mode, so we left it alone. But I'm sure there is a good mechanical constraint out there. Like a good game, the right move feels tantalizingly close, but just out of reach.

Snood: Matching as Means to an End

Back in 1996, David Dobson unleashed *Snood* upon the world (Figure 4.7). Dobson, an associate professor of geology and earth sciences at Guilford College in North Carolina, originally started working on the game as a gift for his wife, a fan of puzzle games. Originally released as shareware, the game quickly spread across the Internet, becoming a phenomenon on college campuses. Many write the game off as a simple clone of Taito's arcade game *Puzzle Bobble* (Figure 4.8). And while the

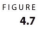

FIGURE
4.7

Snoods are laid out in rows across the top of the game area. The player shoots more Snoods from the bottom to try and form matches. (© Monkey Gods LLC)

games are indeed quite similar, there are a few key game mechanics differences in *Snood* which have contributed to its astounding popularity among casual gamers.

Snood offers an excellent example of a game that scales in difficulty to meet your growing ability. You can play the game in a simple, almost random fashion, quickly firing Snoods into matches. Or you can dig in and play the game in a deliberate, deeply strategic way. Providing this spectrum of challenge is no easy feat for a game designer. *Snood*'s incredible popularity with a range of players from casual to hardcore gamers attests to how well the game runs the gamut from easy to hard, enabling players to engage with the game at the level appropriate to their skill.

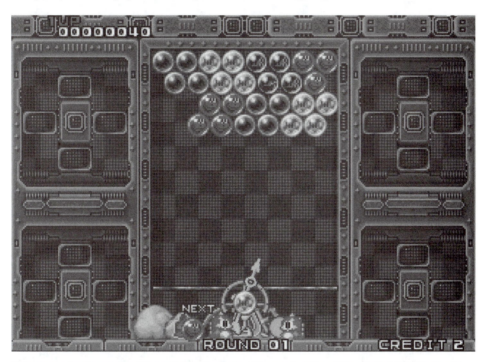

FIGURE
4.8

Many people charge that Snood simply clones the mechanics of *Puzzle Bobble*. The basic mechanics bear a striking resemblance, but a few key mechanical differences lead to different gameplay experiences. (© TAITO CORP. 1994, 2009)

At the beginning of the game, the game field is populated with a random assortment of Snoods hanging from the ceiling in eight rows (Figure 4.7). You control a cannon at the bottom of the screen which launches Snoods. You rotate the cannon by moving the mouse back and forth, and you fire Snoods with a left click. You can see the Snood you are about to shoot and the next Snood in the queue.

Snood allows you to play at your own pace. The game has no timer either on moves or a round of play. This helps keep the game casual. This is not to say the game lacks pressure. Instead of a timer, *Snood* uses a Danger Meter. Each time you fire a Snood, the Danger Meter creeps up a little. (See Figure 4.9.) Fill the Danger Meter and a row of bricks appears at the top of the screen pushing the remaining

FIGURE
4.9

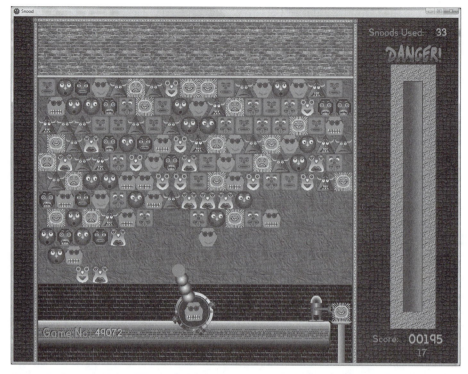

When the Danger Meter fills, a row of bricks appears at the top, pushing all of the Snoods down and reducing the game field. The Danger Meter then resets to zero to begin counting up again when you resume firing Snoods. (© Monkey Gods LLC)

rows of Snoods down. This shrinks your game field and brings you a step closer to losing the game. If any one of the Snoods crosses the bottom line, they all turn to skulls and the game is over. *Puzzle Bobble* offers a similar interaction scheme, but adds a timer to each shot. If you don't shoot before the timer runs out, the game automatically fires a bubble in whatever direction your cannon is facing. *Snood* by contrast will wait for you to fire for all eternity. But when you do the Danger Meter will step up a notch.

The Danger Meter paces the game and keeps a pressure on the player. If the game had neither the Danger Meter nor a timer, it would have no pressure driving the game forward. Instead would simply take all the time you needed to aim, fire and match all of the Snoods on the screen. There would be no way to lose and all of the pressure would leak out of the play experience. The only thing for you to strive for then would be to see how fast you could match all of the Snoods on screen. Without one of these two obvious pressures, *Snood* would feel more like an activity and less like a game.

The more obvious pressure mechanic to apply in *Snood* would have been a timer. This could have taken several forms. You could require the player complete the entire level in X amount of time. You could require the player to shoot every

X seconds as *Puzzle Bobble* does. Or you could require the player to produce a match every X seconds. Any one of these might have worked, but they would have radically altered the experience of playing *Snood*. Time pressure might be fun for some, especially hardcore game players used to games that require a twitch-like skill, but it would probably turn off casual game players unaccustomed to games applying immediate and constant pressure on the player.

And, in fact, later versions of *Snood* introduced a timed mode, which no doubt appealed to hardcore *Snood* players who had already learned the system and wanted new ways to challenge themselves.

The pressure *Snood* offers is much more clever, from a game design perspective. *Snood* gives you as much time as you need for your move, giving you time to think and plan. But it also offers the player a way to counter the pressure applied by the Danger Meter. If players can "release" Snoods, they can push the Danger Meter back down and give themselves more turns before the Danger Meter fills and the Snoods advance. But releasing Snoods is not easy and often puts the player in greater danger of losing (Figure 4.10). Players release Snoods by creating a match above

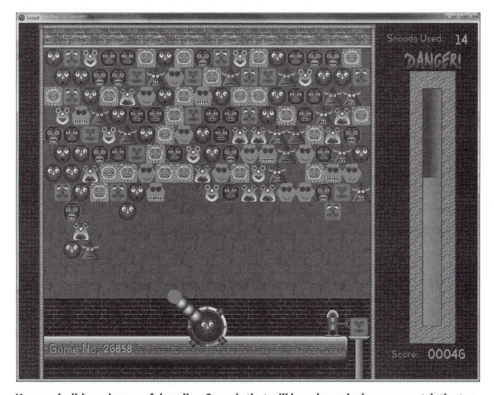

FIGURE
4.10

You can build up clumps of dangling Snoods that will be released when you match the top Snoods. You must be careful to leave enough room to hit the top clump when a matching Snood comes up. (© Monkey Gods LLC)

a set of Snoods. The Snoods that are dangling from the set that was just matched will be left unattached to any Snoods above and will fall off the screen. For each released Snood the Danger Meter is pushed back down. (See Figure 4.11.) Releasing Snoods keeps at bay the encroachment of the hanging Snoods that will cause you to lose to the game. Matching Snoods is the obvious way to play; but releasing Snoods is the strategic way to progress. At times the player is forced to do some of both, but balancing the tension between the two is what makes the game so addictive.

FIGURE
4.11

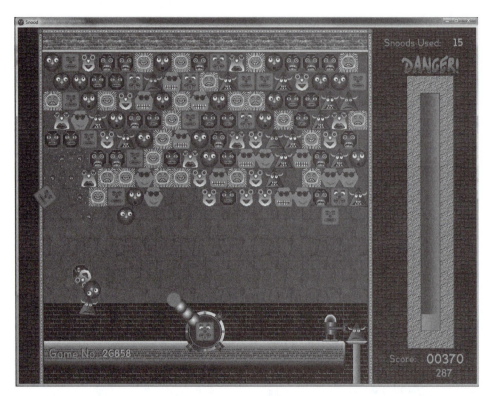

When Snoods are released, they fall off the screen and drive down the Danger Meter, giving you more time before the Snoods advance down a row. (© Monkey Gods LLC)

Instead of tightly constraining a player's actions, *Snood* presents players with a fairly free range of movement and one crucial choice: match Snoods or release Snoods. Matching is simple—just aim a Snood at a group of like-colored Snoods and fire. Matches of three or more Snoods score and disappear. Releasing Snoods is harder.

Plenty of games offer hard choices and strategic depth. What makes *Snood* so impressive is how smoothly these two are integrated into one tight, elegant system. The basic play leads straight into the advanced play. Often, the hardest part of game

design is advancing the difficulty of the game at a rate that suits all players. This is the core of level design. If the game gets difficult too quickly, you risk alienating less skilled players. Increase the difficulty too slowly and you risk boring experienced gamers. The experience of progressing through a game must be carefully crafted. A level structure enables game designers to step up complexity level by level. *Snood* does not have levels, only difficulty settings. So the progression must occur naturally within the game.

Snood handles the progression well by setting up a simple see-saw-like effect that is easy for the player to read and understand. The first time you shoot a Snood into the game field, the Danger Meter ticks up. At this early point it is not clear exactly what the Danger Meter is tracking. However, it becomes extremely clear the first time the Danger Meter tops out and the Snoods advance, leaving a swath of brick across the top of the game area. At this point the Danger Meter resets back to zero. As it begins to tick up again, you begin to understand that this cycle will repeat. At this point, the players have a rudimentary understanding of the pressure being applied to them by *Snood*.

When the players release their first Snood and the Danger Meter recedes, it clues them in to the deeper strategy of the game. It may take some time before the player releases a Snood. Setting up Snoods to be released takes some planning and foresight. But releasing them does happen naturally during the course of play. The astute player will notice the Danger Meter tick down and quickly experiment to find out the exact cause. Since *Snood* offers only the two vectors of matching and releasing, it does not require much experimentation to understand how to make the Danger Meter recede.

The simple UI aids the process of understanding. There are only two indicators of progress that the player must track during the course of play: the progressing Snoods and the Danger Meter. Placed right next to each other and standing almost equally tall, the progressing Snoods and the Danger meter provide visual see-saw. As the Snoods press down upon the player, the Danger meter ticks ever higher. In contrast, when Snoods are released, it clears up space in the bottom of the game field while the Danger Meter recedes downward leaving room to fill at the top (Figure 4.12). This visual dichotomy helps make the central tension of the game easy to understand. You are essentially balancing your play between two pressures, the advancing Snoods and the advancing Danger Meter. You can fight both down, but not always at the same time.

In the beginning, the Snoods are clustered at the top, and the Danger Meter is at the bottom. As you shoot Snoods into the game area, they move downward and the Danger Meter moves upward. This trade-off is reflected in the strategic choice presented to you: should you try to match as quickly as possible or build dangling sets to release? If you simply match Snoods, the Danger Meter will go up. If you build dangling clumps, the Snoods sit closer to the bottom, but they have a better chance of driving down the Danger Meter once released. The simple UI reflects this choice and helps players understand the game, leading them toward more advanced play.

FIGURE
4.12

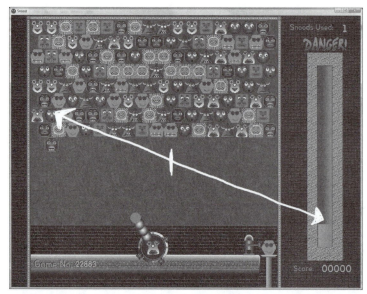

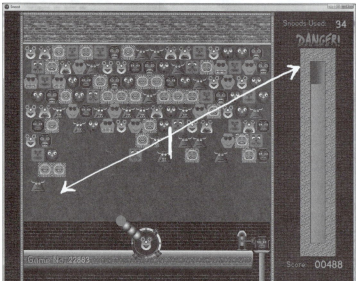

The entire game operates along an axis. This axis is reflected in both the mechanics and the interface of the game. (© Monkey Gods LLC)

Snood further complicates the player's choices by offsetting the grid of Snoods (Figure 4.13). In a matching game like *Bejeweled*, the gems stack perfectly on top of one another in tidy rows and columns. However, in *Snood*, the pieces are offset by half their width. This makes it more difficult to lay out clumps of dangling Snoods

to release. While it is clear to the player the Snoods are offset, it makes parsing the overall grid slightly harder work. Quite often you will fire off a Snood to have it land and snap into a slightly different position than first imagined. You compensate for the offset, but it requires more mental processing power, keeping you more engaged with the game.

FIGURE
4.13

Offsetting the Snoods by 50 percent makes you do more cognitive work and keeps you more engaged in the game. (© Monkey Gods LLC)

Snood provides an excellent example of how a few rule tweaks to a familiar game can produce a game that looks functionally the same as another, but actually engenders a very different experience. Often dismissed by more experienced gamers as a simple clone of *Puzzle Bobble*, the slight changes to the game mechanics produce a very different game. *Puzzle Bobble* offers no way to fight off the impending encroachment of bubbles. The player is simply left to clear the space as quickly as possible. This makes the experience of playing much more immediately hectic and pressure-filled and the long-term play much more skill and reflex based. It effectively asks the player, "How good can you get at quickly reading the patterns of bubbles and getting rid of them all?" *Snood,* on the other hand, removes the immediate pressure of time, but exerts deeper long-term pressure in terms of strategy. The great *Snood* player must learn to manage the twin pressures of the encroaching Snoods and the climbing Danger Meter to create a situation that generates maximum scores.

Summary

Matching games have long dominated casual gameplay, from *Bejeweled* to *Luxor* to *Snood*. This is largely because matching mechanics are so flexible that they can be folded into the mechanics of other games. Matching offers very clear goals and

feedback for each move. As in *Bejeweled,* you can have clearly delineated success and feedback with each move. *Snood* shows how—through spatial complexity—you can add layers of strategy to matching games. These qualities make matching an attractive mechanic to use when you need a mechanic with clear resolution on each turn.

In this vein, *Puzzle Quest* used the matching mechanics of *Bejeweled* to create an entirely new experience. In *Puzzle Quest* (Figure 4.14), the player fights monsters by playing a game very similar to *Bejeweled*. The game uses the *Bejeweled* matching mechanic to create a combat system. When you score a match, it does damage to the monster on the right of the screen. The monster similarly plays *Bejeweled* and deals you damage with matches. The game also layers in role-playing game leveling up mechanics to constantly expand the type of moves you can make in the *Bejeweled* game. This gives the player a feeling of natural progress within a game of *Bejeweled,* which, in its original incarnation, offered no real sense of progress. This may seem like a bald cloning of the *Bejeweled* mechanic, but the game feels entirely different. Game mechanics exist to be copied and modified and put to use in new ways.

FIGURE
4.14

Puzzle Quest uses the basic mechanic of Bejeweled as the combat system in a role-playing game. (Reproduced by permission of Steven Fawkner, CEO, Infinite Interactive)

The simplicity of matching mechanics offers this sort of flexibility. The popularity and innate fun of matching also ensure you are building from an excellent and accessible base.

CHAPTER FIVE

Sorting

Every minute of our lives we are bombarded with information. Our brain grapples with all of this data in an endless battle to parse it all into some meaningful form. Much of it we wind up ignoring. Some of it we chunk into larger symbols that are easier to read than the individual parts (like the way we know to stop as soon as we see a red octagon and white letters before we read the word Stop). And some of it we just have to read line by line, like the book you're holding. We order all of this information any number of ways, by relevance, by danger, by degree of sexual appeal. It's a process so natural that we scarcely realize we do it.

We're such experts at parsing information it's no wonder we enjoy games that explicitly involve sorting. They enable us to practice a natural skill; they challenge our ability; they even help make us better at reading the world. Sorting is another one of those natural activities that game designers have figured out how to mold into games. And these games have traditionally proven very popular.

Sorting manifests itself in a number of different ways. *Solitaire* and games of *Patience* focus on literal sorting of abstract symbols relevant only to the game. Despite using the same set of cards, each variation of *Solitaire* produces a different experience, from slow meditative ritual to hair-pulling anxiety. The popular iPhone game *Drop 7* gives you tiles numbered 1 through 7 to sequence and sort. It sounds incredibly simple, yet it's also quite addictive. The game shows how you can create an engaging, complex experience even when asking players to perform a relatively simple sort—counting from 1 to 7. Word games like *Scrabble*, *Bookworm* and *Wurdle* leverage a broader set of knowledge by having players build words from jumbles of letters. Games like *Jojo's Fashion Show* push the use of contextual knowledge even further making gameplay out of sorting clothes into nebulous style categories. And these are just a few of the ways sorting can be applied in games.

Sorting makes for natural casual gameplay because it doesn't require the player to develop a new skill. Rather it leverages mental skills the player already possesses. In sorting games you don't have to learn to aim a gun with a joystick; you don't have to learn to carefully time jumps in a platformer or play a plastic guitar. Rather, you do something you do every day. Read, parse and act upon information. In actuality, you do this in every game. Games are all about reading information from the game system and deciding how to act. But sorting games make this process explicit.

Quite often, they strip out twitch skills and give players a turn-based chance to read and act. The player simply has to learn and apply the sorting scheme the game demands.

Klondike Solitaire vs. *Spider Solitaire*: More Choices, More Complexity

Patience isn't just a virtue; it's a game.

Mary Whitmore Jones wrote in *Games of* Patience *for One or More Players, second series* in 1898, "In days gone by, before the world lived at the railway speed it is doing now, the game of *Patience* was looked upon with somewhat contemptuous toleration, as a harmless but dull amusement for idle ladies, and was ironically described as 'a roundabout method of sorting the cards'; but it has gradually won for itself a higher place. For now, when the work, and still more the worries, of life have so enormously increased and multiplied, the value of a pursuit interesting enough to absorb the attention without unduly exciting the brain, and so giving the mind a rest, and, as it were, a breathing-space wherein to recruit its faculties, is becoming more and more recognised and appreciated."

Sorting extends the pleasure of matching. It takes the pleasure of pure matching and adds the idea of distinguishing and sequencing. More cognitive thought goes into sorting. Each object becomes a symbol that you are reading and acting on. When you are matching objects, each object in the set has the same value or meaning. Think of *Bejeweled* again. When you make a match of three red gems in *Bejeweled* each piece has the same basic value: it is red. It does not matter what order they go in, only that they each share the same basic quality. In a game that involves sorting, the individual pieces have some meaning in relation to one another. On the most basic level you could be sorting a deck of cards so that all of the red cards are in one pile and all of the black ones in another. This is like matching, but the cards have a bit more of a relationship to one another: this card is red as opposed to black so it goes in the red pile. You could also sort the cards so each pile has alternating reds and blacks. Here we see more clearly that each card has a distinct meaning that applies to itself and also how it relates to the other pieces. The level of meaning involved scales up from there. In addition to sorting cards based on color, you could sequence them based on their numerical values. You can sort and sequence the cards in as many ways as the characteristics of the cards or pieces will allow. For the player, the challenge comes in how well you can read all of the symbols, process their meaning and apply the required sort to those pieces.

Playing cards have a plethora of highly legible symbols. This makes them great for games that involve sorting and sequencing. You could also make games that rely on pieces with less legible symbols. But as the symbols become less clearly legible, you will likely need to simplify the complexity of the sorting players must perform.

In *Solitaire,* the meaning on which you sort is intrinsic to the system. First, you sort cards into different piles based on alternating colors and descending numerical value. Then you re-sort them into another pile by suit and ascending numerical

value. All of the information you need to play exists on the cards and is easily readable and digestible. You have two colors, four suits and 13 values to track.[1] The challenge in the game comes from managing all of that information and figuring out how to sequence the objects.

Playing *Solitaire* (or *Patience*, as it's also known) with cards is as much about the act of laying out the cards as it is sorting them into proper piles. It is a game suffused with ritual. The game even served as a guide to your personal luck meter in Scandinavian and Germanic tradition. If you kept losing, that was a good indication that luck was against you. Individuals would play as a way to slowly and meditatively pass time, shuffling, dealing out seven stacks and then sorting them. Since dealing out the cards requires significant effort, you put all the thought you can into each hand (Figure 5.1).

The version of *Solitaire* included with every copy of Windows since 1990 has made dealing out a deck of cards and actually playing *Solitaire* absolutely prehistoric. I imagine that if you are holding this book in your hands right now you could probably play *Windows Solitaire* without giving a second thought to the rules. But if you were forced to deal out a game of *Klondike Solitaire* yourself, you might have to pause and ask yourself, "How many stacks of cards do I lay out?" and other small but important questions about the rules. *Windows Solitaire* takes care of all the set-up for us and manages the flipping of cards. The computer has taken over processing the tedious parts of the game so that we focus all of our energy on the key mechanics of sorting embedded in the gameplay.

FIGURE
5.1

Windows Solitaire feels like a short fast-paced almost frenetic game, when compared with slow meditative gameplay you get when you deal the cards out by hand.

[1]Okay, numbers are clearly a system of symbols which exist outside of cards. But you could replace the numbers with other symbols, just as the jack replaces 11, the queen 12 and the king 13, as long as everyone knew what the symbols signified. There is nothing 11-ish about a jack. But everyone agrees that (in the case of playing cards) it comes after the 10, so it works to serve as the 11.

Windows Solitaire obliterates the slow meditative tone of the card game and replaces it with a fast-paced intense focus on actual sorting. It's much easier to give up on a hand if you glean from the first several moves that it won't go well. You just re-deal and see how luck fares you the next go-round. If you're used to playing *Windows Solitaire* you probably get very frustrated playing card-based *Klondike Solitaire*. But you are also missing out on a specific quality of the experience that comes from laying out cards.

Despite what game designers might wish, games don't begin and end with actual play. Set-up and the world around the play can be equally important parts of the game. As game designers, we like to think of our games as tight formal systems that exist unto themselves. The rules are the same anywhere you play; so the gameplay experience should be the same. But as anyone who has been to Coors Field in Denver to watch a Rockies' baseball game can tell you: context matters. The dry, thin air resulting from the mile-high elevation of Denver enables baseballs to fly much farther than they would at sea level. Hence Coors Field holds the record for most home runs in a season, eclipsing the closest stadium by 55 home runs—this despite the architects designing an outfield substantially larger than the average stadium. To compensate for the unusual "context" of playing baseball in Denver, The Rockies installed a large humidor where they store baseballs to keep them moist and heavy for games.

The context around a game greatly impacts play. This becomes clear when you sit down to play *Klondike Solitaire* with cards versus playing it on the computer. Because you can so easily deal and start a new game on the computer, the gameplay becomes much faster. Playing with *Windows Solitaire* you can fit exponentially more games into 20 minutes than you could if you were dealing the cards out by hand. So as you repeat and repeat the game, the central mechanic becomes more and more familiar, lodging itself inside your head.

The basic sorting mechanic of *Solitaire* games are incredibly flexible. It is little wonder that people have found so many ways to re-apply the basic mechanic of *Solitaire*. In *Games of Patience for One or More Players, second series,* author Mary Whitmore Jones describes more than 30 different games of *Patience*. And that was written way back in 1898. More have since been invented. At their core, games of *Solitaire* are simply about laying out a specific configuration of the cards in the deck and then attempting to sort them using a particular scheme. *Solitaire* games were of course already common before Microsoft began packaging every Windows PC with *Klondike Solitaire, Spider Solitaire* and *Freecell.* But by introducing the *Klondike* version, *Windows Solitaire* kicked off the casual video game trend, giving everyone with a PC a game they understood and could play. *Spider Solitaire* gave the dedicated *Windows Solitaire* player a more difficult game to graduate to.

These games are not unique to the computer and we can examine their game mechanics with a deck of cards. *Klondike Solitaire* and *Spider Solitaire* clearly share a family resemblance. They each offer a variation on the same challenge and use similar sorting schemes. If you are familiar with sorting patterns in *Klondike Solitaire*, it will only take you a minute to pick up *Spider Solitaire*. Yet each feels like a unique

game and plays very differently. Both use a sorting scheme that requires players to order the cards from highest to lowest. Your goal in each game is to create stacks of the same suit that proceed from the king down to the ace. Both obscure many of the cards from the player in stacks of face-down cards topped by a face-up card.

Spider Solitaire (Figure 5.2) requires two decks of cards shuffled together. The goal of the game is to remove all cards from the tableau (or playing area). You deal out 54 cards face down in 10 piles. The card on top of each pile is flipped face up. The remaining 50 cards go into a pile to be dealt out to the piles when no moves are possible. From this starting position you try to clear the board by creating groups of the same suit descending from king to ace. Once you have such a group, you can remove those cards from the tableau. So you begin to sort the cards into groupings of high to low, moving them about the tableau. When you get stuck, you can deal more cards onto the pile, giving you new possibilities and moves. The game ends when you have either cleared all of the cards or have no further moves to make.

FIGURE
5.2

At the beginning of a *Spider Solitaire* hand, the board is quite legible. With 10 stacks instead of *Klondike*'s seven there's a bit more to take in.

Thanks to a few key rule tweaks, *Spider Solitaire* is more difficult to win than *Klondike Solitaire*. Interestingly, these rules that tweak the way cards are sorted actually give you, the player of *Spider Solitaire*, more flexibility in moves than *Klondike Solitaire* allows. In the beginning of a *Spider Solitaire* game, you sort all of the cards available (that is, face up on each pile). The smart player will pay attention to suit and begin to group like cards to enable future movement. But in a pinch you can simply sort by order, ignoring suit. Ignoring suit allows you to make more moves and constantly shift cards around, moving parts of stacks around the tableau and placing them in more advantageous positions.

At first all of this is relatively easy to parse—cards are progressing from high to low. When you run out of moves, you can deal out 10 new cards, but this is where the trouble begins. You have to place the 10 new cards onto the bottom of each stack. Now the sequences of high to low you created are interrupted at the end by a random card. You resume sorting the cards, building new chains of high to low on top of the old chains. Your moves begin to accumulate on top of themselves. The residue of your own play adds to the complexity of the game. As you move cards around the tableau into different stacks, some of the same suit, some not; some fully ordered, some only partially so, the game area becomes increasingly hard to read and parse (Figure 5.3). The further you progress, the more cards you have turned face up. Just absorbing all of the cards set before you takes longer and longer. Reading the tableau is complicated by the pockets of organization and disorganization within the tableau. This leads to a slow grinding down of the gameplay experience. The game becomes slower and more deliberative the longer you play. It also becomes more frustrating as you are left struggling against the moves you made before and the random cards laid out on top of them. You are eventually locked in by your moves. Your freedom to move cards as you like can eventually lead to disorganization and a locking up of the board.

FIGURE
5.3

To understand if a stack is properly ordered, the player must look at the number and suit of every card in the stack. This makes quickly reading the tableau almost impossible.

Klondike Solitaire, on the other hand, tends to move faster and faster as you progress within a game. This is because the sorting mechanic in *Klondike Solitaire* demands the cards be more ordered than the cards in *Spider Solitaire*. When you glance at the stacks of face-up cards in *Klondike Solitaire*, you know that each sequence of cards is progressing from highest to lowest, because the rules

of *Klondike* do not include layering new cards onto each stack of the tableau (Figure 5.4). This enables you to chunk them in your brain. If there is a big stack of face-up cards, you can safely assume they are in order. You needn't worry so much about the cards in the middle because they are ordered; you only worry about the first and last card. The stack of 10 cards becomes one chunk of information in your brain, "ordered cards." You can then pay greater attention to the cards that aren't in large groups and spend more effort parsing them instead. Sure there are moments when you must pause and consider the game board, and your next move, but in general your play proceeds more quickly.

FIGURE
5.4

Compared to *Spider Solitaire*, reading a *Klondike* game midway through is much easier because the game demands a stack be ordered precisely.

The speed of *Klondike* comes despite the fact that *Klondike* puts greater limitations on your movements than *Spider Solitaire*. Shouldn't the game go faster if I can move cards wherever I want? No. Again we return to the lesson offered in Chapter 4 by *LEGO Fever* and *Luxor*: constraints are good. Constraints can help players. They limit your choices and can point you towards your goal. But isn't choice supposed to be good? Isn't that where we develop strategies? Yes. But it's a fine balancing act. You want to provide interesting, meaningful and directed choices to players, not simply an open field. Too many choices and the player's movement through the game will grind to a halt in analysis paralysis. Sometimes more choices can just be more rope with which to hang yourself. Sometime around the middle of every game of *Spider Solitaire* I experience a moment of great indecision. I start wondering, "What if I just put this card here, or wait, no here, or wait that won't work, maybe it needs to go here…" This goes on for a bit as I move the cards (and hit CTRL-Z to undo a move, if I'm playing on the computer). Then finally I get on with it.

Now this indecision and analysis isn't bad. In fact, that's where much of the joy of *Spider Solitaire* stems from: parsing and solving a complex sorting problem. But it does engender a very different experience from the simpler *Klondike Solitaire*. When you're building your game, you need to be attuned to what sort of experience you want the player to have. Do you want a very light, fast casual game? Then limit the information you are asking the players to digest. Streamline some of the choices they need to make. *Klondike Solitaire* does this by letting the players chunk information into groups so they can more easily read the tableau. The game also limits the players' choices about how they can sort cards and directs them toward making piles that will win the game. You sort cards into piles from king down. To win the games you stack the cards from ace up to king in four piles. Having already made the stacks in the opposite order from king to ace on the tableau stacks makes the final step of placing them on the foundation piles clear and easy. These mechanics can make it feel you're playing *Klondike Solitaire* on auto-pilot. There is a point about halfway through each hand when it becomes clear that you will win the game. You have uncovered the necessary aces and have set up a few stacks starting with kings. Once you get over that hump, it's all downhill—the game practically plays itself from that point. This makes the experience of playing *Klondike* quite casual and fast. Winning a *Klondike Solitaire* hand is satisfying, but hardly thrilling.

Spider Solitaire, on the other hand, takes much longer to play and the further you go in the game, the harder it gets. You are presented with more and more information and—unlike *Klondike,* where all of the stacks you created make your final winning move easier—the stacks you've created in *Spider* may have a modicum of order, but they will make rearranging to a winning state hard. The experience is much more intense and taxing. Winning a *Spider Solitaire* hand gives way to a moment of great elation as the tension of the game built up by slogging through the difficulty of the system releases.

Neither is better, just different. As a game designer, it's your responsibility to consider what type of experience you are creating. There is a reason *Klondike Solitaire* is one of the most popular video games in the known universe. And while many people certainly play *Spider Solitaire,* it can't claim the same ubiquity. It's just more complex and difficult to play and win. *Klondike Solitaire* is easier to pick up and play while talking on the phone; it's easier to play in a few minutes between tasks. It does not require the same level of cognitive attention. But I'd wager that as *Klondike Solitaire* players master the game, they start craving a harder challenge and move on to *Spider Solitaire*. As a result, *Spider Solitaire*'s player base is probably comprised largely of more dedicated *Solitaire* players happy to dive headfirst into the tangled web of cards it produces. Backing up this theory, Microsoft's usability research team found in a 2005 study that *Spider Solitaire* finally passed *Windows Solitaire* (the *Klondike* version) as the most played game on Windows PCs.[2] After 16 years all of those casual *Windows Solitaire* players were finally ready for the greater freedom and complexity of *Spider Solitaire*.

[2]http://blogs.msdn.com/oldnewthing/archive/2005/09/05/461035.aspx

Drop 7: Foiled by Randomness

The iPhone game *Drop 7* made by the New York-based developers Area/Code is a wonderful little sorting game. It shows how much you can do with a simple mechanic and a straightforward sorting scheme. It also shows how puzzle games like this can begin to collapse under the weight of a little bit of randomness and the sheer volume of your accumulated moves.

Drop 7 (Figure 5.5) is touted as a mixture of *Sudoku* and *Tetris*. And there is certainly some merit to this claim. When the game loads, the player is confronted by a seven-by-seven grid. Into this grid, the player drops numbered discs. In each turn, the player is given a random disc with a value ranging from one to seven. If a disc lands in a horizontal row or a vertical stack equal to the number on the disc being dropped, the matching disc scores and disappears. So if you drop a disc numbered four on top of a vertical stack of three other discs, the four disc will score and disappear. That's the core mechanic of the game. Take as long as you need to figure out where to drop the disc. The game ends if any one of your seven stacks grows taller than seven discs.

It seems simple enough. After all, counting to seven isn't terribly hard. However, two small mechanics complicate the gameplay and keep it from devolving to a pure puzzle like a *Sudoku* board. First some discs are grey and don't have a number. You can't score grey discs. You have to reveal what number is hiding under the grey disc. To do this you have to make at least two scores on top of or next to the grey disc. If you have a stack of three discs, with a grey disc at the top, you can drop a four on top. The four will score and a dotted border will appear around the grey disc indicating you only need to drop one more four on top to reveal the number underneath. One you have revealed the hidden number, the disc can be scored.

The game also applies pressure through a second mechanic. After every X number of dropped discs (represented by those dots at the bottom of the screen) all of the discs are pushed up and a row of grey discs appears at the bottom. The number of moves you have between this new grey row appearing decreases as the game advances. These discs must be revealed before they can score and disappear.

These two grey disc mechanics add randomness and hidden information to the game. With more perfect knowledge, you could easily sort the discs in a manner that would enable you to play forever. But the combination of these two mechanics adds enough randomness to the game to eventually cause you to lose. It may take a while to lose on the normal mode, but eventually you will. My wife played for 10 minutes and was convinced she would never lose. I assured her that wasn't the case; that eventually discs would build up and she would lose. I knew from experience, having been addicted to the game for several weeks.

The straightforward sorting of *Drop 7* mixed with the hidden information and randomness of grey discs gives players a lot to sink their teeth into when playing. As with any game the longer you play it, the more you develop an innate understanding of the system and the better you get at scoring points and surviving *Drop 7*.

But randomness eventually brings an end to your game. More specifically it's the ones that kill you. As grey discs appear and break you are awarded random numbers,

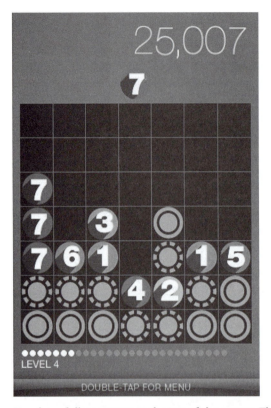

Numbered discs appear at the top of the screen. The player taps on the column where he wants to drop the disc. On this screen, if the player drops the seven disc in that center column, it will score fill the third row with seven discs. So the seven the player drops and the seven disc on the far left will both score and disappear. (© Area/Code 2009)

some of which are ones. Eventually a layer of ones builds up on top of your stack of discs. Once the stack is more than one disc high and multiple ones appear right next to each other it is very hard to get rid of them. They can't be scored vertically or horizontally. Through smart gameplay you can manage this, but the random distribution of ones can sometimes screw you, leaving you with an impregnable layer of ones. These ones will then slowly advance upward until they cost you the game (Figure 5.6).

This death by randomness is not a feature unique to *Drop 7*, but rather an issue that's common to many matching and sorting puzzle games. Your moves build on each other slowly over time. This is similar to the disarray you can find in a *Spider Solitaire* tableau midway through the game. Your game board begins to reflect all the good and bad decisions you made throughout the game. Well, more likely, it reflects the bad moves because the good ones score and disappear. As you gain skill

FIGURE
5.6

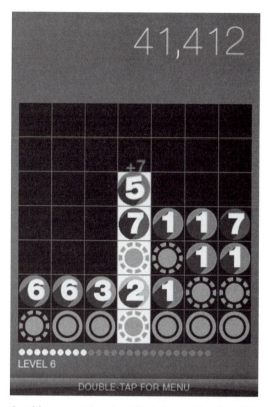

On this screen the player has dropped a five disc on a stack of four. The five disc scores, earning the player seven points. You can also see one discs beginning to build up. Eventually, they will be the undoing of the player. (© Area/Code 2009)

in *Drop 7*, you manage your own moves better, making smarter choices. However, if you have perfect information and control, the game begins to feel static and lifeless. Randomness serves to inject life and even a bit of "magic" into a game. A good random drop can seem like the fates swooping in to save your game or like the hand of god personally smacking you down. In his treatise *Man, Play and Games*, Caillois describes winning games of chance this way: "more properly, destiny is the sole artisan of victory, and where there is rivalry, what is meant is that the winner has been more favored by fortune than the loser."[3]

Without randomness, single-player games inch closer to puzzles. In puzzles there is always a proper path. You just have to find it. Once you've found that solution, you can't really enjoy the puzzle again until you forget the solution. So designers mix in random elements to add challenge and replayability, which brings a game

[3]Caillois, Roger, *Man, Play and Games*, University Press of Illinois, 2001, p. 17

to life. But designers need to remember that this randomness can be a blessing and curse for the player. A player can only do so much to counteract the random pieces dropped in his or her lap. Randomness disrupts the player's perfect pattern. Nowhere is this more evident than in sorting games. No one is surprised when they roll a seven in craps. It's expected. The game is nothing but randomness. And we all know that seven is the most likely number to roll with two dice. But sorting games are about order. So when a random number drops in and throws off the pattern, it can feel especially punishing to players. It ruins the order the player worked so hard to create. Worse yet it can feel unfair. And you want to avoid at all costs your game feeling unfair. Nothing turns a player off faster than feeling cheated.

But that's how randomness works. It's a double-edged sword. No one complains when the dice are with them. And it's never the player's fault when they aren't. Game designers should remember this. Make sure the dice take the blame and not the game system.

Wurdle vs. *Bookworm*: The Replacements

If *Solitaire* relies on a system of knowledge largely intrinsic to the system, word games present a great example of games that rely on a system of information extrinsic to the game system. They borrow the dictionary for a language and use that as the sorting system for the game. Players sort letters into groups which are only valid if they also happen to be a recognized word in the chosen language. Word games don't tend to be interested in the meaning of the words, only the order and perhaps scarcity of the letters.

The iPhone games *Wurdle* and *Bookworm* highlight the way a few key game mechanic changes can lead to very different gameplay experiences. In both games, players trace their fingers from tile to tile in order to link a series of letters into words. After producing a word, the player is awarded points. The goal is simply to see how many points you can score before the game ends. The end conditions, however, differ. In *Wurdle,* the player has a set amount of time to score as many words as possible, giving the game a frantic feel. *Bookworm*'s main Classic Mode, on the other hand, gives players as much time as needed to make a word, pressuring the player instead with Fire Tiles that eventually destroy the board. However, the key difference between the two is really that *Bookworm* replaces letters after you score them while *Wurdle* does not. This change gives rise to much of the major experiential differences between the games. It's what makes *Wurdle* a more casual experience despite a more frantic feel and what pushes *Bookworm* towards a more analytic hardcore play.

Bookworm for the iPhone is a port of PopCap's popular casual downloadable game of the same name. The port to the iPhone carries over much of the same look and feel of the original PC title. The game uses very similar game mechanics. Players touch the letter they want to start with and then run their fingers from tile to tile connecting the letters (Figure 5.7). This control scheme works very well

despite the slightly undersized feeling of the letter tiles. Once you are satisfied with the word you've created you hit Submit and score the word. As you string together letters and build words, the game constantly checks to see if the word is valid. The larger the word, the more points you score. When the word scores, the tiles disappear and new tiles drop in from the top of the screen. In this manner, the board is constantly replenished with new letters to use.

FIGURE
5.7

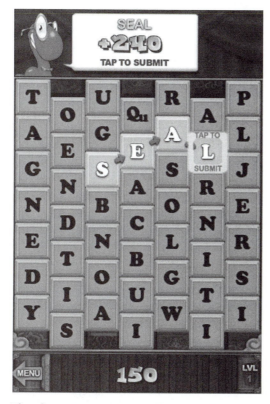

The players trace out a word by connecting letters. Once they have formed a word they are happy with they submit it. Each column of letters is offset, making it more difficult to parse possibilities at a glance than a straight grid would. (Reproduced by permission of PopCap Games)

Having already gone through multiple iterations of development on the PC, *Bookworm* is a very polished experience. The game includes numerous achievements and lists rewarding you for collecting the names of fruits or animal types. The animations and art are very well done and feel entirely of a piece, giving the game a robust feel. *Wurdle*, on the other hand, feels much more sleight and off the cuff. Much of the game mechanic is borrowed directly from the board game *Boggle*. Developed by the Austin indie game studio Semi Secret Software, the game is comprised

almost entirely of orange letter tiles on a crinkled lined paper background (Figure 5.8). The gameplay also feels quick and focused. *Wurdle* focuses solely on the linking of strings of letters into words. There are no long lists of achievements in *Wurdle* or cute animations, only high scores and a list of words you created.

FIGURE
5.8

***Wurdle* players drag across tiles to connect them into words, as in *Bookworm*. (Reproduced by permission of Adam "Atomic" Saltsman and Eric Johnson, Semi Secret Software)**

When the game starts, the player is confronted with a grid of letters. The standard board is five letters by five letters. As in *Bookworm*, you touch a letter to start with and then drag your finger over other letters to include in the word. The bigger letter tiles in the five-by-five grid enable the player to quickly draw and link together letters. In an example of excellent experience design, each letter added to the word is accompanied by a satisfying "boop" sound effect. You can connect letters vertically, horizontally and even diagonally, allowing for a very large, yet understandable possibility space. Your eyes can take in the entire board, staying one letter ahead of your finger as you quickly swipe together strings of letter tiles. When you lift your finger, the word automatically scores, assuming it's a valid word. As you swipe, *Wurdle* also provides a small sound effect indicating that you've hit upon a valid

word. If your eyes settle on S-E-E-M, as you trace a sound effect plays when your finger has traced out S-E-E, letting you know you can come back on the next move and claim that word too. You can do this because after a word scores the letters do not change (Figure 5.9).

FIGURE
5.9

Wurdle **tiles do not change after each word is selected. After grabbing S-E-E-M, the player can go back and grab S-E-E and S-E-A-M, and other iterations of the same letters. (Reproduced by permission of Adam "Atomic" Saltsman and Eric Johnson, Semi Secret Software)**

Because the letter tiles in *Wurdle* are not destroyed and replaced after you use them, the play focuses on quickly iterating through every possible variation of word or set of letters. So you quickly connect T-A-R. Then reverse and grab A-R-T. Then for the next word you quickly grab T-A-R-S. And if you're lucky enough to have another T within striking distance you then grab T-A-R-T; T-A-R-T-S; A-R-T-S and S-T-A-R-T. From start to finish of a game of *Wurdle*, the player is working through the same set of letter tiles. On starting the next game the tiles shuffle and a new grid of letters appears to work through.

The concept of replacement is a key issue in games and one game designers must pay careful attention to when crafting their games. It comes up not just in word games, but card games and any other game with limited resources. The issue of replacement is most evident in card games. Think of how important it is for the balance of a poker game that new cards are not inserted into the deck to replace cards that have been dealt out. If a deck of cards operated with replacement and a new card was added in for each one taken out, it would be possible to end up with five of a kind comprised of a 3 of Spades, a 3 of Clubs, a 3 of Hearts and two 3 of Diamonds or some other such monstrosity. Card games rely on there being only one of each card in play at any given time. A card game goes through an arc from randomness to increased knowability as cards are played and removed from the deck. This enables players to eventually make more informed guesses as to what's coming up. Replacement comes up all the time in video games too. *Wurdle* and *Bookworm* provide a very clear example.

Each game of *Wurdle* is a frenetic race through all of the possible variations available in the grid of letters. You can set the length of your game from between one to five minutes. Then you simply race the clock to score as many points as possible. Your incentive lies primarily in besting your own high score. As you play, you begin to recognize common word patterns in the jumble of letters. Because vowels are more limited and must be sprinkled in among the consonants at a higher rate, patterns emerge. Using vowels as bases for words, you find that you're constantly tracing out the same words in different games. You see a vowel then look for familiar consonants on either side. From A, you look all around and find the familiar T and N. You connect them to make T-A-N, then quickly A-N-T. You automatically group those common letter combinations into words and keep them close to the surface of your brain for quick access in each game. You hardly need to look for these common patterns. When you find one you quickly cycle through all of the variations. This enables you to parse the board more quickly. While your subconscious finds these combinations, your brain can actively look for larger, more unusual words and letter combos. Your fingers seem to find word combos using muscle memory. The faster you can move your fingers, the more you will score. High-level play pushes toward a game of twitch skill. Yet it remains casual feeling despite this rather hardcore finger skill element.

Bookworm, on the other hand, plays much more slowly. Because letters are destroyed and replaced after you use them, the board constantly changes. The players must then constantly reevaluate their moves. This makes the game much more

analytical. A Classic Mode game of *Bookworm* can stretch on for hours. The longer the game goes on, the scarcer vowels become in certain regions, making play more difficult. As in other matching games the player uses up the most adaptable pieces. In the case of *Bookworm*, the player uses more of the vowels, because they form the connective tissue of most words. (This is similar to the way areas of a *Bejeweled* board get harder to play as all of the matches get used up.) Fire Tiles add to the increasing pressure. Fire Tiles drop into the gameboard with increasing frequency as the game progresses and destroy tiles and letters the player might be saving, adding yet another element to the game which modifies the game area pieces (Figure 5.10). From an experiential standpoint, the longer you play a particular round of the game, the more invested you become. You want to prolong your game through any means possible. This forces the player to really consider each move. All this leads the gameplay to grind into a hardcore battle for survival.

FIGURE
5.10

The red Fire Tiles appear at the top of the screen and begin to burn their way through other letters until the player removes them by including them in a word. If a Fire Tile reaches the bottom, the game ends. This mechanic places intermittent pressure on players and forces them to change their plans. (Reproduced by permission of PopCap Games)

In a nutshell, *Bookworm* progresses and *Wurdle* does not. In *Bookworm* the game board constantly changes as new letters drop in to replace scored letters. *Bookworm* is like a long hike up a mountain with ever-changing scenery. *Wurdle* feels like a

foxtrot around the same small dance floor, repeating well-worn steps. From a similar starting point, a few game mechanic differences spin the two games in entirely different directions.

This highlights how careful and deliberate game designers must be with their chosen mechanics. They must remember they are crafting experience and every rule counts. Any one rule has the potential to entirely redefine the experience, as simply replacing letters does in a word game.

Jojo's Fashion Show: Sorting the World Through Play

Games have an amazing ability to install themselves in our brains and take over parts of our thoughts. When I intensely play a game for a while, I often find that even after putting the game down, it keeps running in my mind. I don't actually remember the first time I played *Doom*. But I do remember trying to go to sleep the first night after I played *Doom*. I couldn't. Not because my dreams were full of aliens out for my blood. No, it was because every time I shut my eyes to try and sleep my mind's eye filled with the walls and the distinctive gliding movement of a first-person shooter. I was endlessly gliding forward and backward down hallways and around corners. My brain couldn't stop playing the game.

This same mental replaying happens with other games too. When I play *Tetris* I find that I'm still rotating blocks in my head hours later. Sometimes other shapes, like sofas and tables, take on the likeness of *Tetris* pieces in my mind's eye and I find myself staring at them wondering how I could tightly pack them into a corner. It's as if games are software we install in our brains. We turn on the system by learning the rules. And then sometimes it just keeps running in the background even after we've stopped playing. Moving through the mechanics of a game is a process, one that you do over and over again within a game. As you play more and more, this process becomes more and more innate to the point where you no longer have to think about it to perform the process. The process becomes absorbed into our larger mental operating system for life.

This sort of residual running processing is one of the distinctive ways in which games stick with us; the way they share meaning within our lives. Perhaps the absorption and mental reapplication of a game mechanic or process is the game equivalent of a rich character from a novel cropping up in our thoughts months after finishing the book. Playing the game in your head is the game version of finding yourself wondering what ever became of Holden Caufield or Ivan Denisovich.

The game designer and scholar Ian Bogost argues that games create meaning procedurally. Designers pick a subject or system and then create a set of rules that mimics the subject system. The original system the designer models could be anything from driving to city planning to airport security, as Ian did in *Airport Insecurity*. Of course, everyone will interpret the original subject system differently and each designer will choose different aspects of the system to highlight or model in their game. You may have grown up racing cars and so you love the feel of the open road

and the power of a V-8 engine. A game you make about driving will likely reflect this love. If my formative experience with a car was with a gas-guzzling jalopy that seemed to suck dollars out of my wallet to keep the tank full, I will likely make a very different game. Your game version of driving a car may focus on racing around a wide open track, while mine might focus on carefully managing a gas budget so you can reach your destination. It is through this process of modeling another system and building rules to model it that the game designer embeds meaning in a game.

Then players dive into the game that the designers created, learning the rules and interacting with them. Through play we come to understand the game designer's model of the subject system and thus their interpretation of that aspect of the world. Then, when we encounter those subject systems in the real world again, we can see them through a new lens. We have access to a new interpretive model of the system. So if I play your racing game, I may come to better understand the attraction of speed, while my gas tank simulator may cause you to think about the frustration of managing resources. The mapping need not be so literal. I may bring that new-found desire for speed to riding bikes and you may use your new awareness of resource management buying groceries. That's the great thing about procedural systems like games: they become flexible through their abstraction.

This interplay between the systems of the world and the systems of games is very powerful. An abstract game like *Tetris* makes us think about shapes. A game with largely intrinsic meaning like *Solitaire* may highlight ways items are sorted. As a game designer, it can be very interesting to look for systems where you can create more direct interplay between the world and the game—where the meaning in the game is extrinsic, drawing on meaning commonly found in the world around us. If the game keeps running in your head even after playing, encountering similar items and systems in the world can reinforce the power of the game. The world and the game begin to amplify one another.

As we saw with *Solitaire*, many games rely on systems of intrinsic information. Word games leverage an outside body of knowledge to provide the data set for the game. *Jojo's Fashion Show*, a casual PC downloadable about fashion, relies almost completely on extrinsic information. The choices you make depend not on numbers or colors, but your understanding of fashion. You don't look for garments labeled "three"; you look for garments that are elegant. The actual sorting and ordering you have to do in *Jojo's* is much simpler than the sorting in *Solitaire*. But the process of parsing and understanding that information is more complex.

Jojo's Fashion Show was one of the games I designed while working at the casual game developer Gamelab. iWin published the game. When we originally started working on the project we intended to make a *Diner Dash*-like time management game about fashion. The game was set in a small boutique and the player brought clothes to customers based on their requests. The game combined a time management mechanic where the player struggled to manage the happiness of several customers with a matching mechanic that required the player to bring customers clothes they requested. If the customer asked for yellow items, the player brought them yellow shirts, skirts and shoes.

However, in the process of development we realized the game we were making wasn't really about fashion. It was about working at a retail clothing store. The players didn't need to understand or particularly care about fashion to play. Instead, they simply matched colors and patterns—information as intrinsic to the game as hearts and clubs are to *Solitaire*. To really be about fashion, the game had to be about your understanding of style. And style and fashion are informed by what you see in the world around you and then processed through your personal sense of taste. They are largely personal and unfortunately very subjective. That makes fashion very hard to score. You can't very well tell a player in *Bejeweled*, "You know, I don't really think those three yellow gems go together as well as those other three yellow gems would. You get zero points!" And unlike figure skating, for example, which can rely on human judges and their interpretation of a skater's artistic prowess, video games rely on absolute values. Software is good at knowing if you did something, not if you did it with flair.

This made the idea of creating a game about the subjective nature of fashion a challenge. Instead of being able to score you on a clear right or wrong answer, we wanted to score you on how well you interpreted a particular style. We also wanted to give the players some leeway to feel creative and choose something they really liked rather than just the one outfit we deemed best. We knew we couldn't accomplish this in a time management game paired with color matching, so we set out to find a different way to sort items and score the game.

What we wound up with was a paper-dolling game with scoring. The primary interaction in the game is reading what style to dress a model in and then finding and placing clothes on her that match that style. After you are satisfied with the outfit you created, you send the model out on the runway where she is scored (Figure 5.11). So, for example, the game might ask you to dress a model in a western style. You would look at all of the clothes on the rack and pick out the items you feel best capture a western feel. Some items might be obvious, like cowboy boots. Others might be a little more subtle, like a brown leather jacket with a bit of fringe. Other items might be rather generic, but still give you a western feel, like a pair of boot cut denim jeans.

We realized that no item of clothing fits solely into one style or another. Instead, styles cross-pollinate and borrow features from each other. A pair of jeans could be western in one context, but when paired with a cowl-neck sweater they would make great autumnal wear. Items of clothing are the composite of many smaller attributes. We take in all of those attributes and "read" them together to determine the style.

Just scanning the items in Figure 5.12, you probably have a good idea of which items feel more western to you. This feeling is based on commonly held cultural associations and knowledge of the idea of westerns. You've probably seen some cowboy movies or pictures of country singers like Alan Jackson and Willie Nelson that you associate with cowboys. From this cultural soup, a general consensus about western emerges. Some things seem particularly western—like cowboy boots. Other items have elements that could be viewed as kind of western—like denim. We just needed a system to capture that general notion and feeling. At the same

FIGURE
5.11

The player chooses items from the clothing rack and dresses them in clothes they feel match the styles shown above the models' heads. The player must send out a new model roughly every 30 seconds. (© iWin, Inc.)

time, we wanted this system to be flexible enough to allow players to pick out items that might not appear western, but still shared common attributes. We believed this would make a player feel clever. Like they had made a particularly smart outfit.

To create this system, we developed a scoring framework that gave each clothing item a series of attributes. These attributes were then referenced against style categories that were defined by a list of those same attributes.

Each item of clothing has a set of attributes attached to it that describe the item. For example, the blouse in Figure 5.13 has the following attributes:

- Blouse
- Low cut
- Sleeveless
- Complex shape
- Slim

FIGURE
5.12

Quickly scanning these items you can probably tell which ones feel more western than the others. That feeling stems from all of the cowboy movies and country songs you've come across. (© iWin, Inc.)

- Lightweight
- Red
- Solid
- Ruffles
- Trim

FIGURE
5.13

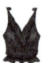

This simple blouse from *Jojo's* had a corresponding entry in the game configuration files which extensively described all of its characteristics. (© iWin, Inc.)

The game contained a list of roughly 30 style categories. These categories ranged from western to summer to punk. Each of these styles was then defined by a series of the same attributes used to describe the clothing. The attribute list for western looked something like this:

- Pants
- Jacket
- Poncho
- Vest
- Cowboy boots
- Closed-toed

- Cowboy hat
- Kerchief
- Low heels
- Loose
- Tight
- Brown
- Red
- Turquoise
- Silver
- Gingham
- Skull
- Snakeskin
- Cotton
- Wool
- Denim
- Leather
- Plaid
- Ruffles
- Belted
- Fringe
- Stitching
- Trim
- Chaps
- Boot cut
- Worn

This list reflected attributes that western clothes displayed. To figure this out, we looked at scores of pictures of models dressed in western-inspired get-ups at runway shows and in fashion magazines and movies. We used that wonderful purveyor of crowd intelligence: Google Image Search. From all of this visual research, we made lists of attributes commonly found in western-themed clothes. The same sort of process was applied to other styles like eveningwear, punk and futuristic to generate a list of similar and overlapping attributes.

Through this process we were able to develop a scoring system that began to reflect fashion. We relied on extrinsic information about fashion—commonly held cultural preconceptions—to create a scoring system.

The system allowed players to dress up models in a range of different clothing, trying out different combinations to find the highest scoring set or simply assemble an outfit they felt looked good together. When the attributes of the outfit selected match the attributes of the style requested, the player scores points (Figure 5.14).

FIGURE
5.14

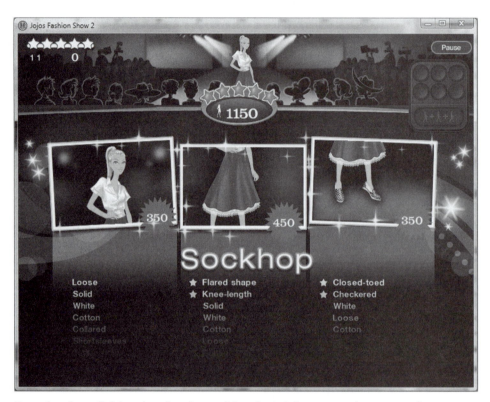

Once the player finishes dressing the model and sends her out on the runway, the attributes of the clothing are cross-referenced with the attributes of the style. Where the clothing attributes match the style's, the player scores points. (© iWin, Inc.)

Of course none of this was spelled out for the players. They did not have access to the written list of attributes for each item of clothing. Rather, they had to glean the attributes by looking at the item of clothing. They also had access to only a partial list of some key attributes for each style. Instead of having perfect information, the player learned to read the clothing for attributes. The player learned to parse the clothing for specific attributes and sort the whole item of clothing into different styles or categories. At any given moment, the player only had access to 9 or 10 items on the clothing rack to choose from. A timer ticked down, telling the player how long before they had to send out the next model. Generally a player couldn't spend more than 20 to 30 seconds on any one model. With three models in the

dressing room, each with a different style, the player has to divide his or her attention. These time and attention pressures required the player to quickly parse the clothing and its attributes to find the item that would best fit the required style. This process of quickly sorting the clothes into categories, weighing each item against another, provided the key challenge of the game. The player would look over a top and think, "This blouse is yellow, has an empire waist, long sleeves, it's kind of loose and flowing. It's more of an autumn shirt, but right now I need a summer shirt and the loose nature, as well as the yellow, make it kind of summery. More so than that red leather coat, that's for sure."

Because this system of processing and sorting into categories was fairly unusual for a game, we found we couldn't have any complex sequencing or other interactions demanding the player's attention. We tried out a few mechanics to divert players' attention, but found that they already had their hands full parsing the clothing. Other interactions simply overwhelmed the player. So we stripped them out and focused the game on sorting the clothes. As always, playtesting proved invaluable. Game designers are so familiar with their own game system that frequently it doesn't challenge them. But players aren't as familiar with the game. Many of the variables and mechanisms so apparent to the designer are actually obscured from the players, as in *Jojo's*. They have challenge enough just figuring out the game system. Don't overburden players, unless your game is about overburdening the players; but we'll get to that when we look at time and attention management games in Chapter 7.

In casual game design, it is generally a good policy to be generous with your player. *Jojo's Fashion Show* obscured a lot of information from the player. It was generally a more difficult system to read than a typical game system of exposed symbols like *Solitaire* or a match-three game. The information was there, but it was buried in details of the clothing. To compensate for player confusion, we pushed the game to be forgiving in the scoring. You scored a lot of points for items, and the levels were generally easy to pass. We didn't want players getting stuck on a level because they couldn't understand our interpretation of disco or some other style. To reward different levels of skill, we instituted a star system. You only needed three stars to pass a level. Getting three stars wasn't too hard. Getting all five stars was a bit harder. This allowed the game to scale to player's ability and prevented the game from blocking people's progress simply because the information they needed to properly sort the clothes wasn't clear.

Tuning your game to the right difficulty is part science and part dark art. Your game can't be too easy or players lose interest. If they cruise through every level with no difficulty, they will assume the entire game is easy and dismiss it as too simple. Much of the challenge of play comes in facing and meeting challenges. Occasionally failing a level can incentivize players. They will think, "Oh yeah!? This game's not gonna beat me, I'm gonna beat it!" Conversely, if the game constantly frustrates the players' every attempt to win, it can turn players off as well. They will begin to assume that a level can only be beaten by following one exacting path, which they may decide they don't want to traverse. To make this balancing act even more difficult, every player has a different skill level and different desires for difficulty.

Hardcore gamers generally want a stiff challenge. Casual players get frustrated more easily and grow dismayed with losing. Still other players just want content. I fall into this category: I hate games that block my progress. I don't necessarily want the game to be a cakewalk, but I also don't want to bang my head for days over some puzzle or tricky jump in a game. I want to keep progressing with occasional moments of repetition.

I think we actually made *Jojo's Fashion Show* a little too easy. We worried too much about frustrating the players and not enough about challenging them. Our rationale was that *Jojo's Fashion Show* was largely about content. We believed people would be more interested in seeing new dresses and clothing items than they would be in maximizing their score on any particular level. I still think this is largely true of the game, but that *Jojo's* could also have benefited from a little more difficulty to challenge and incentivize the player to take the game seriously.

In the end, it was good we changed course and abandoned the time management game with matching and focused on a sorting game. A number of other time management fashion games came out at the same time as *Jojo's Fashion Show*. *Jojo's* sold better than those time management games. The typical sentiment found in user comments on various Web sites was that players felt *Jojo's* was actually about fashion, while the other time management games felt more like retail simulators. As we hoped, sorting was a much better way to emulate the source system of fashion than time management.

In fact, a number of players reported that the game lodged itself firmly in their brains. They found themselves playing the game in their heads as they walked down the street. They would catalog each item a passer-by was wearing, parse it into attributes and assign it to a style. "Peep-toed, yellow, flats; knee-length skirt, flared skirt; sleeveless, halter neck, tank top; definitely a four-star summer outfit." One blogger went so far as to dress up in all of the clothes in her closet, take pictures of herself and then score the outfits based on the *Jojo's* attribute scoring system. The game began to alter players' perceptions of fashion and the way small attributes carried over from style to style. Each item of clothing the player saw and parsed in the real world reinforced the game system. Real-world fashion and *Jojo's Fashion Show* became enmeshed in a small feedback loop.

Working on *Jojo's* and watching how players reacted to the game highlighted the interesting potential of using information extrinsic to the game system. Because the players encountered similar information and attributes in the real world they continued to play the game even hours after they shut it off. Of course not every game needs to leverage extrinsic data like this. Fashion is a very peculiar system that already has game-like qualities (That's in style; that's so out!). But for casual games using this sort of real-world information can be a very potent tool. Players don't have to learn a particular new system of thought to play the game. Rather, they get to lean on one they already know and enjoy interacting with. Making a game of one of your favorite activities, in this case dressing up, is a great way to make a game that people will immediately identify and connect with. After all, it's much easier to fall in love with a beautiful pair of black slingbacks than it is the seven of clubs.

Summary

Sorting mechanics up the ante from more basic matching mechanics. As with matching, players have a natural affinity for sorting, especially if the characteristics being sorted are obvious and highly legible. They also offer players a system that directly rewards moves. The state of the game is entirely embodied in the array of pieces on the game board. Players can scan the game board and understand the state of the game. If the pattern is simple, reading that state is easy. As the pattern and number of pieces involved grow, legibility suffers. Depending on the game you are making, this can be good or bad.

Fortunately for designers, sorting allows for more complicated patterns than straight matching and thus more diverse gameplay. However, this added complexity comes at a price. The more complicated the pattern gets, the more important that the designer crafts a game which clearly teaches the player how to match the pattern required by the sorting. Through the careful crafting of mechanics like randomness, replacement and move patterns the designer can build an array of different games.

CHAPTER SIX

Seeking

Making a game can be as simple as hiding an object and sending players on a hunt to find it. This simple mechanic of seeking out a hidden object informs everything from scavenger hunts to Easter egg hunts to hidden object video games. This simple mechanic comes with many advantages for game designers. It's straightforward and easy to implement. The idea is so simple even small children instantly understand. You can scale it from easy to difficult simply by leaving objects in plain sight or burying them under layers of other objects. Seeking and finding mechanics tap into the natural playful instinct to find things. Just look at how peek-a-boo entertains babies for hours. The puzzlement of the search and the sheer of joy of finding the hidden object play across their faces each time they discover it.

FIGURE
6.1

A child searches for Easter eggs hidden in his backyard. (WikiCommons[1])

[1]http://commons.wikimedia.org/wiki/File:Easter_egg_hunt.JPG, User: bobjgalindo

But this simplicity also points to the limitations of building a game entirely around seeking. It offers little in the way of strategic complexity and replayability for adults with longer memories. Scavenger hunts are closer to puzzles than games. Once you find the hidden objects, you can't really play the game again. You have already solved the game.

Still, hidden object games have tortured players for ages. From the back cover of *Highlights* magazine exhorting you to find mistakes in the scene, to the 16th century Dutch painter Hans Holbein placing a large distorted skull across the front of his painting *The Ambassadors* (Figure 6.2), artists have long challenged viewers to decode images. As he painstakingly painted the ceiling of the Sistine Chapel, Michelangelo slyly included the likeness of his enemies burning in Hell. So seeking and finding hidden objects in art has a long—if not particularly kind—history.

I must admit that while I sometimes find myself engrossed in hidden object games, I don't find them particularly fun. As games, they generally lack strategic depth. Instead of developing strategy, you find yourself reduced to squinting and cursing as you scan through a morass of illogical objects strewn about the game area. The seek-and-find mechanic offers less chance for creativity than matching or most other casual mechanics. Seek-and-find games seem to reduce to a series of awkwardly placed roadblocks you must hurdle.

FIGURE
6.2

Holbein embedded a distorted image of a skull at the feet of his ambassadors to represent death. (WikiCommons[2])

[2]http://commons.wikimedia.org/wiki/File:Holbein-ambassadors.jpg

Yet, I admit, I am often engaged.

The basic mechanic of a seek-and-find game is very simple. Fill the game area with a large number of objects, then give players a partial list of those objects and tell them to find them. The players find and click the object. This object is crossed off the list. When the players find all the objects on the list, they win. If you want to get really fancy, you can add a timer.

The rules for a seek-and-find game are even simpler. You can boil them down to one rule: Find all of the listed objects before time runs out.

This simplicity certainly contributes to the popularity of seek-and-find games. You come to the game already understanding how to play. Simply looking around the world has taught you almost all you need to know about the game. This makes the game uber-casual. A seek-and-find game is the basic activity of looking around for the goal item.

This game mechanic has been applied to everything from weddings to murder mysteries and uses a relatively standard formula. Present the player with a beautiful background scene and layer on top of that a number of smaller images of objects that the player must find. New levels bring new background scenes and new objects to find.

If matching games tap into our desire to find and match patterns, seek-and-find games tap into something even more basic: the desire to just find one thing—to spot it and say, "There you are!" Instead of looking for patterns, you simply look for one object. There can be real joy in this discovery, especially if the object is hard to find. It's analogous to the joy a bird-watcher feels upon spotting a particularly rare speckled what's-a-ma-doodle. The satisfaction comes in part from the building tension and frustration as you search for an object and then the release of that tension when you actually find the object. You could argue that this release of tension is more elation at having finally found the object than sustained joy from consistently doing a good job. You get the same feeling when you find your misplaced car keys or discover your sunglasses on top of your head after 10 minutes scouring your apartment. But you can't deny that a lot of people enjoy the feeling. Seek-and-find games make up a significant portion of the casual market and have proven consistently popular with a large part of the audience.

Finding each object is a game unto itself. There is no build-up of moves as in a game like *Luxor* or *Snood*. In those games, your choices build up on themselves— you operate on a continuum of actions. In a traditional seek-and-find game, each move is entirely isolated. Finding one object doesn't really help you find others. This makes seek-and-find games very stop and go. The experience stutters along from one object to the next, making it hard to build up a sense of flow. While not necessary, a sense of continual progress to your actions—that you are making moves and meeting increasing challenges—leads players into the flow state. If every move is unto itself, building up to that state can be difficult.

A great strength of seek-and-find games stems from their mutability to different narrative content. It's very easy to apply seek-and-find gameplay to different stories and themes. Granted, they lend themselves most strongly to mysteries. They are often used for licensed games, perhaps because a lot of licenses revolve around mysteries.

For example, the downloadable *CSI: New York* offers hidden object gameplay. It is such a basic form of gameplay that it doesn't overwhelm the story. Instead, because the actual mechanic and feeling it produces maps very closely to real-life activities like hunting for lost keys, the mechanic doesn't need a lot explaining or justifying. For a match-three game to work with narrative content, you have to do some tricky shoehorning. "Well, you see, the ancient Egyptians used these rolling marbles as puzzles to lock the doors to their tombs...yeah, that's what they did!" Seek-and-find games demand less explanation—you're looking for clues, you're taking photos on vacation, you're shopping. We all look around the world for stuff; only the most neurotic of us line things up in groups of three.

At its most basic, this sort of gameplay isn't terribly interesting. There isn't much to say about it on a mechanical level. That doesn't mean making seek-and-find games is easy. There is, of course, logic to hiding objects. But basic seek-and-find games require more content production than game design. They require a lot of artists to draw numerous backgrounds and objects.

Mystery Case Files: Huntsville: Simple Seek-and-Find

But like all games, the seek-and-find mechanic is mutating and evolving. As we've discussed, games trend toward increasingly hardcore play. Well, even a simple mechanic like seeking and finding hidden objects is no different. As the fans of this mechanic play more games, they are growing more sophisticated and demanding more out of the mechanic. The game mechanic is becoming more complex as a result. The phenomenally successful *Mystery Case Files: Huntsville* released in 2005 seems almost primitive next to more evolved versions of the game mechanic found in *Dream Chronicles* and *Azada* released just a few years later. Interestingly, games like *Azada* bear a strong resemblance to classic adventure puzzle games like *Myst*. *Myst* came out in 1993, but the casual seek-and-find gameplay is just now catching up with this old-timer. The casual audience has evolved to the point where they want the sort of challenge that previously only serious gamers sought.

This new breed of seek-and-find games offers a wider variety of puzzle types. Each level seems to offer some new puzzle type. It almost makes you wonder if the lack of pure hidden object levels disappoints serious fans of seek-and-find gameplay. But the games don't just add complexity and depth by throwing puzzles at the player. Some actually evolve the seek-and-find mechanic. Games like *Azada* actually try to add depth and logic by asking the player to step through a logical sequence of steps.

A traditional seek-and-find game like *MCF: Huntsville* gives the player a word and asks the player to find the graphical representation of that word. This is the prototypical mapping of a seek-and-find game (Figure 6.3).

FIGURE
6.3

In *MCF: Huntsville*, the players are told to look for a flashlight. They must find the graphical representation that matches the item on the list.

However, game designers are now finding ways to make this mapping more complex and less one-to-one. Instead of providing a word and asking for the player to simply find the iconic version of it, the game puts the player in a specific situation and asks the player to solve it by finding the right tools. So now the mapping looks a bit more obtuse, as in Figure 6.4.

Navigate a ⟶
dark room

FIGURE
6.4

More complicated seek-and-find games offer clues to identify the sought object, rather than simply stating what players should be looking for.

These games are beginning to embed logic into the seek-and-find gameplay, moving them from an act of pure scanning to visual puzzle and process. These games offer not just pure pixel hunting, but the challenge of stepping through a logical process.

This style of logic is familiar to players of adventure games and role-playing games. You are constantly being given objects which you can use to overcome hurdles. But it does represent a shift in the logic of casual seek-and-find games.

This addition of logic greatly expands the potential of these games, both from a narrative and gameplay perspective.

MCF: Huntsville showcases the traditional seek-and-find mechanic. You play a detective trying to find clues and solve a number of mysteries. This amounts to visiting a number of different scenes and searching for objects. The game takes you to a café scene crowded with objects (Figure 6.5).

You have a limited amount of time to dig through the picture and find all of the objects the game demands. If you get stuck on an object, you can ask for a hint. When you find an object and click it, the item is removed from both the game area and the list. As the game progresses, the game gets both easier and harder. On one hand, fewer objects clutter your vision, making it easier to read the game area. But as the list dwindles, you also have fewer objects to choose from, leaving you with only the well-hidden objects to find.

Once you find all of the objects in the room, it's on to the next scene and a new set of hidden objects. The complexity of the game doesn't change, the objects just become harder to find.

As you can see from Figure 6.6, seek-and-find games ride a fine line between realistic and entirely surreal. To adequately hide objects, artists and game designers stuff the scenes so full of objects—from the logical to the absurd—that the scene borders on nonsensical. I mean, sure you might keep your tambourine on the bookshelf (far left, second shelf from the top) right next to the cobweb and underneath the spoon, but only a slob leaves their nautilus shell right next to their axe and underneath the wooden mallard on the bookshelf.

FIGURE
6.5

The area on the left is the game area. The list of objects you must find in the game area is on the right. (© Big Fish Games)

FIGURE
6.6

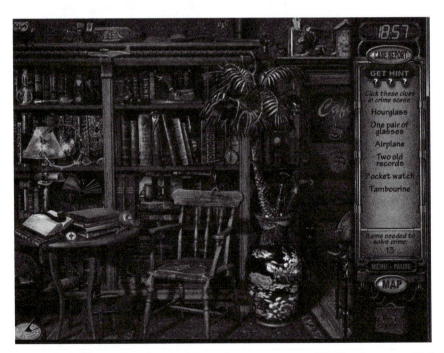

As you find objects, they disappear from the game area and list, leaving you with fewer choices for seeking. (© Big Fish Games)

There is no strategy in *MCF: Huntsville*. In fact, there is no real logic for the player to work through. Otherwise, there wouldn't be an axe, a rolling pin and spoon all on the same bookshelf. The interaction and experience are flat, held together only by that tension of desperately searching for something you just can't seem to find. Only this object wasn't just misplaced, it was deliberately hidden and obfuscated. You get the release of finding a hidden object, but not the satisfaction of solving a problem that leads to finding the object.

Azada: Introducing Logic to Seeking

Games like *Azada* evolve the seek-and-find mechanic and in doing so, engender different feelings in the player. In *Azada* the player is presented with a scene like the one in Figure 6.7.

FIGURE
6.7

To complete the puzzle, you must find an object in the dark room on the left of the screen. (© Big Fish Games)

Here we have a much more realistic scene of a workshop, not nearly as cluttered, and a pitch black area next door. The items you must find are displayed graphically on the sheet of paper. As you find the objects, you grab them and place them in

your inventory. You can then use each object to perform another action. The challenge lays in figuring out the right way to use the items. Sometimes they are used independently and sometimes together. In Figure 6.8, you find the flashlight and batteries and then use it to find the light switch in the dark room next door.

FIGURE
6.8

After finding the flashlight and batteries, you can use it to shine a light into the dark room and find the light switch. (© Big Fish Games)

This represents a significant departure from the way the player interacts with the seek-and-find mechanic. Yes, the player still scours a picture for a specific object. You could even argue that the change in the mechanic is largely perceptual. After all, there is still only one right answer. You have to find the flashlight. Then you have to find the light switch with the flashlight. The game still demands you check items off a list. However, the experience feels different. When I encounter this sort of seek-and-find puzzle, I feel a greater sense of accomplishment. As I work through the logic, I feel increasingly clever. "I found this flashlight. I wonder if I can use it to see anything in that black area. Ooh, it lights it up. Hmm, I wonder if there is a way

to turn on more lights. Oh, look at that, a light switch!" Instead of feeling flat, the experience feels layered. Through an increase in complexity, it gives the illusion of choice. And with choice, we get the first glimmer of strategy.

This evolution of the seek-and-find mechanic from one-to-one mappings to strings of logical actions has strengths and weaknesses. It allows for a more realistic, less surreal game area. Artists no longer have to place every object up front. Now they can embed them within a logical set of steps. Click the toolbox to open it. Click the hammer in the toolbox. The complexity can be hidden in many sub-areas. However, this requires the player to understand the logical steps the game demands. To make the steps legible, the logic needs to be clear to everyone. This can be a tall order when the sequence is based on one person—the game designer's expectations about what should be done. Simple scenarios like turning on a light seem very obvious, but without the right context, even that can seem illogical. Demanding a series of interactions pushes these games toward the old stumbling blocks encountered in adventure games: you just have to keep clicking around trying different combinations until you finally put the monkey on the wrench.

If the logic isn't clear, the game must offer hooks to help the player parse the logical sequence demanded by the game. *Azada* guides the player by using highlights around the places the player should click. This definitely helps guide the player, but it runs the risk of dampening that moment of tension release that accompanies finding an object. The highlights enable the players to scan the game area with their mouse to see what lights up. This is a trade-off the game seems happy to make in exchange for the depth of logic. I would tend to agree with this trade-off. I'll always take a bit of depth over a flat exercise—even at the cost of making the game easier.

Summary

This new use of logic in seek-and-find games holds out the promise for more complex gameplay as the mechanic evolves and the audience adapts. Eventually, the games will evolve to a place where the players can take multiple logical paths to the same conclusion. They will be able to find a flashlight or a book of matches to find the light switch. This introduction of more varied choice will strengthen the gameplay hooks. As the sought items become actual objects with cultural and functional associations the player will not just consider the appearance of the objects on the screen, but the functionality as well. This dual processing will offer a more engaging experience. It will also allow the players to feel clever, creating what they believe are their own solutions.

Chains of logic also hold out the potential for ushering players into a state of flow. If they are part of a sequence, then moves are building on one another. This offers the player a more integrated set of moves and smoother experience. Each move feels related to the next, rather than entirely individual.

Of course, multiple paths through a space present other problems. It complicates level design and muddies the clarity of the game. Multiple paths to success can also

mean multiple paths to failure. But great game systems enable this sort of creative play. Chess is open to thousands of different gambits—it's up to the player to creatively apply them. There are hundreds of ways to approach any game of *Luxor* or *Bejeweled*. But right now, there is really only one way to approach a seek-and-find game. It is a puzzle. But the introduction of a bit of creative logic and planning on the player's part may enable seek-and-find games to shed a bit of that constraint. And in doing so, it will open them up to deeper engagement.

CHAPTER SEVEN

Managing

Games often walk a fine line between work and play. We engage in repetitive tasks, follow someone else's rules and strive to stay one step ahead of our colleagues—all to accomplish small goals that, if we weren't being paid for playing a game, we would never bother with. Sure, some games feature tasks we naturally enjoy, like hitting plastic moles on the head. But many games ask us to perform tasks that at first glance seem barely more diverting than playing with an Excel spreadsheet. And nowhere is this more true than in strategy and management games—from time management to resource management. These games force players to keep track of multiple elements while furiously clicking around the screen trying to keep everything on track. As if this didn't feel enough like work, the games often take a workplace as their setting, like an office or a diner. And then there's that name for the mechanic harkening us back to the office: managing. It's a wonder anyone would want to play these games.

For centuries there was an upper limit on the computational complexity that games could present players. When you make a board game or non-digital game, the number of variables in the game must be limited to what your average players can reasonably manage—how many pieces they can move around, how many calculations they can do—though games like *Warhammer* (Figure 7.1) certainly try to push these boundaries. Even if the actual computation simply requires rolling a die, just managing all of the pieces can become overwhelming.

Video games erase these computational limits. Computer processors can keep track of exponentially more variables and do calculations faster than any human. So you can create whole new types of gameplay that would have been far too complex or tedious to track in a board game. This includes not only tracking more pieces, but also managing things like multiple timers and the spatial relations related to all of those pieces.

When Sid Meier designed his video game *Civilization*, he borrowed elements from a complex board game also called *Civilization*. The board game was very involved and took roughly eight hours to play. But thanks to the processing power of computers, a video game that attempts to represent the process of building civilizations can be made orders of magnitude more complex. Every unit can have multiple variables, as well as dynamic information like timers. Turn-based strategy games revel in this

FIGURE
7.1

Games like *Warhammer*, seen here played on a large table, push the computational boundaries of a non-digital game. Computers enable us to manage more game info more easily. Computers are also much better at tracking dynamic data like timers. (WikiCommons[1])

complexity. The games throw tons of details, variables and relations at you to manage. Real-time strategy games ask you to handle all of that management in real time, no pausing to think on your turn. These games are great, but ultimately limited in their appeal by the intense demands they put on players. But because the computer handles many of the details, you can hide much of that complexity from the player with clever game design. A very complex game can actually be very casual, assuming you choose the right variables to expose to the player.

A batch of casual games has grown up to do just that. They aren't quite hard-core strategy games, but they share some similar characteristics. The player manages multiple different units or processes at once, paying attention to many different timers. Many games ask players to manage different resources. But these games take the management aspect of the game and push it to the forefront, making it the dominant mechanic in the game. They push you to manage more and more stuff to see how much you can wrangle before the whole thing comes tumbling down.

Diner Dash: Spinning Plates

Diner Dash was developed by Gamelab and published by PlayFirst in 2003. The game was designed by Nick Fortugno, who has designed a number of popular casual games. *Diner Dash* went on to become one of the best-selling casual games of 2004

[1]http://commons.wikimedia.org/wiki/File:Warhammer_game.jpg, User: Ranveiq Thattai

and has since spawned numerous sequels and a whole genre of time management games. Some of these games, like *Roller Rush*, feel like rehashes of the main mechanic of *Diner Dash*. Some, like *Sally's Salon*, refine and polish the mechanic to a bright sheen. Others, like *Cake Mania*, evolve the main mechanic by adding new layers of complexity. But each takes a similar management mechanic as the starting point of the game.

In *Diner Dash*, the player takes on the role of Flo, a white collar worker who trades in the corporate rat race for the excitement of running her own diner. You quickly realize that running a diner and keeping all of your customers happy produces whole new levels of stress.

You guide Flo as she plays hostess, waitress, cashier and bus boy (Figure 7.2). Customers enter the diner. Over their heads, hearts indicate their level of happiness. If all of the hearts disappear, the customer gets angry and leaves in a huff without paying. To keep the customers happy, you must move each of them through their dining experience by completing a set of ordered steps.

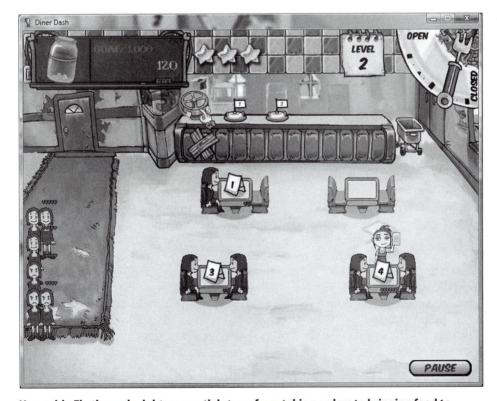

FIGURE
7.2

You guide Flo through eight sequential steps, from taking orders to bringing food to dropping off the check. (Copyright © 2003 PlayFirst, Inc. Reproduced by permission of PlayFirst, Inc.)

First, you click and drag the customers to a table. They will then look at their menus for several seconds then raise their hand indicating they are ready to order. Clicking them will bring Flo to the table to take their order. Then you click the kitchen, and Flo will walk over to the kitchen and drop off their order. The chef will take a few seconds to prepare their meal. When he's done, a bell rings and a plate of food appears on the kitchen counter. Click the food and Flo walks over and picks it up. Clicking the table where the food needs to be delivered spurs Flo to walk over and deliver the food. The customers take several seconds to eat, and then they raise their hands, indicating they want the check. Click their table, and Flo will bring them their check. Your happy customers pay and leave, leaving their dirty plates behind. Click the table and Flo picks up the dirty dishes, then click in the kitchen and Flo drops off the dirty dishes. Then the process starts all over again with a different set of customers.

Serving each customer requires a set of eight sequential clicks. The game responds contextually to each command, simplifying the process. You don't have to direct Flo to take an order versus bring the check. Once you send her to a station she takes the appropriate action. This makes interacting with the system very simple—all you need to do is point and click.

When you only have one customer to attend to, it's easy to bring them what they need before they run out of hearts. The complexity comes when you have to start serving multiple customers at once. Lose too many customers and you won't earn enough money to pass the level. This forces you to balance the different timers against one another. Because that's what the customers are: timers. Essentially, each customer in the game is a timer that's constantly ticking down. Interacting with the timer adds seconds back on to it, giving you more time before it runs out the door in a huff. Flo complicates the player's task. When you click a customer to take their order or bring them their food, it does not happen instantly. Flo has to walk there and perform the interaction. All of this may only take a second or two, but it adds time. It also separates you, the player, from Flo. Flo is always trailing behind where you are looking, performing her actions in the order you prescribed. You must keep track of the sequence of actions you have stacked up for Flo.

And you can't just stack up all of the actions to perform automatically. You need to wait for the customer to be ready. Customers need to know what they want to eat before you can take their order; the food needs to be prepared before it can be delivered and you can't give your customers the check until they finish (unlike at a real restaurant). The time customers take to perform actions adds a third set of timers to the game on top of the heart meter and time it takes Flo to perform a task. Naturally, these games are referred to as time management games. But I think there is a slightly more elegant name for this mechanic: spinning plates.

Spinning plates is that freakish form of juggling in which the performer spins a flat object like a plate on top of a pole. The gyroscopic effect keeps the plate upright on the pole, much like a top. Over time, though, the spinning plate slows down and falls off unless the performer gives it the occasional whirl to keep it going. Spinning one plate on a tiny little point is impressive, but the real spectacle comes in

seeing the performer line up five, ten or even a dozen plates, and keep them all spinning (Figure 7.3). The performer must look across all of the different plates and quickly gauge which plates are slowing down and then dash among them to give the slowing plates a quick tap to speed them up again.

FIGURE
7.3

These jugglers spin bowls on top of long poles, managing all of them as they independently slow down. As a plate slows, the juggler must give it a tap to keep it spinning. (WikiCommons[2])

This pretty much describes the feeling, and a bit of the joy, of playing *Diner Dash*. You constantly survey the field of customers, trying to discern who needs attention and when. Providing the attention to keep them going is not hard, but it takes time, so you need to be efficient in how you deliver your attention. You feel great as you get more and more plates up and spinning and particularly satisfied when you save one just before it topples to the ground. The physical skill required to balance a plate on a pole differs from the skill required to click through *Diner Dash*, but the cognitive process and calculations are quite similar. It's not the deep strategic thinking, but rather the process of paying attention to many timers at once, that takes up much of your cognitive bandwidth. It also enables you to adjust your difficulty up or down a notch. If you think you're doing well, you can add in an additional plate. If you get overwhelmed, you can try leaving one slot empty. This helps get you into the flow state and stay there.

[2]http://commons.wikimedia.org/wiki/File:Opening_Ceremony_Plate_Spinning.jpg

It's amazing how flexible and how popular this mechanic of managing multiple timers has proven. The basic mechanic has been applied to content from running a diner to a hair salon to a bakery. The time management mechanic works best when a process can be broken down into sequential timed steps. This enables designers to map the game to all manner of familiar content. And the familiar content is key to *Diner Dash's* success. We have all eaten at restaurants and have a good sense of the order of affairs over a meal. We already have a mental model of ordering food, eating and paying. The game doesn't have to teach us this. So the sequence of events in *Diner Dash* makes immediate intuitive sense.

The mechanic is also simple and straightforward. You are marching through a series of logical steps one step at a time. Each step is clearly represented visually, from the image of customers perusing a menu to the hands in the air asking for the check (Figure 7.4). To interact, you simply click where you want the next thing to happen. The game picks the right thing to do for you. Your responsibility is simply to stay one step ahead of the action and try to point out the most efficient way to get everything done.

FIGURE
7.4

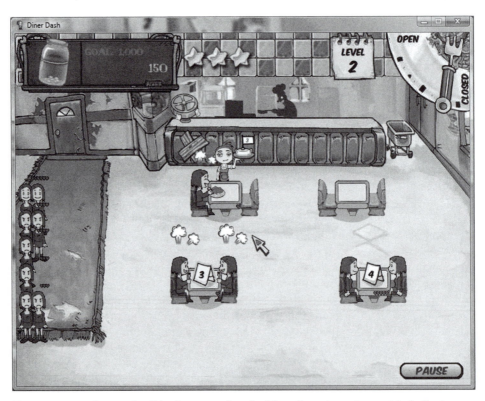

The game uses the very legible signs associated with eating at a restaurant to indicate steps. Orders are scribbled on pads, hands are upheld for checks and frowns indicate customers are getting tired of waiting. (Copyright © 2003 PlayFirst, Inc. Reproduced by permission of PlayFirst, Inc.)

Cake Mania: Managing and Matching

Cake Mania, designed by Andrew Lum and developed by Sandlot Games, uses a variation of the spinning plate mechanic but adds in another vector of complexity. When the game was released in 2006, some saw *Cake Mania* as another knock-off of *Diner Dash*. While the game does bear some mechanical similarities, it has several key mechanics that differentiate the gameplay and lead to a very different experience from *Diner Dash*.

Like *Diner Dash*, *Cake Mania* centers on the glamorous and naturally playful world of retail food preparation. You help Jill build her bakery business, guiding her as she prepares cakes for different customers. As in *Diner Dash*, you click locations or stations and guide Jill through a series of timed steps. First, Jill gives the customer the menu. The customer then requests a specific shape of cake and icing color (Figure 7.5). Jill bakes the cake, then decorates it before giving it to the customer. Each step takes several seconds as Jill scurries back and forth and does her work. All the while, each customer's heart meter ticks down. If they lose all of their hearts, they leave without paying.

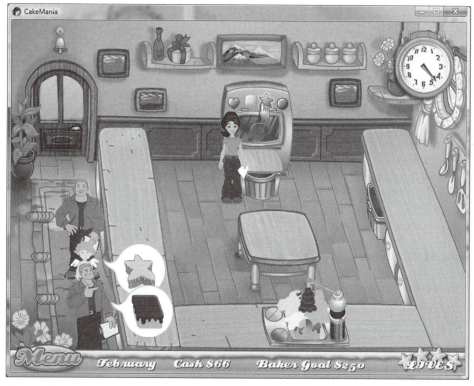

FIGURE
7.5

Cake Mania complicates the time management mechanic by asking players to bake cakes that match the shape and color of customer requests. The player must select the appropriate shape on the oven and color on the frosting station. (Cake Mania and Sandlot Games are registered trademarks of Sandlot Games. All rights reserved)

Like *Diner Dash*, the player moves through a linear progression of steps. But where stepping through the process in *Diner Dash* was very controlled, preventing you from making mistakes, *Cake Mania* asks you to make further choices about the shape and color of the cake, opening up the door for more potential mistakes in the process. In *Diner Dash*, essentially every customer orders the same thing. You don't have to worry about what to bring them. You just pick up the plate labeled "2" and deliver it to the table bearing the "2" flag. Click the wrong table, and Flo will stop and stand in front of the table, but she won't give them the food. In this way, the player only has to worry about getting the process right, not about the content that the process produces.

In *Cake Mania*, on the other hand, you build each cake to match the customer's order. There are four buttons on the oven for the four cake shapes and four color buttons for the different icing at the frosting station. You can trip up and bake the wrong shape of cake. You can slip up and put the wrong icing color on the cake. Or you can accidentally stack two cakes on top of one another. These cakes must be thrown out or stored to give to another customer. You are not being asked to make strategic choices about what type of cake to make, but simply to match the shape and color requested by the customers. *Cake Mania* layers a very light matching mechanic on top of the time management mechanic. This extra cognitive task adds another vector of complexity to *Cake Mania*. The game feels much more about creating the right cakes than it does about rushing through customers like *Diner Dash*. This makes the overall experience of playing *Cake Mania* a bit slower and more contemplative, while the incessant drive through the process and churn of customers make *Diner Dash* feel more frantic and rushed.

The delta in game mechanics between *Diner Dash* and *Cake Mania* again illustrates how slight changes to mechanics have big impacts on a game system. *Cake Mania* also shows how you can continue to evolve a game mechanic by bringing in an asymmetrical mechanic. Color and shape matching has little to do with time management, but adding it to the straightforward march of time management makes the system feel more robust. Selecting the shape and color of the cake makes you feel as if you are baking a cake more than if you simply clicked straight through the process. The designers smartly scaled back the complexity of the color matching and shape sorting so that it would dovetail nicely with the time management. All you have to do is choose the same shape and color you see in the customer's speech bubble. As the game advances, the matching and sorting gets more complex and involves multiple layers, but it still remains straightforward and easy to emulate. Most importantly, you are not constrained in what you can choose. If you need a red cake, you have the materials and equipment to bake a red cake. You don't need to do any rearranging to make the red cake. Your limiting factor is time.

Managing Attention

Time is certainly not the only thing that needs management. Turn-based strategy and real-time strategy games force players to track dozens of units. Games can also

ask you to manage your own attention. They throw as many elements as they can at you and see at what point you simply can't keep up with the game and pay attention to every element. If time management games are like spinning plates, attention management games are like juggling. Except there is another clown standing off to the side that keeps throwing more balls, torches and chainsaws up into the air for you to catch. Your job is to see how many of these pieces you can keep in the air before one lands on your head.

Insaniquarium: Overwhelming Yourself

As the name suggests, *Insaniquarium* is a rather surreal game. In many ways, it seems like a hodgepodge of different ingredients all thrown into a cauldron and mixed together, with little regard for how well they actually taste together. And yet the game works. The game was developed by Flying Bear Entertainment and published by PopCap Games. George Fan designed the game. While *Insaniquarium* does not hang together tightly, it does offer some interesting lessons. In many ways, the looseness—both in gameplay mechanics and content—contributes to a game's appeal.

In each level, you must collect enough money to purchase several pieces of an egg shell. To earn the money, you must manage a fish tank full of guppies and fend off aliens which appear periodically and eat your guppies. No move in *Insaniquarium* requires much skill. You buy guppies and they drop into the tank. You must feed the guppies to keep them alive. To feed the fish, you simply click in the tank and a piece of food drops in and floats to the bottom. The guppies produce coins which also float to the bottom of the tank and disappear. You collect the coins by clicking them. When the alien intruder appears to eat your guppies, you rapidly click the alien to kill it. The game boils down to a collection of hundreds of clicks. The clicks don't even require a particular logic be met. *Bejeweled* asks that one of the gems being swapped results in a match. *Solitaire* requires the cards to be in the right order in order to be placed. *Insaniquarium* has no such restrictions on your clicks. You can click anywhere and based on the location, the game determines the action to be performed. So if you click in the water, food drops. If you click a coin, it scores. If you click the alien, it shoots him. This makes the interaction required to play *Insaniquarium* incredibly simple and straightforward.

Yet you can feel the tension building in *Insaniquarium*. Nothing in the level demands you finish the level more quickly. You could, if you wanted, just drop one fish in the tank and occasionally drop food in when the fish turns green. The fish would occasionally drop a coin for you to pick up. With one fish, you would only need to interact with the game every four or five seconds (Figure 7.6). At this density of interactions, the game does not require much attention. You could easily tend to the game and peruse a newspaper article at the same time. It only requires partial attention. But you can also choose to add another fish and then another, scaling up the difficulty of the game. Each new fish results in numerous additional clicks to maintain the fish tank (Figure 7.7).

FIGURE
7.6

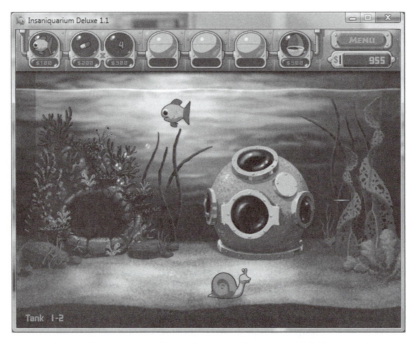

The attention that *Insaniquarium* requires scales based on how many fish you drop into your tank. With one fish you may need to interact with the game only every four or five seconds. (Reproduced by permission of PopCap Games)

FIGURE
7.7

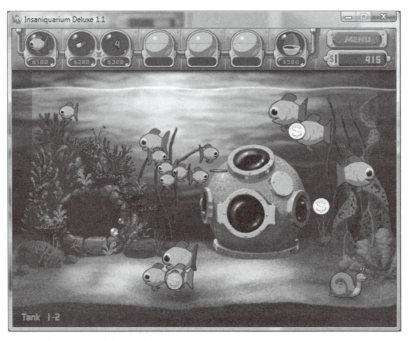

As you drop more fish into the tank, you can earn money more quickly, but you also have to pay attention to more fish and drop more food to keep them alive. (Reproduced by permission of PopCap Games)

Instead of deriving tension by navigating the logic required to perform the action, *Insaniquarium* builds gameplay tension out of the sheer number of clicks the player must perform. To pass the level more quickly, the player needs to click more coins. To produce more coins, the player must have more guppies. More guppies means more fish to feed. More fish also means the alien may pop in and grab one more quickly. No single element adds much to the difficulty of the game. However, each thing the player adds requires several additional clicks. So when you add a fish, you must click around in front of it to feed it more. The fish will drop more coins, which you'll want to grab. You'll want to be able to drop more food simultaneously to feed all of your fish, so you'll need to upgrade. The sum of all of these elements—and the clicks they require—makes the game more and more frenzied until it takes up all of your attention.

By the time you have four or five fish in the tank at once, you must pay full attention to the game, watching for hungry green fish and coins floating toward the bottom. Once the game has all of your attention, your interaction shifts to one of managing your own attention. How quickly can you scan around the game space and take in all of the information presented? At some point, the game passes your ability to quickly take everything in and fish begin to die because you didn't see them turning green (Figure 7.8). Coins slip to the bottom and disappear because you were focused on feeding a group of fish on the other side of the tank. The process the game requires you to step through—feed fish and pick up coins—remains incredibly simple, yet it feels much more difficult because you must do so much of it simultaneously. This is similar to how the physical act of juggling increases in difficulty simply by tossing another ball into the air.

And just as you control the difficulty of the game by plopping more fish into the tank, you scale back the difficulty by letting fish die. There is little penalty for losing a fish. You just have to buy a new one. So if the game overwhelms you, just let it slow back down. Drop a few balls to the ground and now you can comfortably focus on just three of them.

In many ways, it's amazing how this difficulty lever works in *Insaniquarium*. The game does not require focused play. That's something you impose on yourself through your own decisions. And at the same time, you are not punished for finding yourself overwhelmed by the situation you create. The game balances itself. This dynamic makes *Insaniquarium* feel very casual and generous towards its players. The game gives you a gas pedal and lets you decide the speed you feel most comfortable driving. Achieving this equilibrium is not always possible or even desirable—it could feel shapeless and unchallenging—but when it comes to managing attention, it's a great balance to strike. It lets you feel only as harried as you want to feel.

Flight Control: Being Overwhelmed

The Australian company Firemint developed a wonderful little game called *Flight Control* that, like *Insaniquarium*, manages to suck up all of your attention by asking

FIGURE
7.8

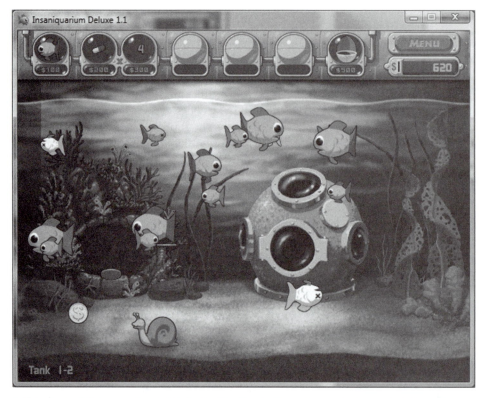

Fail to feed a fish for too long and they go belly up. There is no penalty for losing a fish other than the cost of buying a new one. You don't lose the level. So if the game becomes too hectic, you can simply let a few fish die and scale back the attention the game requires. (Reproduced by permission of PopCap Games)

you to manage more and more elements on the screen. Designed by Robert Murray, the game requires players to land different color aircraft on a series of matching runways (Figure 7.9).

Flight Control makes admirable use of the iPhone's touch interface. The player taps a plane and then draws a line to the runway using a finger. This leaves a thin line showing the plane's path to the runway. Red jumbo jets, small yellow prop engine planes and slow green helicopters continuously enter your airspace and require direction onto the appropriate runways and helipads. Drawing the flight paths feels very intuitive, making the game feel like a natural fit for the iPhone. It's wonderful to see a game find new ways to truly take advantage of the technology offered by a platform. Not only does it make for an interesting, integrated gameplay, but it delights players. It can make players feel privy to something special,

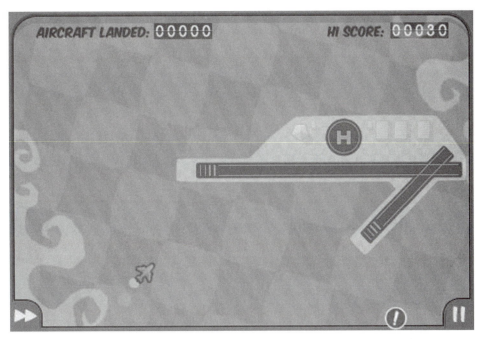

FIGURE
7.9

The game starts off easy to manage. With only a plane or two, it is easy to direct them in a clear path to their matching runway. (Reproduced by permission of Firemint)

reinforcing their attraction to the game. They feel they've discovered something new and now have the chance to learn a new mechanic. The trick is making the new mechanic so intuitive that the learning hurdle doesn't trip up players. Drawing is such a natural act that we intuitively understand the interface of *Flight Control*, even though few games use a similar drawing mechanic.

The different plane types travel at different speeds, requiring careful management of the size of the loops the planes fly in. As in a time management game, each plane is a timer. Once it is hooked up to the runway, the plane will fly there and land and score. However, unlike *Diner Dash*, where the customers are straight clocks, the timers in *Flight Control* have a spatial component as well. They move steadily through the game space towards their goal. If the path is clear, you don't have to worry about them. But if there is another plane in the vicinity, you need to think of them like timers counting down to the moment where they might come in contact with another plane. You can tap a plane and redirect it by drawing a new flight path. Managing one or two planes is not difficult. You can keep their paths separate and clear. It's when more planes enter the space and the paths cross and entangle that the game gets difficult (Figure 7.10).

FIGURE
7.10

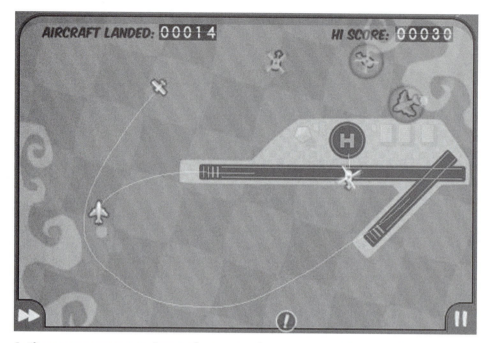

As the game progresses and more planes enter the game space, it becomes increasingly hard to keep track of all of the planes and the paths you have drawn for each. (Reproduced by permission of Firemint)

Like *Insaniquarium*, *Flight Control* requires you to manage your attention. The more planes on the screen and the more complicated the paths you create, the more you must pay attention to all at once. By the time you have four or five planes on the screen, it can be very hard to keep track of all of the movements and when the different planes might overlap. However, unlike *Insaniquarium*, *Flight Control* offers no release valve for the building pressure. While you can let fish in *Insaniquarium* die to make the game easier, if two planes collide in *Flight Control*, that's it: game over (Figure 7.11). Eventually you lose *Flight Control* simply because you can't keep track of everything and two planes collide. Quite often, your loss comes as a surprise. It happens over on the other half of the screen while you were directing a different set of planes to the runway.

Flight Control feels much more hardcore than *Insaniquarium*. Both have cute, pleasing art and accessible game mechanics. But your ability to play and progress in *Flight Control* is limited by your ability to take in all of the information at once and your skill at quickly drawing new lines. This fits with the overall structure of the game. *Flight Control* generates the planes and their starting points differently each game. The game seems to draw on a wave system, giving the array of planes a rising and falling tension. More planes enter the space until finally they slow down for a bit, giving you a breather before the game scales the difficulty up even higher than

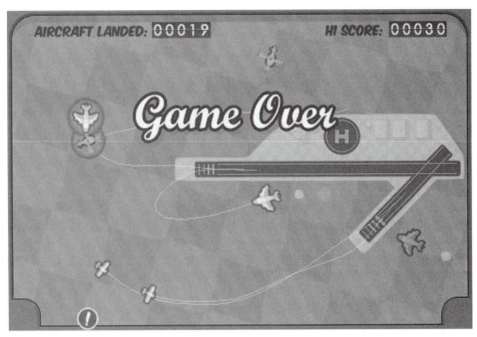

FIGURE
7.11

Eventually, two planes collide, often while you're looking at the other side of the screen to manage a different plane. You simply run up against the limit of how many things you can track at once. (Reproduced by permission of Firemint)

before. This sort of procedural play lends itself to hardcore play. You must constantly play the beginning of the game, getting a little bit further each time before dying and starting again. *Flight Control* breaks down to a game of inches. Each game, you may do one or two planes better or worse as you slowly improve at the game. The only progression offered to the player is a slight increase in your high score.

This short intense gameplay works fine in *Flight Control*. The game is played on a device which travels with you. You play in short blasts, so dying and starting over feels less harsh. But it still limits the time the average player will spend with the game. Without a sense of progression, many players will play the game several times, say, "Okay, I get it," and move on because they aren't willing to spend the time practicing to push up their high score by a plane or two. The game doesn't scale to your interest and abilities. Instead it eventually just aces you.

Summary

Games about managing often feel more complex than other games. *Civilization* certainly requires more attention and cognitive focus than most games. But even a game like *Diner Dash,* which contextually intuits what you want to do, still requires a great deal of focus. It's not necessarily that the patterns you are being asked to

perform are more complex than those in, say, a *Solitaire* game, it's that the primary pleasure of the game stems from how fully it occupies your attention. To be fun, the game must be demanding. Board and card games can demand attention through the management of pieces, but they can't demand as easily attention through temporal and spatial pressures. By using the computer's ability to track variables of time, spatial relations and volume, these games tap into our playful desire to serve as puppet master and orchestrate the world. To keep the play casual, though, game designers must carefully choose how they will build up pressure in the game and how they will release it. Will they let players have that control? Or will they impose a hectic pace on the players?

It's interesting that so many of these games take work as their setting. Through game mechanics, the game designers seek to emulate established working processes. And players take to them. Much of this has, no doubt, to do with familiarity. The games provide a view into processes with which we already feel familiar. This makes them instantly familiar. Look through time management games and you'll find mostly games that emulate well-known work processes like waitressing, styling hair, grooming pets and other retail jobs. These are jobs with clear and repeatable steps. They are also known and understood by players, even if they don't perform that job for a living. As you would expect, you see fewer games about jobs like, say, managing hedge funds. That may even be a mappable process, but few people are as familiar with it, which would make it less intuitive.

Many of these games emulate an aspirational version of work. You are a baker starting your own store and building up an empire or a hair stylist trying to make it to Hollywood. Sure *Diner Dash* feels less aspirational. Flo eventually opens more diners, but waitressing isn't a common fantasy in the way being a fashion designer is. But what *Diner Dash,* like the other games, offers is clear reward for your labor. These games offer a version of work that provides rewards in direct proportion to your efforts. You serve the customers, they pay, and you advance to the next level. What job offers a career path that clear and that immediate? In the end, perhaps that is a big part of the appeal of time management, attention management and all other forms of management games. These games offer a clear path to the management position. You get to be in charge. You get to tell everyone what to do. You simply open and start clicking and you're the boss.

CHAPTER EIGHT

Hitting

Great pleasure can be found in hitting something. Just whacking the hell out of it. On some level, it's an act of brute force. Somewhere in our caveman ancestry, we realized it's just fun to hit things with a club. And if you hit the right thing, like a tasty bird or a 100-mile-per-hour fastball, it can be profitable too.

Hitting—the process of reaching out and coming into contact with another object—is such an elemental play mechanic that we tend to overlook it as a game mechanic. Games like boxing revolve around hitting in a very obvious way. The central act of boxing is punching your opponent. Other games couch hitting in more baroque systems, burying the mechanic in among a slew of competing interactions. When we think of baseball, we think of pitching, catching, throwing and running the bases, but the core of the game is hitting. Hitting puts it all in motion (Figure 8.1). Sure, the pitch comes before the hit, but really it's when the bat comes into contact with the ball that the rest of the game system comes alive. The ball arcs through the air, the players in the outfield begin moving and the runners dash

FIGURE
8.1

Hitting animates games like baseball and puts the entire game system in motion. (WikiCommons[1])

[1]http://commons.wikimedia.org/wiki/File:Kevin_Millar_hitting.JPG

around the bases. In fact, the beginner version of baseball, T-ball, does away with the pitch and jumps straight to the hit. Because at the center of baseball lays the sheer act of whacking something as hard as you can.

In talking with game designers, I've sometimes picked up on a note of disdain for hitting as a mechanic. It's easy to write off the swinging of a stick or the smashing of your hand into another object as an uninteresting act of sheer brute force. The sentiment seems to be that hitting is so simple and basic that little can be said or explored around hitting. This denies the sheer fun of hitting as a mechanic. It also ignores the subtleties of a basic play mechanic like hitting. Hitting ranges from easy to incredibly difficult, often within the same game. Just look at any sport that involves hitting and you'll see the incredible range of complexity that can be embodied in each swing. Reducing boxing to simply "punching your opponent" ignores all of the myriad types of punches, feints and jabs that exist. Once you get past the spectacle of two humans punching each other, you realize that boxing is an incredibly technical sport with a complex array of hits, jabs, crosses and cuts. The joy that comes from hitting, combined with the way it scales to ability, makes the mechanic of hitting worth a second look by game designers. Hitting is a great example of play mechanic that scales directly into a robust game mechanic.

Natural Feedback

Our parents trained us well. It's a little uncouth to admit how much fun it is to hit something. We've all endured countless admonishments from our parents, crying out, "Hey, no hitting!" But I would presume to state that we've all felt the joy of picking up a stick, hefting it from hand to hand, judging its weight and strength, and then smashing it against a rock or another tree and watching it splinter. Or maybe we pick up a pebble on the beach, whack it with our stick and watch it sail out over the water. Why is this expression of force so pleasurable? Well, in some measure it has to do with the feedback.

When expressed, hitting has a very clear result and feedback. If done properly, the thing that's hit moves clearly in the opposite direction. Having such clear discrete outcomes is immensely attractive. There is no ambiguity.

It's infinitely more satisfying to watch that stick splinter into a million pieces than it is to find yourself still holding an intact stick after you give it a whack. Successfully hitting something provides clear and direct feedback. Either you accomplished what you set out to, or you missed the object and failed. There is clear and direct feedback to your actions. Clear feedback amplifies gameplay, making it more legible. Players understand the consequences of their actions and can make informed decisions based on that understanding. You toss a rock up in the air and swing your stick at it. If you see the rock sail through the air, you know you hit it well. If the rock drops to the ground, you know you missed.

Hitting things clearly falls into the category of physical play. We hit things in some part to explore them, to test their strength and to see what they are made

of. Hitting is such a physical play activity that it quickly acquaints us with many aspects of the object of our aim. Through swinging a bat at a ball, we come to understand the weight and density of the bat. We feel its shape and experience how it cuts through the air. From the vibration that rings through the bat upon contact with a ball, we gauge what material it's made of. And as we focus on the ball, we suss out its characteristics as well as intuit basic properties of Newtonian physics, from gravity to friction to torque. This learning happens for everyone, from kids to adults. This process of learning and exploration combines with the visceral expression of power to form a powerful play cocktail.

Scaling with Skill

It's no wonder that hitting, in its myriad forms, sits at the center of so many games, from sports like baseball and soccer (albeit hitting with your foot) to arcade games like *Whac-A-Mole* to digital games like *Wii Tennis*. Each of these games places hitting into a game context where it draws on the visceral expression of power and the exploration of physical characteristics. Hitting imbues each of these games with a clear starting point. The main mechanic for interaction is so familiar that it requires no explanation. It gives each game clear feedback. But the degree to which each game succeeds in providing long-term play depends on how well the game harnesses the potential of the hitting mechanic to scale and meet various skill levels.

It would be easy to assume that hitting is simply a brutish act with little finesse. But what's great about hitting is that it scales with skill levels. While it's easy to hit something, it's very hard to hit with skill. Take baseball again. Swinging a Wiffleball bat and knocking a ball off a tee is not that difficult. With a little coordination and a few swings, we can all master it. Hitting a softball thrown by a pitcher can be more difficult. The ball flies through the air and you must quickly calculate its speed and arc, plus how long it will take you to bring your bat around in time to make contact. All the while you have to keep your eye on the ball if you want to hit it. And if hitting a softball seems hard, hitting a fastball thrown by a professional pitcher is nearly impossible. In his book *How We Decide*, Jonah Lerner breaks down the near absurdity of hitting a Major League Baseball pitch. A typical Major League pitch takes 0.35 seconds to fly from the pitcher's hand to the catcher's mitt. It takes a batter about 0.25 seconds for his muscles to initiate a swing. It takes a few milliseconds for the visual information of the oncoming pitch to travel from the retina to the visual cortex. This leaves the batter with about five milliseconds to decide if he is going to swing. The problem is people can't think that fast. It takes the human brain about 20 milliseconds to even react to sensory input.[2]

So Major League batters begin collecting information about the pitch before it's thrown. They read clues in how the pitcher stands, how he winds up, what pitches

[2]Lerner, Jonah, *How We Decide*, Houghton Mifflin, 2009, p. 25

he's already thrown. And at the moment of the pitch, the batter relies on instinct and years of training.

Hitting a baseball exists on a spectrum of skill, from straightforward to incredibly complex. The difficulty of completing the interaction demanded by the mechanic of hitting a baseball scales with a player's ability with very little modifications to the rules of baseball. Little kids play T-ball. They aren't usually the most coordinated players. The tee provides a way for them to hit the ball despite their poor coordination. As we get more coordinated, we move on to little league or office softball teams (both requiring about the same skill level). The amateur pitcher probably can't throw very fast, so hitting isn't usually that hard. It's largely a matter of keeping your eyes on the ball. Moving up to Major League Baseball, the act of hitting becomes more nuanced and skill based. But in each situation, the rules are essentially the same.

This skill scalability in physical play mechanics like hitting offers designers interesting opportunities. All games must be able to scale to player skill if the game is to continue to hold player interest over a long period of time. A game like Tic Tac Toe doesn't scale. Once you know how to win or force the game to end in a tie, the game breaks; there's no point in further play. Most people figure out how to move so that Tic Tac Toe will always end in a tie after only a few plays. Chess, on the other hand, offers a sufficiently complex system to allow for continued play over many years. Your physical skill at moving pieces never improves, but your mental skill does. As you continue to play, you gain a greater understanding of the ways in which the movements of the different pieces interlock in complex strategies.

Multiplayer games rely on the increasing skill levels of other players to extend your engagement. As you get better, you can challenge more talented players to test yourself. Physical games scale along with your physical ability. As you get better at controlling the bat, you can swing and hit the ball in different directions. Multiplayer physical games like baseball can take advantage of the scalability of both multiplayer variability and physical skill.

Not all physical play scales as well as hitting. Jumping, for example, tops out with the strength of your legs. No one has crafted a game as rich as baseball with jumping at the center of the game—a game that takes advantage of the subtleties which might be inherent with different types of jumping.

Hitting takes many forms. You can hit objects in so many different ways. This makes it extremely mutable as a mechanic. You can hit with your hand, with a stick, with a racquet, with your foot. This mutability allows hitting to work for games as different as boxing and *Wii Tennis*.

The clear outcomes of hitting also make it ideal for building a scoring system. The result of hitting something offers clear feedback which can be easily quantified. You can record anything from "you hit the object" to "you hit the object this hard" to "you hit the object this far" to "you hit this object to this location." This enables you to use the same mechanic to build a scoring system which accommodates everything from simple games like *Whac-A-Mole* to more spatially complex games like baseball.

Whac-A-Mole: 30 Seconds of Primal Pleasure

Hitting as a mechanic finds an almost primal expression in the family arcade game *Whac-A-Mole* (Figure 8.2).

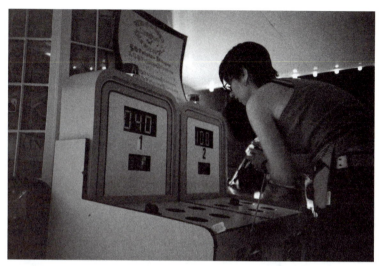

FIGURE
8.2

A player gets ready to whac a mole as soon as it pops up its little plastic head. (Flickr[3])

Aaron Fletcher created *Whac-A-Mole* back in the early '70s. Fletcher sold the game to a carnival operator who later sold the game to Bob's Space Racers who continue to manufacture the game and other similar arcade machines to this day. In 1980, Fletcher helped co-found Showbiz Pizza Place, which became one of the main buyers of his old game *Whac-A-Mole*. Showbiz eventually merged with Nolan Bushnell's Chuck E. Cheese's Pizza Time Theatre (he of *Pong* and Atari fame).

Whac-A-Mole is held in a large cabinet. The player stands in front of the game holding a large mallet. The goal of the game is to score as many points as possible by bopping moles on the head. Moles pop up out of holes in the cabinet. The player tries to hit each mole on the head before it disappears back down the hole. After a mole is struck, it retreats. The player scores points for each mole hit, and the points appear on the three-digit readout atop the cabinet. Each mole appears for a limited amount of time and retreats automatically if the player does not hit the mole. The game starts slow but quickly speeds up, with more moles popping up for shorter periods of time. The game lasts for a limited amount of time. On repeat plays, you can try to beat your own score.

In some ways, it's an excellent example of a casual game. From the second you pick up the mallet, you know exactly what to do. As soon as the moles start

[3]http://www.flickr.com/photos/sa_ku_ra/18984918, by sa_ku_ra

popping up, you're off and running. When you make contact, you get clear and direct feedback as you bop the moles on the head. You feel them crack beneath your mallet, you watch them disappear into their hole and you see your score tick up. Arcade machines need to be even more accessible than the casual video games you play at home. Sitting in the arcade, they have to compete with all of the other games and entertainment options just steps away. And since arcade games typically last somewhere between 30 seconds and two minutes, the player can't waste time with tutorials and learning to play. The player must be able to jump right in. *Whac-A-Mole* fits this bill.

It's a primal expression of power and aggression. It taps directly into our play instinct. In this manner, *Whac-A-Mole* exemplifies casual design. But in the end, it's a little too simple and a little too physical to inspire long-term play. Your interest in the game eventually exhausts itself, on both a physical and mental level. It turns out our desire to smack things on the head draws from a finite well. With each successive whack, the primal joy felt in hitting is replaced by a different type of enjoyment: the joy of meeting challenge with success. This joy lasts until the game begins to outpace us. Eventually the bobbing heads come too fast and you can't keep up. The game breaks down from the pressure to move faster.

The game only has one vector along which to scale difficulty: speed. More heads pop up simultaneously, but this is also a speed challenge. The only way for the player to get better is to get faster. Traditionally, casual players tend to shy away from skill-heavy twitch games. Action games requiring lightning-quick reflexes and hand-eye coordination can alienate casual game players. If the game requires high degrees of a specific physical skill, it prevents the average person from playing. *Whac-A-Mole* does not require much initial skill. But the number of moles you hit in a game will top out without more practice.

For most people, there is a rather finite limit at which our arm will allow us to swing the mallet. Sure we could practice more, but the game doesn't provide enough reward through addictive gameplay to compel you to undertake the sort of rigorous practice that it demands.

Whac-A-Mole's failure to draw the player into deeper and longer engagement is a consequence of limited choice and randomness. The game offers almost no deeper strategic play. There are not many interesting choices in the game—you want to hit as many moles as possible. You may be strategic in which clumps you choose to go after to take advantage of proximity, but really, you just want to bop every critter that pops up.

You can't really fault *Whac-A-Mole* for failing to engage players over a long period of time. The game is designed to be played in short bursts. It is entertaining for exactly the amount of time it needs to be. This is an important lesson for game designers to learn. Not every game needs to be chess, engaging the player for hours at a time. Sometimes, a few minutes are enough. The designer needs to take into account the context in which the game will be played, as well as the player's relationship to the game. It's perfectly fine for some arcade games to last only a

few minutes. Players at an arcade sample a number of different games, so they will likely move on to another machine at some point no matter how deep or compelling your game is. There's no point in building lots of content that few will ever see.

Designers should always consider where their game will be played and under what conditions. If you are designing a game for a console, players will expect longer and deeper gameplay. A console is a piece of hardware dedicated to playing games. Players carve out time to sit down in front the console and play for significant chunks of time. If a console game has gameplay that wears out after several minutes, players will no doubt be disappointed. Consumers of PC downloadables expect three to four hours of play out of the game. Designers making games for Web sites like Kongregate and Addicting Games must realize that, like an arcade, they must hook players fast as there are dozens of other games one click away and most players will only dedicate a few minutes to their game.

FIGURE
8.3

A Web version of *Whac-A-Mole* translates the gameplay to a digital format. (WHAC-A-MOLE and associated trademarks and trade dress are owned by, and used under permission from, Mattel, Inc. © 2009 Mattel, Inc. All Rights Reserved)

Though *Whac-A-Mole* may be short and punishing, its impact has been wide. The mechanic has been translated directly into Web banner ads goading you to "Punch the Monkey" and downloadable titles like the Nuclide Games-developed and PopCap-distributed *Hammer Heads* (Figure 8.4).

FIGURE
8.4

Hammer Heads replicates **Whac-A-Mole** gameplay in a PC downloadable. (Reproduced by permission of PopCap Games)

Not only have variations of the *Whac-A-Mole* mechanic found new incarnations in digital games, the term has made its way into wide-spread colloquial usage. The term whack-a-mole now connotes a repetitious and likely futile task, in which you will keep trying to hit a target that pops up seemingly at random. Among game designers, the term also describes a moment when a game breaks down to random actions to which the player must respond. Any game has the potential to devolve into whack-a-mole if the designer adds too many random interactions with little choice. For example, a shooter game can devolve into a state of whack-a-mole if enemies keep popping up with no rhyme or reason. Even games like *Bejeweled* can engender feelings of whack-a-mole; the player simply matches gems only to have new random gems appear in their place.

In cases where your game devolves to whack-a-mole, you need to look for ways to reapply order to the randomness and find a way to give the player meaningful choices. You can institute more legible patterns or scale back the variables generating the randomness. If you don't, the game will quickly run its course as players tire of the noise. This may be okay if the game is designed to provide a quick visceral experience. But if you want longer strategic interactions, players need better choices than whacking random moles.

Wii Tennis: The Swing Is the Thing

Wii Tennis derives its primary pleasure from swinging your Wiimote like a tennis racket. Before you can even start playing, you have to push your coffee table out of the way and clear a big enough area for you and your opponent to really wind up and crank the ball. You loosen up, stretch your arms and get ready to swing. When the game comes on, you bob from foot to foot just as you would if you were playing real tennis and you swing with great intensity as the ball comes bouncing toward your little Mii. Sure, all you hit is air, but when you look at the screen and see your ball zipping back towards your opponent and skipping just out of his or her reach, you experience a moment of intense satisfaction, as if you actually creamed a real ball (Figure 8.5).

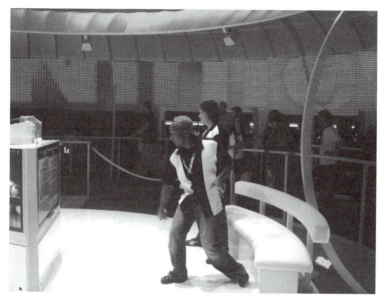

FIGURE
8.5

A player swinging the Wiimote to nail a ball in *Wii Tennis*. (WikiCommons[4])

Of course, experienced Wii players realize you don't need to swing the controller to hit the ball. A simple flick of the wrist will do just fine. The accelerometer tucked inside the Wiimote, which measures the force applied to the controller, isn't all that refined. A small child can easily apply enough force to top out the meter. It's much more efficient to sit back on your couch and play *Wii Tennis* by flicking your wrist in tight controlled motions at the exact right moment. But it's also a lot less fun. By playing the game as you would any other video game (namely sitting on your butt on the couch), you rob yourself of the visceral pleasure that makes *Wii Tennis* so unique—the wind up and swing.

[4]http://commons.wikimedia.org/wiki/File:Wiiate3_2006.JPG, User: Cian Ginty

As we discussed earlier, *Wii Tennis* offers a new vision for casual gameplay. The game—combined with the Wii hardware—drew in players who had little interest in video game consoles. It promised and delivered a more physical play. You can argue that the motion detection software is not terribly robust and that it has largely served to enable mini-games. But this misses the fact that a lot of people still swing the Wiimote even though they know they don't need to. It's fun. And better than that, it's instantly fun. You don't have to go through a long learning process to see the complexities of the game in order to appreciate the play.

The game does a great job of translating hits on screen. A really good, well-hit serve zips across the net, leaving a trail of ghostly balls. The designers also made hitting relatively straightforward. Players don't need to run to the ball. They just need to swing at the right time. Since the game doesn't require a specific motion— just a general change in force—players can easily pick up the game and play without learning a specific motion to hit the ball. However, the game does leave some room for improvement. Players can improve their timing, hitting the ball at just the right moment to improve their hits.

The simplicity intentionally built into *Wii Tennis* does limit its long-term playability. It's not too hard to master *Wii Tennis*. The game definitely enables players to improve their swings some. But a swing in *Wii Tennis* offers far less complexity than hitting a real tennis ball. This is not meant to fetishize simulation or to suggest that *Wii Tennis* should more realistically model real tennis. It should do no such thing. *Wii Tennis* is designed to draw players onto the Wii, not to offer deep long-term strategic gameplay.

The lack of much scalable skill in *Wii Tennis* points to a contrast between physical games and digital games. Physical games have analog inputs, meaning the input operates on a spectrum. There is an almost infinite number of ways to bounce a ball or swing a tennis racket. Each swing of a real-world tennis racket is comprised of small adjustments and motions from your grip to the length of your wind up, each contributing to how the ball reacts on impact. This spectrum of inputs leads to a greater number of outputs. In this way, real-world physical games have a wide variance of outcomes. Players practice and practice so they can better replicate the good outcomes. They can spend years doing this. As they master their sport, they learn to use the minor adjustments to get the exact outcome they want.

Video games have digital inputs—they are either on or off. Either you press A or you don't press A. You may press A closer to the right moment, but you don't press A with more or less skill. Board games generally have these sorts of digital or on/off inputs as well. This pushes video games to be more about decision-making than physical skill. This is not to say that video games don't require skill. They require quite a bit of skill, but of a very different nature than physical play. They require good timing combined with decision making. Many video games resort to exacting timing and spatial puzzles that players must play and repeat until they solve them. But this is more like asking a player to memorize and recognize patterns than build up a skill. This means many video games must eke long-term play out of decision-making and not mastering a specific physical skill.

Wii Tennis presents an interesting mixture of digital and analog. The swing the player performs is analog, but the input is still relatively digital. It may take a number of samples of your movement as you swing, but the number of vectors it tracks is nowhere near the number involved in swinging a real tennis racket. This is not bad. In fact, it's what makes *Wii Tennis* playable and fun. If *Wii Tennis* meticulously simulated a real tennis swing, the game would be much harder. First, the Wiimote does not provide the same heft and feel of a real tennis racket. You never actually hit a ball, so you never learn how different hits feel and react, making it much harder to parse and repeat your swings. It lacks true physical feedback. Second, tennis is hard. To play tennis on the level of even a Mii in *Wii Tennis* would take a non-tennis player weeks of practice. But no one wants to wait weeks to be good enough to have fun at a video game. You want success at a video game much sooner. And you want success at a casual video game almost instantaneously.

Digital inputs enable players to successfully perform moves faster than analog inputs. Players can reach competency with a video game much faster than they would with a sport. But this also means that players may tire of a video game faster than a sport because it is easier to master. Video games combat this in several ways by requiring a greater and greater number of inputs to successfully perform a move. Fighting games like *Tekken* or *Streetfighter* require the player to perform long sequences of arcane button presses to perform special moves. By adding inputs, the game seems to be attempting to emulate an analog spectrum of inputs and the skill required to perform them quickly and in combination.

While *Wii Tennis* does not increase the range of inputs to formally complicate the swing, it takes advantage of the appearance of being analog. It looks like you should give the Wiimote a full-bodied swing. As we all know, appearances can be deceiving. They can also be fun.

Summary

Physical play mechanics—like hitting, shooting and running—offer game designers rich bases on which to build games. Though they often appear quite simplistic and straightforward, mechanics like hitting actually allow for deep interaction as players work to master the physical skill. This can be both a blessing and a curse for game designers. By relying on players to develop physical skill at activities like hitting, game designers can create very simple straightforward casual games that still take time to master. However, if the game doesn't engage players enough to inspire the necessary learning, they will quickly abandon the game.

Translating these physical mechanics into the digital realm can sometimes be tricky. It often flattens the interaction. Video games must reduce the physical nuances into digital inputs. However, through clever feedback, video games can still emulate the powerful sense of feedback one gets from physical interaction.

As we saw with *Whac-A-Mole*, hitting alone can seem a little thin. Once the visceral pleasure wears off, the game needs something else to buoy the gameplay.

Because it's so mutable, hitting can easily be combined with other mechanics. Even baseball embeds hitting within a rich gameplay system of other physical mechanics, like running, catching and throwing, as well as resource mechanics like strikes, outs and innings. Similarly, it's easy to imagine new video games growing out of combinations of physical mechanics like hitting and mental mechanics like matching or sorting. Sorting or matching could provide the robust decision-making side of the gameplay, while hitting could inject a bit of theater and visceral fun.

Chaining

Sometimes a game just needs a little something more to bring it all together. You can have a well-crafted core mechanic that works as expected and still find playing the game to be a little lifeless, a little boring. For a designer, this can be vexing. Through iteration, you've given the core mechanic the proper constraints. The interaction plays as you envisioned it. The player can move straight through the game, accomplishing small goals which lead to winning the level or the game. Yet playing the game feels as if you're painting by numbers and the game lacks a sense of tension. In cases like this, the game probably needs an additional mechanic, to add a different vector to the gameplay. By adding another vector, you offer a fork in the clear path through the game. The player can no longer simply proceed along the straight line toward the finish line without at least considering taking the other path. Done right, adding another vector adds tension and choice to the game and infuses it with more life.

There are many ways to add another vector to a game. Sometimes a game just needs more stuff—more things to look at and click on. In *Insaniquarium*, the game designers build this tension by adding more of the same. They stack similar interactions on top of one another until simply performing all of these interactions builds a requisite level of tension (or in the case of *Insaniquarium*, frenzy). You can imagine the designers, starting with the management of fish, feeding them by dropping food in front of them. That mechanic engages the player, but not fully. So the designers layer in the act of picking up coins in addition to the feeding. Now players must feed fish and pick up coins. This engages the player a bit more and adds tension in the form of more activity. Then on top of that, the designers add the alien-shooting mechanic. Performing all three interactions in concert, the game begins to achieve a sufficient level of tension. For good measure, the designers add a few more interactions: items for the player to purchase and power-ups, all with the hope of bringing the game to buzzing life. And it works. With enough interactions and stuff going on, *Insaniquarium* begins to feel dynamic, even if all of the interactions are along a similar vector (Figure 9.1). They all point the player toward the same goal. The conglomerate of these stacked interactions makes *Insaniquarium* feel a bit patchwork.

FIGURE
9.1

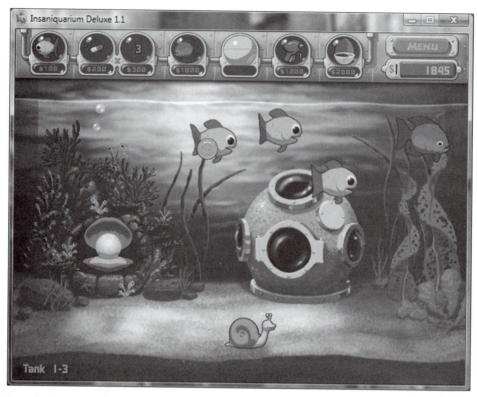

Insaniquarium **brings the game to life by adding interaction upon interaction. The core of the game is feeding fish. On top of that the player collects coins, buys power-ups, shoots aliens, upgrades tools, buys new fish and clicks on pearls. Through the accumulation of clicks, the game becomes dynamic. (Reproduced by permission of PopCap Games)**

Sometimes a game comes to life with a few more points stirred into the mix. Never underestimate the importance of clear feedback and rewards for the player. In fact, some games get by almost entirely on their feedback. The pleasure in pachinko and playing slot machines derives almost entirely from the garish feedback (Figure 9.2). Sure, the random test of fate eventually grips many a gambler, but the lights and sirens draw them in. PopCap seemed to recognize this when they designed *Peggle*, their video game version of a pachinko machine. Players shoot balls at pegs and watch how they bounce around and score other pegs. Each peg awards you more points. Then at the end of the level, after you've knocked out your last peg, you are treated to a rousing rendition of Beethoven's *Ninth Symphony*, rainbows and fireworks (Figure 9.3). It's all enough to make you feel darn special and help you forget the fact that for most of the game you're simply watching a ball bounce down among a series of pegs.

FIGURE
9.2

Slot machines are studies in oversized feedback. The bells, whistles and garish lights all serve to draw the player in and make the very simple exercise of pulling a lever feel meaningful and grand. (WikiCommons[1])

FIGURE
9.3

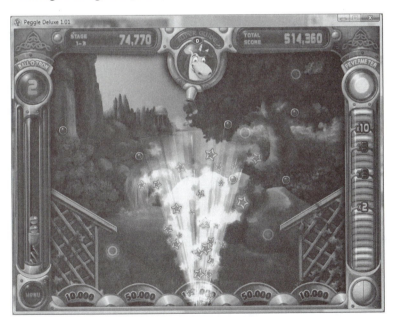

At the end of each level in *Peggle*, the game treats the player to bursts of fireworks and streaking rainbows set to the score of Beethoven's *Ninth Symphony*. (Reproduced by permission of PopCap Games)

[1]http://commons.wikimedia.org/wiki/File:Vegas_slots.JPG, User: Mormegil

Sometimes, though, a game can't be brought to life by simply adding more clicks and stars. The game may require a different vector that actually directs player behavior and gives the experience more shape and tension. This vector needs to be at slight odds with the main gameplay. It should present a different choice or ask you, the player, to do something different from what the main game mechanic asks. Sometimes, this second vector stands in actual opposition to the main mechanic, asking you to do something which puts your success with the main mechanic at risk. This forces you to continually make the decision: do I take the easy route and do okay or take the more complex route and risk failure, but reap serious rewards?

Diner Dash: Pushing Your Luck

The chaining mechanic in *Diner Dash* provides an excellent example of a vector that runs at almost perpendicular angles to the main mechanic of ushering customers through their meal. Peter Lee, the co-founder of Gamelab and the producer of *Diner Dash*, maintains that *Diner Dash* wasn't fun until they started giving players points for every click. Despite the engaging spinning plate core mechanic, the game still felt a bit limp. But when they started giving points for each step in the process, the game came to life. As always, more feedback is a good thing. But it's not just that *Diner Dash* awards lots of points, it's how *Diner Dash* awards those points that really imbues the game with a dynamic back and forth between risk and reward.

The basic mechanic of stepping through the process of serving customers is relatively straightforward. The player learns the basics in the first level and, after a few customers, the player has the process down pat. Plus, the game won't let you bring customers the wrong order or botch the order of steps. This means the game really only gets complicated when you must serve multiple customers at the same time. When you have multiple customers, you must watch their moods and make sure you react quickly in order to move keep the line moving. But even in these cases, your best option is generally to proceed in the order the customers arrived.

This sort of straight path through play can be deadly for a game. After a bit of experimentation, players will find a game's optimal strategy and set of moves. Then they will continue to perform that set of moves over and over. They will do this even if it makes the game more boring to play. In response, frustrated game designers bemoan, "But it's more fun if you play it this way!" That very well may be, but designers can't expect players to go that extra mile and play the game the right way, just to have fun. This sort of frustration often grips first-time designers. See, the funny thing is, players don't really want to have fun. No, they want to win. Fun is a sort of happy accident by-product of playing a game in order to win.

Players want to win, and through the structure of the game, you've told them the way to win. Once players find the optimal strategy—the strategy that results in the fewest moves in proportion to the greatest score—they will continue to do that until something prevents them from doing it. Sometimes, it takes a little while to figure out the optimal strategy. But every player, from the moment they sit down with the game, is looking for the path that offers the least resistance and the greatest reward.

As a designer, ideally you want to create games that don't reduce to one optimal strategy, but instead offer an array of different strategies that offer different rewards. This can be really hard to do. Even complex systems often break down to relatively simple answers. One way to get around your game reducing to one obvious path is to offer an attractive alternative to the optimal strategy.

Diner Dash smartly avoids pitfall of having just one optimal strategy by offering a mechanic which pulls the player in an alternate direction. To add choice and tension to the gameplay, *Diner Dash* employs a chaining mechanic that subverts the straightforward march through the process of serving each customer.

Diner Dash rewards you for performing the same action multiple times in a row. Each time Flo takes an order in *Diner Dash*, you receive a base amount of 20 points. However, if you take multiple orders in a row, meaning you don't bring another customer food or clear a table, but instead just walk around taking orders, you receive a multiplier bonus that increases for each customer in the chain. So, for the first order you receive 20 points. For the second order, you receive a bonus multiplier of two, doubling your score to 40 points. For the third order in a row, you receive a bonus multiplier of three, for a total score of 60. So if you take three orders in a row, you score a total of 120 points. This is double what you would have earned if you took three orders in the normal course of play. In this way, chaining greatly increases your score. You earn a similar bonus by chaining other actions in the serving process. The longer the chain, the bigger the reward. Through these bonus points, the game heavily incentivizes you to chain.

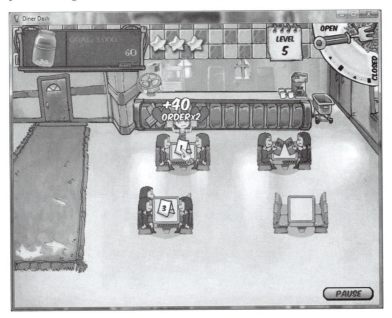

FIGURE
9.4

When you perform the same action consecutively, you receive a bonus multiplier for chaining the actions. The more times you perform the action, the longer the chain and the bigger the multiplier. (Copyright © 2003 PlayFirst, Inc. Reproduced by permission of PlayFirst, Inc.)

This incentive to chain puts you at odds with the straightforward play path of just serving customers and answering their needs as they come up. Playing without chaining, you would rush over and take a customer's order as soon as their hand comes up, and then bring the food as soon as it appears in the window. But chaining orders prevents you from playing this way. You must line up actions, delaying taking actions on a customer until you can create a situation where you can perform multiple instances of the same action consecutively.

This forces you to hold off serving some customers even if they are getting impatient and losing hearts. For some players, this can be very hard to stomach. When those fumes of anger appear over a customer's head (Figure 9.5), indicating they are about to lose a heart, your first impulse is to rush over and serve them. You know if you wait too long, the customers will leave and you will lose points. But experience has also taught you that you will score more points if you can hold out and chain your actions. Chaining presents both greater rewards and risks.

You must perform the necessary risk assessment on the fly and decide when to chain to maximize points and when to break the chain in order to save a customer. It seems like a straightforward decision, but sometimes it may actually be more cost-effective (in terms of overall score) to lose a customer than to break a series of chains.

FIGURE
9.5

Chaining puts you at risk of losing customers. In the queue on the left, customers are already losing hearts, with no foreseeable place to seat them. This tension animates the game. (Copyright © 2003 PlayFirst, Inc. Reproduced by permission of PlayFirst, Inc.)

To complicate matters, the game layers in multiple types of chaining. You can chain actions on customers, as well as by matching customer colors to seat colors. Lining up all of these actions can get complicated, and a bit stressful, when those customers' hearts start to disappear.

Initially, the game does not require you to chain. The score thresholds are low enough that you can get by merely serving customers on an ad hoc basis. The game teaches you to chain from the very start, but it does not require it. But as the game progresses, the score thresholds rise, forcing the player to confront the rewards and risks of chaining. This adds tension to the gameplay. Eventually, to pass certain levels, the player must chain. At this point, the game rewrites the dominant strategy of the game. Until this point, the dominant strategy (or in this case, the path of least resistance) was to churn through as many customers as quickly as possible; the new dominant strategy requires you to chain in order to maximize points to win the level. The game now teaches you that the path to success is through chaining.

In later levels, the play shifts yet again and it becomes better to quickly serve customers and ignore chaining. This ever-shifting set of strategies keeps the game fresh. The different vectors created by the spinning plates mechanic and the chaining mechanic give the game designer a number of different levers to pull to create differing experiences from level to level. Nick Fortugno, the game designer behind *Diner Dash*, milks this tension, giving the level progression a feeling of evolution.

Chaining wouldn't work, however, if the player were simply being rewarded for doing things in the same order the main mechanic requires. It would reinforce the main mechanic, not add tension to the game. If the game rewarded you with bonus points for following the path of least resistance, the game would become boring, as it would make the dominant strategy even more obvious, robbing you of any need to make strategic decisions.

Chaining is a very clear way to shape player actions. The designer can lay out a specific chain of actions, effectively saying, "This is the order I want you to do things in, even if another element of the game says do them in a different order." It also gives the game designer a clear way to say, "I know you want to do this, but you might want to do this." The game designer can lay out these multiple options, then leave it up to you, the player, to choose which path you want to pursue. This gives you a meaningful choice that directly impacts your experience in the game.

Chaining asks you to push your luck to see how long you can accomplish both goals before having to meet the requirements of the main mechanic. The longer you can keep a chain going, the more rewarding (and thus more exciting) the game grows.

Many other games use some form of chaining to help shape the experience. Time management games often use some form of chaining to add tension to the game. We used forms of chaining in *Jojo's Fashion Show* to help shape the levels and add tension. Players scored bonus points in *Jojo's Fashion Show* if they sent out multiple models dressed in the same style in a row. They received an even bigger bonus if they could fully dress all three models and send them out without making changes to their outfits. This incentivized players to quickly dress models and also really consider whether they wanted to change an outfit to give a model a higher scoring

top or whether they wanted to take the chaining bonus. Even this small, minor choice complicates play and keeps players on their toes.

Matching games like *Bejeweled* and *Luxor* have their own forms of chaining as well. They enact chaining by rewarding players for multiple matches that occur without having to make other moves. The first set matches and causes other matching pieces to come in contact with one another, creating another match. This encourages players to arrange pieces into arrays that will result in multiple matches when the first match is triggered. To find these chains of matches, you must look several steps ahead. This takes the rather simple mechanic of matching and makes it much more complex as you must account for much more spatial information. By producing these chains, you can reap outsize rewards. But if the game has a time limit or some other game-ending mechanic, setting up the multiple match chains can be risky. Players must quickly weigh the risk and rewards of setting up complex chains of actions.

FIGURE
9.6

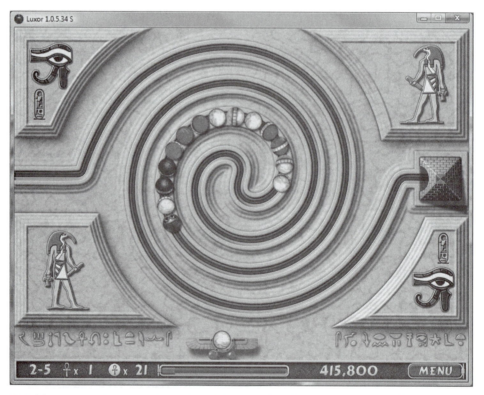

Matching games often use a form of chaining seen here in *Luxor*. When you shoot the yellow into the group of three yellow balls in the middle of the loop, the reds on either side will roll together and create another match. (© MumboJumbo)

Chaining certainly isn't the only way to add additional vectors to gameplay. Providing supplementary goals in the form of rewards for specific types of behaviors—such as collecting achievements and items—accomplishes a similar effect. However, they are most effective at creating tension when the supplementary goals don't simply reflect or reinforce the main goal of the game. The dozens, sometimes hundreds, of achievements now built into Xbox games for players to find provide one example of supplementary goals. However, these awards usually serve more to bolster replayability than to add tension to the original play.

Be careful with chaining and additional vectors. Too many additional vectors and the game may grow confusing. The second vector cannot simply run perpendicular to the main gameplay or it will seem tacked on and contradictory. This will confuse players and potentially turn them off. Casual games can have multiple vectors, but they need to be carefully considered. Instead of running perpendicular to the goal of the main mechanic, the secondary mechanic should run at an angle to your core mechanic. It should complicate the achievement of the main goal, but in doing so allow for even greater success than simply following the more obvious path.

Summary

Looking for new ways to build in supplementary goals, chaining and push-your-luck moments into games can be a good way to inject new energy into a lifeless game. For example, you could imagine a *Solitaire* game where the player is rewarded for moving cards of the same color in consecutive moves. This mechanic would stand at odds with the normal alternating color play of *Solitaire*. Some places you might screw yourself and bury a card you need later, but having to make that choice would be a fun and tension-filled moment.

Chaining isn't the only way to add additional vectors to gameplay. It's just a very straightforward one that enables you to directly craft alternate paths. As you design games, you will often find yourself in need of some other vector that pulls the player away from the optimal strategy. The best way to find that other vector is to run through a series of mechanics that pull and push at your original gameplay. It can be nerve-wracking for designers, especially casual game designers looking to make clear and concise games. Additional vectors complicate and cloud the clear core mechanic you spent so long polishing. But you may find great rewards, if you just push your luck a bit.

CHAPTER TEN

Constructing

Games provide great laboratories for experimentation. They exist in a space largely free of real-world consequences. When you first come to a game, you have only a vague idea of how things will play out once the game is set in motion. You may look at the board and think, "I see. I should buy as many of these properties as I possibly can, especially these two cheap ones right by GO," only to find out as you play the game that Baltic and Mediterranean Avenue barely earn you two pennies. That's okay. Now you know and the next time around you can experiment with buying different properties. Games enable you to take clear quantifiable actions, observe the results and then develop new strategies. You get to see the direct results of your actions. You get to develop theories about what will work better and then test those theories in a closed environment free of consequences.

You get to design a building without worrying if it will truly be able to stand. Or you get to run down a tunnel full of hostile aliens, be killed, respawn and run down a different tunnel instead. Critics of games bemoan this lack of consequences as one of the key deficiencies of games. They believe that players, particularly kids, take away from games the notion that they can simply restart a level if they get into trouble. These critics see this as a dangerous lesson because no such do-overs exist in real life.

But this freedom from what are really more repercussions than consequences should actually be celebrated. Yes, games may teach kids they can do things over and over again until they get it right, but this is actually a really important notion to grasp. What games teach is something close to the scientific method. You get to formulate an hypothesis about what will work and then devise a means to test that hypothesis. You get to say to yourself, "If I jump over here and flip this switch, I think I'll win the level." And when that doesn't work the way you expected, you can say, "Okay, now I know that platform is too far away. I wonder if I jump here instead and then there, if that will get me to the switch." This process teaches kids to experiment and develop systematic problem-solving skills.

So games don't lack consequences. If anything, they are nothing but chains of actions and consequences. What they lack are moral consequences. And moral consequences are quite a burden to expect games to bear. Games themselves are agnostic to morality. As in all forms of media, the morals in a game reflect the moral viewpoint of the author.

In his excellent book *What Video Games Have to Teach Us about Learning and Literacy*, James Paul Gee examines the ways games encourage systematic learning. He makes the compelling argument that games teach valuable skills not being taught in traditional primary school education.

Gee believes that games teach players about domains of knowledge and how to transfer knowledge from one domain to another. The world is full of different domains of knowledge, from law to basketball. Each domain has its own particular set of signs, symbols and rules which define or apply to the domain. In order to understand the domain of law or basketball, we must learn to read the signs and symbols associated with it. In a legal environment, this may mean understanding the difference between a tort and a law. Reading basketball demands you understand that a player must dribble the ball and that shouting "Outlet" refers to a specific pass pattern. Court in law and court in basketball have very different meanings. Yet they also share some elements of meaning. In both law and basketball, court refers to a stage where things play out.

The various domains we encounter within the world overlap, sharing some aspects of meaning. We are constantly transferring our knowledge from one domain to the next. When we encounter something new we haven't studied, we approach it with all of the knowledge we have built up by studying other subjects and domains. But this transfer of knowledge isn't always straightforward or easy, especially when our schooling separates subjects and pushes us into specialization. It's a skill we must build up through practice and experimentation.

Games exist within their own semiotic domains. *Bejeweled* represents its own domain. The player learns the rules and mechanics specific to *Bejeweled*. Gems can only be swapped into matches. At least three like-colored gems must be present to create a match, etc. Surrounding *Bejeweled* is the larger domain of match-three games. When a *Bejeweled* player encounters another match-three game like *Luxor*, she immediately makes certain assumptions about how the game works, such as to make a match she must create groups of at least three. She assumes she must create matches based on color. These assumptions bear themselves out. The player may at first assume she can only shoot balls into matches, but she quickly realize this is not the case. Players can place balls anywhere they want. This new bit of knowledge then helps her shape her mental model of match-three games.

This process of knowledge transfer bears itself out as the player explores different games. The important thing is not necessarily the specific pieces of knowledge that the player takes from domain to domain. What's important is the thought process which goes into transferring the knowledge. Gee makes the important argument that the most valuable learning that goes on during gameplay is not the acquisition of specific facts or pieces of knowledge, but practice at systematic thinking and experimentation. Games teach us to creatively approach and solve problems.

Games centered on constructing highlight this scientific process and foreground it in a way other games merely hint at. All games offer chances for experimentation, but nowhere is the process more manifest than in games that revolve around building and constructing. These games provide sandboxes to build everything from

skyscrapers to three-course meals without having to worry if it will stand or give you food poisoning.

Tetris and *Crayon Physics*: Two Approaches to Building

Did you know that playing *Tetris* actually thickens your cerebral cortex?[1] Apparently spinning and slotting together all those tetrominoes is like the mental equivalent of push-ups. It may not make you Mr. Universe, but it does help you stay in shape. A number of researchers have investigated the effects on the brain of playing *Tetris* and found that the game increases cerebral energy and boosts general cognitive functions, from critical thinking to language processing.

I doubt that *Tetris* is the only game that stimulates mental activity. I would hazard a guess that most games foster at least some increases in cognitive activity. *Tetris'* ubiquity and simplicity make it an ideal candidate for study. Thanks to its extremely casual play, anyone can get into the game and be a test subject. And its incredible addictiveness must make it easier to find test subjects willing to keep playing the game. But there are also some interesting features of the game mechanics which could very well be driving those boosts in cognitive activity.

So what makes *Tetris* so compelling and addictive? The actual mechanics are very simple. You work with seven shapes, often referred to as tetrominoes. Each piece consists of four squares. Tetrominoes drop from the top of the screen one piece at a time (Figure 10.1). As soon as one piece reaches the bottom, a new, random tetromino starts falling. You rotate and slide the pieces back and forth as they fall, to get the pieces into ideal positions before they hit the bottom. As more pieces fall, the game board fills up, but if you fill an entire row with pieces, they score and disappear. Scoring pieces gives you more room. Clearing multiple lines at once scores more points than clearing lines individually would. The game ends when the stack of tetrominoes reaches the top of the screen.

As the game continues, the pieces fall faster and faster. The game starts easily enough, but soon the pace quickens and the game grows more frantic. You become unable to fit the pieces together evenly. Then the little mistakes eventually begin to stack up on top of each other. As this happens, you have less room to work and the game becomes even more difficult. And then suddenly the game ends as the stack reaches the top.

The limited set of pieces makes each easy to recognize, keeping the game casual, but also enabling you to play much of the game in your head. Once you grow familiar with the shapes, you can rotate them in your head before you rotate them onscreen. If *Tetris* was filled with more complicated shapes in greater numbers, you might have a more difficult time doing the quick mental manipulation of pieces that the game requires as it speeds up. Figuring out how a piece would look rotated 90 degrees

[1]"PLoS ONE: Can Playing the Computer Game 'Tetris' Reduce the Build-Up of Flashbacks for Trauma? A Proposal from Cognitive Science," http://www.plosone.org/article/info:doi/10.1371/journal.pone.0004153

FIGURE
10.1

**When you first learn to play Tetris, you spend time just clearing rows as fast as you can.
(Reproduced by permission of Tetris Holding, LLC)**

and how it would fit together with other pieces would require more experimentation. But since you can easily conceive of and recall the different rotations of each piece, you can imagine the piece in the right position before pressing a button. This mental modeling of the game probably accounts for some of why the game embeds itself so deeply in the minds of players. Players frequently report that after an intense game of *Tetris*, they continue to "see" and manipulate *Tetris* pieces in their head.

The game derives its tension from the balance of risk and reward of building. Though it may not look like it (because the goal of the game is to actually get rid of pieces), *Tetris* is really a game about building. To score more points, you must build structures with holes you can plug with specific pieces to earn big scores (Figure 10.2). Big structures present a big risk: you have less space to work with while you wait for the right piece. New *Tetris* players tend to focus on clearing rows as quickly as possible. But as their play advances, many will start building up stacks and dropping in pieces that enable them to score multiple rows at once. (Clearing four rows at once is called a "tetris.") This produces much higher scores. It also offers greater challenge. Like the chaining mechanic in *Diner Dash*, higher scores for multi-row clears give you a valve you can turn to modulate part of your challenge. If you feel comfortable clearing pieces and the play hasn't grown too fast, you can

FIGURE
10.2

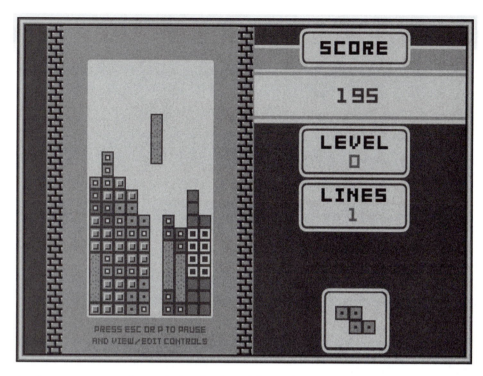

As players get more advanced, they begin to build up larger and larger structures so they can clear multiple lines at once for much larger scores. The tension in the game rests on this fulcrum between risk and reward. (Reproduced by permission of Tetris Holding, LLC)

start building stacks and leaving holes to plug later when you get a specific piece that will enable you to fill multiple lines. But if the tower gets too high and you get nervous, you can plug holes with stop-gap pieces to start clearing lines, giving yourself extra breathing room.

The building process in *Tetris* also gives the player room for some creativity and self-expression. Not only do you choose how much you want to risk, you also get to build in ways which fit your skills. Each *Tetris* player probably stacks the blocks slightly differently, preferring different shapes and formations. Your creativity is, of course, limited by the range of shapes and the fact that they all fall from the top. The game allows creative building within a narrow channel.

The downloadable game *Crayon Physics Deluxe* provides a very different take on building and constructing. It offers a much wider channel of options for the player to explore, while still directing the player towards a specific goal.

Crayon Physics was created by the Finnish game designer Petri Purho. Purho has made an amazing career out of experimentation and rapid prototyping. He frequently develops his games, or at least the core gameplay, in a single week. The original version of *Crayon Physics* was developed in five days. Purho claims he

was inspired by descriptions of the classic children's book *Harold and the Purple Crayon,* about a small boy who can change the world by drawing on it with his purple crayon. In many ways, *Crayon Physics* hands players that magical crayon and lets them draw bridges, cantilevers, baskets and hammers, all of which come to life in the game and affect the gameplay. Purho posted the game on his Web site, where it garnered widespread popularity and acclaim. After the success of the initial version of *Crayon Physics,* Purho spent more than a year developing a more robust version of the game called *Crayon Physics Deluxe.* The game went on to win the grand prize at the Independent Games Festival in 2008.

Crayon Physics Deluxe is a puzzle game consisting of more than 70 levels. In each level, you must move a ball around the playing area so that it touches all of the stars spread throughout the level. However, you can't directly control the ball. Instead you must devise a system of objects which knock, push or carry the ball to the stars. You create these objects by drawing them on the screen with a crayon (Figure 10.3). Depending on how you draw them, the objects become rigid surfaces,

FIGURE
10.3

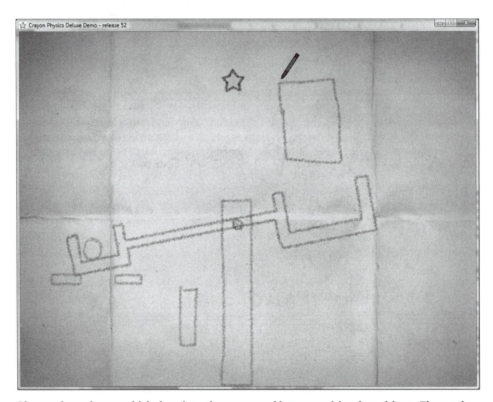

Players draw shapes which drop into the space and interact with other objects. The goal of each level is to move the red ball so that it touches the yellow star. In this level, the player draws a large block which drops into the lever and flings the ball up to the star. (Reproduced by permission of Kloonigames)

pivot points, wheels or ropes. The ball and all of the objects you draw are affected by gravity. They will roll, fall, slide and swing depending on how they are positioned. The freeform drawing mixed with the dynamics of physics provides a wide range of solutions to each level. There are many different things a player could draw to solve each level and even a wide variety of subtleties possible in a single line.

The game takes brilliant advantage of a common playful activity—doodling and drawing—and transforms it into a game. Everyone can draw a square or circle, if perhaps a bit of a lopsided one. This makes the core idea of the gameplay intuitive and casual. The core idea of drawing a path to another object clicks instantly, giving the player access to the concept of the game. In actual implementation, the game feels much less casual. The main problem is that drawing is most definitely a skill-based act. While the game does not require you to be a skilled draftsman, it certainly helps to have a steady hand. You also quickly find that drawing with a mouse is much more difficult and awkward than drawing with a pen. In addition, the added dimension of physics complicates the drawing and makes the play much less straightforward than simply drawing a path. The player must figure out how to set everything in motion. Fortunately, the game is very forgiving and allows the player room to experiment, fail and succeed.

If the building in *Tetris* is hindered by the time pressure, *Crayon Physics Deluxe* is quite explicitly about building and experimenting. You can take as long as you need to finish a level. The focus of the gameplay is on creatively solving the problem posed by each level. This focus on creativity manifests itself throughout the game. The game doesn't just give you a series of blocks and joints to creatively arrange. This would have been hard enough. No, *Crayon Physics* considerably expands the possibility space by enabling you to draw a range of shapes in different sizes (Figure 10.4).

Yet *Crayon Physics* still directs your play towards a goal. It is not simply an open-ended creativity tool. To keep progressing through the game and gaining access to different levels and content, you must complete levels by moving the ball and hitting those stars. This simple goal gives shape to the entire game and spurs players to craft their objects in specific ways. While there is probably a broad range of solutions possible for many levels, I imagine most players take a relatively direct route. Because the game asks the player to progress, many players will focus on solving the problem as quickly as possible rather than building elaborate or elegant machines to move the ball. There will, of course, be players who do sketch out elaborate solutions for each level, priding themselves on their ingenuity. This is similar to the way expert players in *Tetris* move away from simply scoring single rows and start constructing more elaborate structures that offer more reward both in points and personal challenge.

Despite its casual, almost childlike, look and feel, *Crayon Physics Deluxe* feels much more hardcore and more difficult to master than *Tetris*. The game does an excellent job of guiding the player through initial play. But it also places higher demands on the player. The game uses a model of physics to determine movement in the game space. This makes for a lot of interesting possibilities, but it also makes the consequences of chains of events much less exact. Small changes in placement

FIGURE
10.4

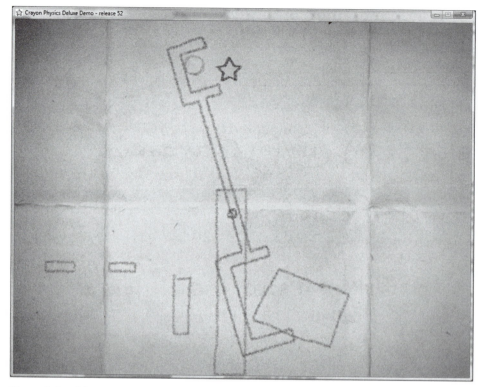

Most of the objects in the game space react to gravity. As the game advances, the player learns how to draw more complex objects, from lines to joints to levers. (Reproduced by permission of Kloonigames)

and shape can produce very different results. Blocks fall in *Tetris*, but they do so at a very constant, easy-to-read pace. There are no physics to speak of. When a tetromino hits the ground, it does not bounce or roll. It simply snaps into place. The result is that the game space is much easier to read. You don't need to experiment when placing a piece. You know exactly how it will fit in. This is not to say *Tetris* isn't hard. It gets extremely hard and eventually beats you no matter what. But *Crayon Physics Deluxe* requires cognitive involvement along more vectors. The player must think not only about the spatial puzzles, but about the best shapes to achieve the ends and how all of those shapes will interact with gravity and friction.

Both games hint at ways building can be used within goal structures to create interesting gameplay. One offers a wide-open freeform playing field, while the other feels more structured and constrained. But the key to both, what drives the games forward and gives the experience a sense of tension and shape, are the goals the games lay before players. Constructing is a natural playful activity. We grow up building towers out of blocks and watching them topple. Games like *Tetris* and *Crayon Physics* tap into that playful constructive impulse and give it goals.

Creative Construction

Games with building at their core provide a different sort of expressive play than you might find in more tightly bound game systems. With a looser system, you open up the possibilities for the player to expressively solve problems.

In his essay "The Heresy of the Zone Defense," art and cultural critic Dave Hickey bemoans the use of zone defense in basketball. As Hickey sees it, zone defense limits improvisation and creativity in basketball. He uses the example of Julius Irving's up and under layup in the 1980s NBA finals game between the Seventy-Sixers and the Lakers. Julius Irving drives in from the right side of the lane. As he jumps, Kareem Abdul-Jabbar turns to meet him and raises his hands to block Irving's path to the hoop. Irving twists in mid-air. He looks like he's going to fly out of bounds. But then suddenly, from behind the backboard, he pinwheels his arm and flips the ball off the glass and into the hoop. It's truly an unbelievable moment that seems to defy the laws of gravity and your notions of what is possible in basketball. As Hickey writes, "Consider this for a moment: Julius Irving's play was at once new and fair! The rules, made by people who couldn't begin to imagine Irving's play, made it possible."[2]

Through Irving's shot, Hickey makes a beautiful case for the possibilities of creativity within games. We tend to think of rules as restraining us, as preventing us from our full range of self-expression. But you could also look at rules and say they give us a platform on which to express ourselves. By limiting some types of behavior, rules and games provide a similar context in which we can operate and interact. The shared context ensures that when you find that new creative path, that moment of self-expression, we—players and spectators alike—recognize it and appreciate the ingenuity involved.

All games with multiple paths to success enable creativity. Players find new and expressive ways to play the game, often surprising the game designers by finding new ways to win. Sports, with their massive spatial and physical possibilities, offer great variation in paths to success. The laws of physics, working in conjunction with the laws of basketball, make Irving's shot so remarkable. Performative games like *Pictionary*, *Charades* and *Celebrity* encourage creativity and reward it through the reactions of human judges. These games rely on the ability of the human participants to interpret and react to the messages and gestures players create. While more tightly constrained by the limitations of their platforms, video games and board games can also enable creative play.

Encouraging creativity in a video game is hard. As we discussed in Chapter 5 in the section on *Jojo's Fashion Show*, games are very good at judging hard quantifiable data and very bad at qualitative data. A game knows you pressed a button. It doesn't know if you pressed the button beautifully. So if the game is about creativity and seeks to reward personal expression, game designers are at a bit of a loss. We are still looking for ways to judge expressiveness.

[2]Hickey, Dave, *Air Guitar*, Art Issue Press, 1997, p. 156

Video games aren't the only form of game with this problem. Despite the beauty and improbability of his up and under, Julius Irving still only scored two points. Players and spectators alike find judging in all games to be fraught with pitfalls. In his philosophical treatise *In Praise of Athletic Beauty*, Hans Gumbrecht describes the irritation we often feel with judges for figure skating or diving in big events like the Olympics. Some of the ire directed at judges stems from perceived personal or national biases, but some of it is also aesthetic. Gumbrecht writes, "A more interesting reason for discontent with judges is that they interfere with the ability of great athletes to let new and interesting things happen in their sport. Achieving the impossible, letting loose, being in the zone—these phrases capture our desire to see athletic performances that are unencumbered by restrictions and controls... Letting those things happen is incompatible with the act of judging, which has as its goal assigning merit (or lack thereof) to an athlete's ability to perform a prescribed form."[3]

Despite the difficulties inherent in judging, some games have made notable attempts to encouraging creativity. They give players a blank slate and an assortment of pieces and ask them to construct something. Creating a game system around building is not hard. But creating a game system around judging the artifacts the player has built is. As games and their mechanics evolve, designers will have more tools at their disposal to integrate expression into games. *Line Rider* and *Top Chef* provide two instructive examples of digital self-expression, one in the context of a toy and the other in the context of a game.

Line Rider: A Toy for Self-Expression

You can make the argument that the Internet phenomenon *Line Rider* is not, in fact, a game. And you would probably be right. In fact, that's what Boštjan Cade, the designer and developer of *Line Rider*, contends. He prefers to call *Line Rider* a toy. With no explicit goal built into the system, *Line Rider* offers users a palette with which to express themselves. It falls into the tradition of applications like the *Sims*, which feel and look like games, but are really toys to explore. Players project onto them their own goals for playing.

Line Rider offers players a blank canvas with which to interact. The only rules are simple:

- With the pencil tool, draw a line from top-left towards bottom-right.

- After you finish drawing, press the play button and watch the rider go.

- When you feel he is finished, the stop button will bring you back to the track editor.

Line Rider enables players to draw lines on the screen. When the user hits play, a small boy on a sled drops down until he hits a line and then starts sliding down those lines (Figure 10.5). That's it. It's incredibly simple, yet users spend hours and

[3]Gumbrecht, Hans, *In Praise of Athletic Beauty*, Belknap Press of Harvard University Press, 2006, p. 180

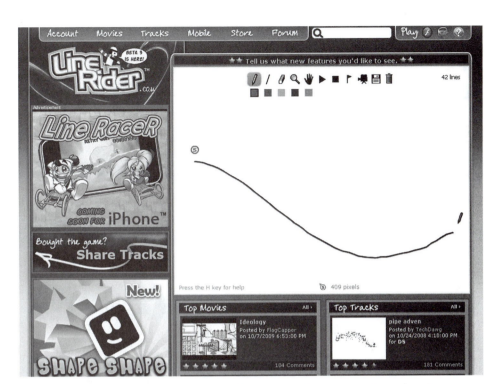

FIGURE
10.5

Line Rider, more of a toy than a game, provides users with some simple tools to draw courses with simple lines. These drawings spring to life when the rider sleds down the lines. (© inXile entertainment)

hours engaging with it, figuring out how to make the rider go faster, jump larger gaps and flip and fly through the air in elaborately constructed tracks.

When Cade released *Line Rider* in 2006, it quickly became an Internet phenomenon. The game spread virally as users passed the game along to their friends and power-users began posting elaborate videos of their play and creations on sites like YouTube. These videos became as popular as the game itself. Users created elaborate tracks, decorating the background with intricate line drawings. But it's not the drawings that amaze. It's the way the rider interacts with the drawings. The best tracks follow an interesting logic, revealing the larger picture as the rider sleds through the landscape. If the rider falls off the track or stops, so does the ability of the viewer to see the image. So the users must be careful in the construction of their track to make sure the rider can continue to progress (Figure 10.6). In viewing these tracks, you are often left watching, mouth agape, as it looks like the rider is about to come off the track, only to see the rider skip and skid onto another piece of ingeniously laid track that keeps the entire thing going.

Despite its apparent simplicity, *Line Rider* is not casual at all. Like *Crayon Physics*, the game is easy to grasp. The rules presented to the player spell out the

FIGURE
10.6

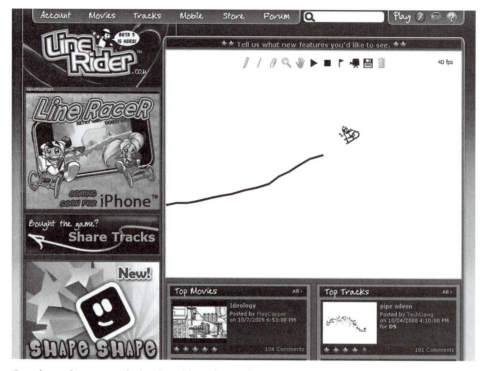

Creating coherent tracks in *Line Rider* takes an immense amount of patience, as you must continually play and review the track to make sure the rider can stay on track and on his sled. Here the rider flies off into the digital ether. (© inXile entertainment)

interaction. And after the first time you hit play and watch the rider fall, catch a line and slide off, the play becomes very apparent. All of these meet our traditional requirements for casual play. But the lack of directed goals mean only hardcore users will dedicate long periods of time playing and constructing long tracks.

It doesn't matter if your rider manages to sled for three seconds or three minutes. Your desires are what drive the path you build. This lack of focused goals as presented or controlled by the game is part of both the charm and limitations of *Line Rider*. Without goals, the average player's interest fades relatively quickly. You may try out a few ideas before finding that creating interesting tracks actually requires a lot of work. More serious users, however, see a powerful tool for expression and spend hours creating elaborate systems, capturing them in video and sharing them on the Internet. The lack of goals frees these users to build the track they want without having to worry if the game system will accept it. This is a boon for all of us casual users. We have plenty of amazing tracks to watch.

In the case of *Line Rider,* the directed play—the game, as it were—lays entirely outside of the application. The meta game of *Line Rider* is creating tracks to impress

other viewers and creators. LineRider.com enables users to upload their tracks and viewers to rate the tracks of all users. Earning high praise for a track becomes the goal of the "game" of creating tracks.

When *Line Rider* was ported to the Nintendo DS, they added puzzles and scenarios to give the game direction and draw in the average player to longer periods of engagement. Without the puzzles, *Line Rider* works as a toy. To make it a game, it needed to offer some way to track progress. Some may feel this robs the player of his freedom and expressivity. Others with less to express may find it finally gives them a reason to play.

Top Chef: A Game for Self-Expression

The PC game *Top Chef* couches expression, construction and creativity in a more constrained fashion than *Line Rider*. Like *Top Chef* the TV show, *Top Chef* the game seeks to harness the creativity of players by tasking them to create elaborate meals.

Each week on *Top Chef*, contestants vie to create the best meal while meeting specific challenges. These challenges ask players to work in a variety of styles and ethnic cuisines, or with a particular twist or theme. At the end of each show, a panel of judges rates the dishes based on taste, presentation and creativity in meeting the requirements of the challenge. Despite all of the backbiting and kitchen intrigue, the eating and judging is the most exciting element of *Top Chef*. It's at this moment that the dishes are fully revealed. Often, the meals look bizarre and tantalizing at the same time. Just looking at them makes your mouth water. Quite an amazing feat, since the TV doesn't allow you to smell or taste any of the food.

When the game designer Mattia Romeo from Gamelab set about designing a downloadable version of the game, he wanted to find a way to preserve the feeling of mouth-watering ingenuity. A number of earlier cooking games asked players to create dishes by following set recipes. Players picked out, in order, a bun, lettuce, tomato, cheese and a beef patty to build a cheeseburger. These games used a sorting mechanic not unlike, say, *Solitaire*. To progress, a player had to use the right ingredients in the right order. And this produced some lovely cooking games. But none of them produced the feeling of creativity that comes with being a skilled chef—the joy of going to the pantry and choosing any number of ingredients that you think will produce the flavor and textures that you desire. Instead, these cooking games left you feeling like a line cook following someone else's recipe over and over again.

But how do you evoke the feeling of creativity in a video game about food and, more importantly, how do you build a game that will judge that creativity? If you let players build their own recipes out of any item they want, you'll wind up with some very bizarre combinations. The more freeform you make the process of creativity and construction, the harder it is to quantify and judge. When you have human judges who can taste the food, savor it and see how, yes, a little goat cheese goes great on top of eggs, chives and mushrooms, then quantifying and judging a dish

is easy. The judges may not always pick your favorite dish, but you understand the reasons they choose the dish they did. And this is a very important point. Judging a creative endeavor must be accompanied by clear and legible feedback or risk seeming entirely arbitrary.

Perhaps the easiest way to go about making a cooking game would be to use a match-three mechanic. However, this would push the player to match visually. Romeo wanted the players to match with their taste buds. So, instead of simply color-coding objects, the game gives objects a range of attributes, such as savory and sweet, which align with how we commonly think about the item. Each ingredient in the game is backed by meta data which describes attributes of the food. So a diverse set of ingredients (for example, goat cheese and bacon) can have the attribute savory (Figure 10.7). These same ingredients may also fit into other categories. The game also uses traditional pairings from cookbooks to suggest ingredients that go well together, like mushrooms and veal. Before each level, the game reveals to you a bit of information about the ingredients that appear within the level in order to help acquaint you with the attributes and combos which work well (Figure 10.8).

FIGURE
10.7

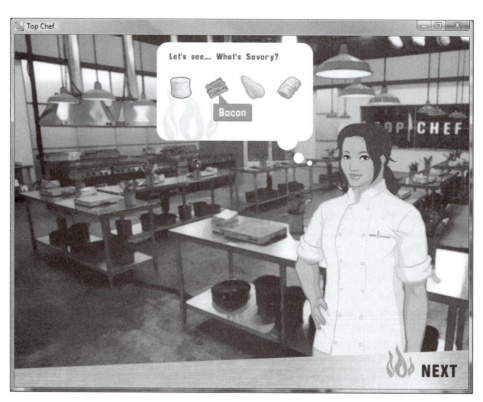

Here the player is told items like goat cheese and bacon are savory. Within the level, it will be up to the player to interpret which other ingredients are savory. (Reproduced by permission of Brighter Minds Media)

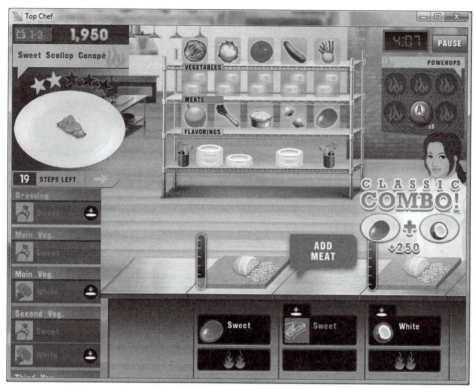

FIGURE
10.8

Players are awarded with classic combos that reflect ingredients that go well together, according to classic cookbooks. These combos reward the players' general knowledge of cooking. (Reproduced by permission of Brighter Minds Media)

Each level asks you to make a different type of dish, such as a savory sandwich or a spicy pizza. Once in the level, the player must pick the ingredients that will produce a meal that matches the dish category. The game presents you with a series of slots you must fill. So to make a sandwich, the game might require you to choose one savory meat, two vegetables, two sweet flavorings and one savory flavoring. As the slots come up, you must scan your pantry and find an ingredient you believe fulfills the requirements of that slot (Figure 10.9). You may find you actually have several ingredients that fulfill the requirement. This is where the creativity comes in. You can choose the ingredient based on what you think will produce the tastiest sandwich.

The fun of the game comes from looking at all of the ingredients and trying to decide which ones match the attribute you need. Functionally, picking ingredients that are savory is the same as picking ingredients that are red. But experientially, picking savory is quite different from picking red items. Savory is not a clear-cut category. It is open to interpretation, and it is in that interpretation that you get to express yourself. You can derive satisfaction from the feeling that you have correctly interpreted the ingredients and found just the right item to bring a dish to life.

FIGURE
10.9

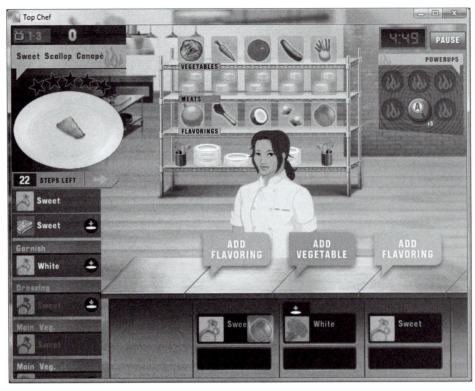

Each dish follows the outline of a recipe. The recipe has a number of slots which the player must fill with ingredients they feel best match the taste requirements and will produce the best meal. Here the player selects peach for a sweet flavoring. (Reproduced by permission of Brighter Minds Media)

At the end of the level, judges review the meal and give you feedback on how well the items included in the meal met the requirements laid out at the beginning of the level. First you are presented with an image of what the meal on your created looks like. The game procedurally builds the meal based on all of the ingredients you include. So no two meals in *Top Chef* look exactly alike. If you play the same level twice and choose a few different ingredients, the meal on your plate at the end of the level may look entirely different. This gives you the impression that you are truly building a unique meal with its own particular look and taste. While the game may actually just sum the number of items you included in the meal that were savory, it gives the impression that your score is based on a total review of the dish, from appearance down to taste.

You could make the argument that this system does not actually encourage or reward creativity. It simply rewards parsing and identifying the game's underlying system of attributes. And while this may be technically true, players often make choices that illustrate personal preferences, tastes and creativity. Players who like apples will find a way

to work them into meals, creating gourmet brie and apple sandwiches they might personally like to eat. And the system is flexible enough that it can often reward players for these personal choices. The procedural-level outro screens also give the impression that you are being watched—that someone is reviewing the meal for consistency and taste. Even a line like, "Excellent choice of scallops to really give this dish a sweet taste," builds up the world of the game and draws the player into the fiction and character of being a chef. The level outros illustrate the importance of elements that appear before and after the actual gameplay (Figure 10.10). By carefully constructing the level intros to introduce concepts of taste and the level outros to reinforce those concepts, *Top Chef* gives greater context, meaning and drama to the play within the level.

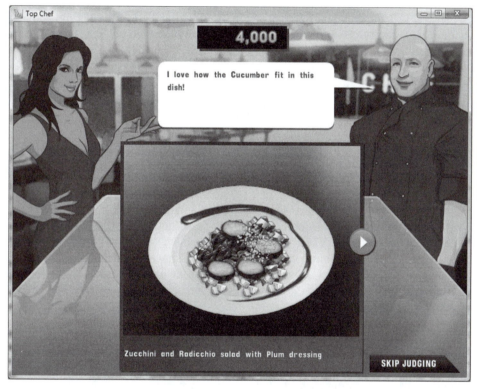

FIGURE
10.10

The game makes great use of level outros to build up the fiction of the game. These outros give you the impression your dishes are being qualitatively judged, making you feel creative. (Reproduced by permission of Brighter Minds Media)

Some hardcore players will optimize their play and select items based on what they believe will score the most. They will forsake any sense of creativity in favor of score and select foods simply based on apparent attributes. This is true in games like *Celebrity* and *Charades* as well. Once players have developed a language of

movements to describe certain items, they'll resort to those movements again and again to optimize play. Creativity and optimization don't always play well together.

But *Top Chef* is not necessarily trying to serve hardcore players. *Top Chef* the game aims to serve fans of *Top Chef* the show. These viewers-turned-players are likely foodies. They enjoy thinking about, looking at and eating food. So the game needs to deliver on the promise that they will get to truly interact with ingredients and food. And in large part, the game does this. It gives you some latitude to make your own choices about what to include in a meal. Using a robust taxonomy of ingredients, the game truly rewards knowledge of food and how things taste, as well as what ingredients go well together. Then the game sets up a scoring and judging system which gives players the impression that they are being rewarded for their clever choices.

Now there is the very serious of question of whether video games should actively encourage creativity or simply allow for it. Or should creative expression be left up to applications like Photoshop? I'll dodge that and say it depends entirely on the aesthetics of the game you are trying to create. If you want the players to feel creative, then yes, you need to give them a dynamic system that allows for that feeling. The designers of *Top Chef* believed the feeling of creativity was an integral component of feeling like a chef. So for the game to achieve the aesthetic of making the player feel like a chef, it had to make the player feel creative.

So if it's so hard to capture the aesthetic of self-expression in a game, why bother? Because creativity excites us. It allows us to push our games, our play and ourselves further. It expands the possibilities. There wasn't a basketball fan in the arena the night of Julius Irving's up and under shot—be they a Laker or a Sixer fan—who wasn't on their feet in pure joy as that ball flipped and dropped through the net.

What *Top Chef* offers is just enough room for construction to achieve the aesthetic of creativity. It does not definitively solve the problem of how to create a system to procedurally judge absolute creativity. Instead it shows that what a game must provide is the right amount of leeway and reward for a player to make interesting and unique choices. The game doesn't seek to become a cooking tool. Instead, it recognizes its own limitations as a game and works within those to allow for player choice. The game will not produce amazing recipes every play through, but on more than one occasion I've looked at the sandwich produced at the end of a level and thought to my own surprise and gratification, "You know that looks darn tasty. I might just go see if I have the ingredients to whip up a goat cheese, avocado, tomato and bacon sandwich with a dash of mango sauce." And just that simple thought freed my play from the confines of the game and brought it out into the larger world, where it has new meaning and purpose.

Summary

Games with construction and building at their center demand a lot of players. The most open-ended construction games give players pieces and a goal and force them

194

to figure out how to get from point A to B. Even when the game constrains the problem space and directs the player through tight goals, the open nature of building leaves players with plenty of room to pursue different paths. Unlike games oriented towards a specific process, like *Diner Dash*, or games focused on particular patterns like *Solitaire*, building games are inherently more open-ended. This makes them ideally suited for players looking to experiment and exercise their creative muscles in a constrained game system. However, a game with very open-ended goals may find its appeal among very casual players limited. All that room for experimentation can sometimes feel unstructured. Too many paths to success may leave players flailing around looking for a goal to grasp onto and direct their play. But for players willing to experiment and create their own goals, constructing games can be immensely satisfying. Game designers can also broaden the appeal of the constructing mechanic by constricting the freeform play with achievable goals and narrative that contextualizes the construction, as *Top Chef* does.

ELEVEN

Bouncing, Tossing, Rolling and Stacking

We all know that if we throw a rock up in the air, it must come down. We know that friction will eventually slow a rolling ball and bring it to a full stop. Toss a ball straight at a brick wall and it will bounce back. Throw the ball at an angle, and it will career off the wall at an angle. To throw a football a long distance, we must increase the force and arc we put on the throw. Years of living in this world and obeying the laws of Newtonian physics have taught us this much. Exactly how much heft and spin to put on a basketball is a matter of intuition mixed with muscle memory and guesswork. Despite our familiarity with the basic laws of nature, we are often surprised by the results. I've been playing basketball for the better part of two decades and I'm still filled with a burst of joy every time I hit a three-point shot. Despite hours of practice, there's some part of me that still can't believe I can throw a large rubber ball 21 feet and into a hoop perched 10 feet in the air.

Physics-based games tap into this potential for amazement and joy. The games rest on the simulations of the basic laws of physics, emulating things like gravity, friction and force. The laws of physics become rules within the game system that impact your moves. Toss a ball into a set of pegs and it will bounce from one peg to another. Shoot an arrow through the air and gravity will slowly overtake the forward motion of the arrow and draw it back to earth. Build a structure out of heavy objects and thin supports and gravity will pull them down as it applies force to the weaker joints.

Our experience with the physical laws of nature informs our understanding of these games. The game system emulates systems we are already familiar with, making it easier to pick up the basic concept of the game. It also taps into the magic and mystery of physics. Just because we understand the basic laws doesn't mean we understand exactly how things will behave. It is only through experimentation that we can sort out exactly how far objects will fly or which direction they will bounce. That's exactly what designers of physics games base the play on: exploring, discovering and mastering the effects of actions within the game's simulated laws of physics.

Bow Man 2: Experimentation and Repetition

Bow Man 2 is a simple game. Your goal is to shoot arrows at the other player until you kill them. This grizzly duel is represented in stark black and white with patches of green grass and bursts of red when you finally pierce your opponent.

Bow Man 2, created by Free World Group, looks like one of those one-note gags that makes its way around the Internet. "Check it out! You shoot arrows through this stick figure's head and blood splurts out!" It's so short and to the point that you could almost be forgiven for mistaking it for a banner ad game. But the design of the game is actually quite elegant and allows for a lot more replay than many similarly small games.

The game is turnedbased. Players trade turns drawing back their bow, selecting the proper angle and letting arrows fly at one another (Figure 11.1). The player who inflicts the most damage on the other player wins. You shoot an arrow by clicking and drawing across the screen to select the strength with which you want to shoot the arrow. You adjust the angle of fire by moving your mouse up and down. When

FIGURE 11.1

To draw back your arrow, you click and drag your pointer back across the screen. This determines the strength of your shot. Moving the mouse up and down determines the angle of your shot. (Reproduced by permission of www.freeworldgroup.com)

you're satisfied with your aim, you lift your finger off the mouse button and the arrow sails through the air. This simple mechanic of drawing back and angling up and down provides a very simple yet satisfying simulation of holding a bow, drawing back an arrow and releasing. While using a mouse is nothing like drawing an arrow, the mechanics combine to create a dynamic that produces an aesthetic experience that resembles drawing an arrow.

The arrow flies up and across the sky, but eventually gravity overtakes it, and the arrow falls back to Earth. When choosing the force and angle of the arrow, you must contend with the forces of gravity. Ambitious players can turn on wind which further affects the flight of the arrow, shortening it or lengthening it depending on the direction it blows.

Even still, the game would be over in a matter of seconds if the game designers hadn't cleverly hidden one essential piece of information from the player. You don't know how far away your opponent is standing. When you start the game, you see only your bow man standing in the middle of the screen facing to the

FIGURE
11.2

As you watch the arrow's flight, you get the chance to see the landscape and hopefully where your opponent is standing. If you overshoot, you know on your next shot you'll need to either decrease the power or lower your aim. (Reproduced by permission of www. freeworldgroup.com)

right. You draw back your arrow and blindly select an angle. When you release, the game camera follows the arrow as it arcs through the air and plunks down into the ground. By watching the flight of your arrow, you begin to get a sense of the space. If you don't see your opponent during the flight and fall of the arrow, you know he's farther back and you must adjust your next shot. As you play, you go through a process of bracketing to figure out two things: how far an arrow will fly based on power and angle and how far away your opponent is standing (Figure 11.2).

This process of bracketing doesn't take very long. Each game only lasts about a minute and a half. And once you've found the correct angle and power, you simply repeat that shot and hope you make the critical blow before your opponent does. There's not a lot of strategy to *Bow Man 2*. Instead, the game is about sussing out several pieces of information and playing with the way gravity affects your moves. When you start playing, it can be just as interesting to shoot arrows straight up into the air and watch them fall back into your own bow man's head as it is to try and hit your opponent. In fact, much of the fun in *Bow Man 2* comes from exploring the way your actions interact with the game's model of physics (Figure 11.3).

FIGURE
11.3

To determine the appropriate angle of fire, you can bracket your shots, aiming a little lower and then a little higher until you find just the right angle to send an arrow through your opponent. Your misses litter the ground, giving you an idea of your progress. (Reproduced by permission of www.freeworldgroup.com)

In fact, this sense of exploration and experimentation undergirds most games based on physics. In physics-based games, the designers and programmers lay out a game system in which the player's interactions are affected by a model of physics. Objects fall and bounce. Balls roll. Friction slowly overcomes bodies in motion. In these games, simplified versions of Newtonian physics become part of the rule set for the game. You can shoot an object at a target, but the rules of physics determine the flight path, with gravity eventually pulling your shot down. What in other games would have been a simple matter of pointing requires more complex calculations in a physics-based game.

Physics games complicate the player's moves. Input and output no longer match each other exactly. The physics of the game system stand between your input and the output in the game. You can no longer simply think about the move you want to make; you must consider how you make that move and how physics will impact your move. You input your move and, depending on slight variations, it can have a wide variety of outcomes. In this way, physics games are all about reading, understanding and then internalizing a system of variable input and output.

The physics of the system often make the right move opaque, so players must learn what they can and cannot do. Because there are a range of forces acting on the objects you set in motion, very slight changes in the input can produce drastically different outcomes. You aim your arrow up an extra degree or two and suddenly the arrow flies well beyond its mark. This can make physics-based games very frustrating. It often looks like you're doing the same thing—repeating a move—but you get a wildly different result.

To prevent players from growing frustrated, interactions must be kept simple and short. To remain casual and friendly to the player, physics-based games must allow the player to practice by either repeating moves or easily starting again. To understand how the physics system works and interacts, the players must be able to try and try again until they get it right—they must be able to experiment.

This need to repeat and perfect a move sounds more like the sort of play patterns generally associated with hardcore play than casual play. Casual games generally focus on clarity and quick, concise rewards. What keeps these games casual is the way they map onto our real-world knowledge of physics. They enable you to play with a replica of a system we interact with and deal with everyday. We know what gravity feels like; we know what it does. So when we encounter it in a game system, we have an immediate relationship to it. We may not know exactly how it will affect objects in the game, but we know it will. And we're willing to experiment and figure out how.

Paper Toss: Simple Choices with Unclear Outcomes

A game like *Paper Toss* for the iPhone, which mimics throwing paper balls into a garbage can, feels instantly recognizable. After years and years of throwing things out in all manner—from dropping paper cups into the wastebasket to tossing wadded

up junk mail across the room—we have a sense of the loft and heft required to throw a ball into a garbage can from a distance. *Paper Toss*, developed by Backflip Studios, even looks familiar. It situates the game in a generic cubicle. When one of your throws accidentally floats out of your cubicle, voices from off-screen admonish you with comments like "Watch it! I'm trying to work!"

The mechanics of *Paper Toss* are incredibly simple. A fan sits to one side of you, blowing across your line of sight. In the distance is a garbage can. Your goal is to get the paper ball in front of you into the garbage can by flicking it. But you must take into account the wind from the fan. A number and arrow denote which way the wind is blowing and how strongly (Figure 11.4). If the fan is blowing to the right with a strength of 4.4, then you must flick your paper ball far to the left to account for the wind. If you simply flick it straight, the breeze will catch the paper ball and blow it far off to the right. The strength and direction of the fan changes with each toss, but it is always printed on the screen for you to read. The goal of the game is to see how many balls you can toss into the wastebasket before missing (Figure 11.5).

FIGURE
11.4

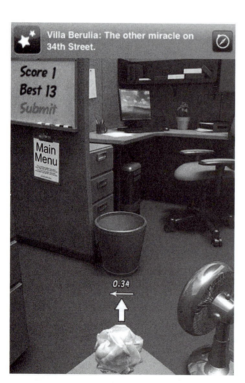

You simply want to toss the paper ball into the wastebasket. For this toss, the wind is light, so you can toss the ball straight into the basket. (Reproduced by permission of Backflip Studios)

FIGURE
11.5

**The ball arcs through the air toward the basket. The scoreboard on the left keeps track
of how many shots you make in a row. Your goal is simply to top your personal best.
(Reproduced by permission of Backflip Studios)**

It's curious that the game tells you the exact direction and speed of the wind.
It would seem that giving this information to the player would remove all mystery
from the game. In *Paper Toss,* you can't control the power of your throw. There
is no hidden information. Each throw flies with the same force. You simply select
the direction. So, by telling the player the direction and strength of the wind, all
that's left for the player to decide is how far to the left or right to aim. And it turns
out that choice is enough to deliver a compelling, if short, game. The game offers
three settings: easy, medium and hard. In each successive mode, the basket moves
farther away. This gives the wind from the fan more time to affect the flight of the
paper ball. In easy mode, the player can make rough choices about direction. The
wind will not have enough time to radically alter the ball's flight. But on the hard
setting, the player must pay careful attention to the power of the wind and choose
a very exact angle for the shot (Figure 11.6). If you don't compensate enough, the
wind will blow the ball wildly off course. Because a shot in the easy mode does not
need to be very exact, the player quickly learns the necessary angle to compensate

FIGURE
11.6

The Hard mode requires the player to internalize the physics of the game and select the angle of the toss with more precision. (Reproduced by permission of Backflip Studios)

for the wind and the game approaches a sort of tedium. Mastering the exact angles required in the harder levels takes more practice.

Paper Toss demonstrates a quality shared by many physics-based games. Most of the fun comes from learning the system and the impact of wind, gravity, friction and the like. Once we master the laws at play, the game becomes trivial. Physics-based games tend to rely on the complexity of the physics simulation over strategic play. This makes many of them feel more like toys than games. Physics-based games replicate the simple pleasure we find in stacking blocks.

Jenga: The Inherent Drama of Gravity

The best physics-based games find a way to harness playful interaction and fill it with drama. Think of *Jenga* (Figure 11.7). It uses blocks, friction and gravity to create a dynamic system. You create a stack of blocks and then players take turns pulling out pieces one by one and placing them on top of the stack, until the whole structure comes toppling down. As in physics-based video games, you must learn the way the system interacts with forces applied to the game pieces by gravity.

FIGURE
11.7

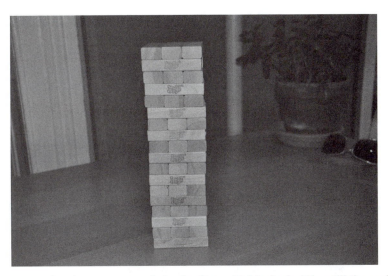

Jenga plays into our natural play instinct with blocks: build up till they collapse.

How does the friction of the wood affect the tower when you pull out a piece? How much downward force is being exerted on the lower pieces as opposed to the upper pieces?

Jenga taps into the natural drama of building a tower of blocks and amplifies it. When we play with blocks, whether as kids using wooden ABCs or as adults stacking more elaborate pieces of machinery, one of our first instincts is always to see how high we can stack the blocks before they topple over. Leslie Scott, the designer of *Jenga*, recognized the drama in the moment of collapse and sped up the play to that moment. The game ignores the initial building. The game starts with a complete tower. From there it proceeds directly toward collapse by demanding players remove pieces from the foundation of the tower and add them to the top (Figure 11.8). This makes collapse inevitable. It's just a matter of not being the one to cause it. So every move, even the early ones, feels fraught with tension. With each pull, every player stares and asks themselves, "Is this the one? Is this when it falls?"

As in other physics-based games, the gameplay revolves around learning and control. The player learns which pieces buttress others and therefore which ones can more safely be removed. The player also garners skill at actually removing pieces, developing a steady hand and sure fingers. The rules of the game don't take long to master, but mastering the interaction does. In this way, physics-based games are one of the few casual games that really feel skilled based.

Physics-based games open up a wide variety of possibilities for a game very cheaply. Once the developer has built the physics engine, they can use that system to create a number of different interactions using the same rules. Objects can be shot, thrown, bounced and stacked, among many other things. The trick is adding meaningful and interesting goals to accompany the physics.

FIGURE
11.8

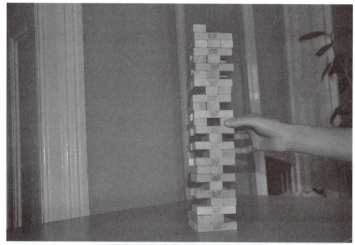

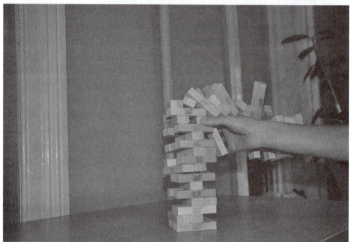

The game starts with a built tower and proceeds immediately towards an unstable structure as players pull out foundational pieces.

World of Goo: From Toy to Game

The game *World of Goo* takes physics-based gameplay and expands it beyond the feeling of a toy or the very simple games that often result from giving a playful activity a goal. *World of Goo* was developed by 2D Boy for the PC and Nintendo WiiWare. The game, designed by Kyle Gabler and Ron Carmel, is based on a proto-type called *Tower of Goo* that Gabler created as part of the Experimental Gameplay Project at Carnegie Mellon University. Comparing *Tower of Goo* to *World of Goo,* you can trace the development of a physics toy into a game.

The Experimental Gameplay Workshop focused on rapid prototyping of new game ideas. Participants were charged with producing games in a matter of days. The idea was to generate as many prototypes as possible in an attempt to discover new game mechanics. The rapid prototyping generated a lot of very small games, some fun, some not so much. But by trying out a lot of different ideas, designers improved their chances of coming up with something successful and innovative, as opposed to the traditional model of game development in which you spend a lot of time refining one idea you hope will be fun.

The original *Tower of Goo* was developed in four days. Players grab little black goo balls and drag them. As you drag a ball, areas where it can be placed are highlighted. When the ball is placed, it forms struts connecting it back to the mass of other goo balls (Figure 11.9). By repeating this process and dragging multiple goo balls into position, the player can build towers and bridges. The web of connected goo balls resemble trusses (Figure 11.10). The play in the system stems from the flexibility of these trusses and the movements of unused goo balls. Stack too many

FIGURE
11.9

The intro screen of *Tower of Goo* quickly lays out the basic mechanics of the game. (Reproduced by permission of Kyle Gabler)

FIGURE
11.10

Since *Tower of Goo* doesn't offer an explicit goal, it feels more like a toy than a game. "Higher and higher" is more of an exhortation than something you can actually achieve. (Reproduced by permission of Kyle Gabler)

goo balls on one area and the whole structure may begin to tilt and bend. If you work quickly, you can shore up your tower by adding supporting trusses. But take too long and the whole thing comes toppling down. Adding to the confusion, the goo balls climb the tower, constantly trying to reach the highest point, adding an ever-shifting weight to your structure (Figure 11.11).

The original *Tower of Goo* has no hard goals. As you build up, the game announces new heights. But there is no hard mechanic spurring you to build upwards. You could simply hover near the ground if you like. Like stacking building blocks, building higher is mostly an internal goal. This lack of a clear goal and sense of progress keeps *Tower of Goo* in the realm of a toy. To this day, it remains a free download and provides a good 10 or 15 minutes of fun.

When Gabler and Carmel decided to turn *Tower of Goo* into a commercial game, they kept much of the gameplay from the original concept. The basic mechanics of building remain the same. The biggest change to the game is the addition of finite goals and a level structure. In *World of Goo*, you build structures from goo balls, but

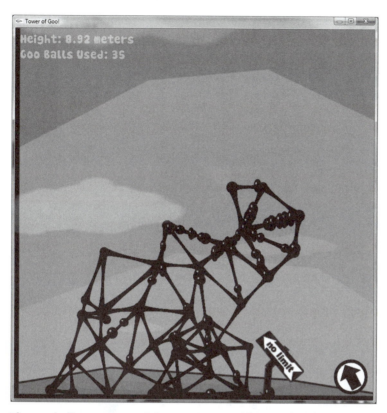

The goo balls move around the structure, seeking out the highest point. This can overload weakly reinforced towers and bring them tumbling down to the ground. (Reproduced by permission of Kyle Gabler)

now you must build them to a pipe which sucks extra goo balls off the tower. To pass a level, you must build a tower and pass a specific number of goo balls into the pipe (Figure 11.12). This goal feels like a natural addition to the general *Tower of Goo* structure. It also proves to be a relatively flexible goal that allows for natural permutations that grow out of the central building mechanic.

The levels require the player to build towers, as well as bridges and structures which wind around various hazards (Figure 11.13). This forces you to continually learn new tricks to keep structures intact. You master the physics of one scenario only to confront a slightly different scenario in the next level, requiring you to modify your building patterns. This forces you into deeper engagement with the physics of the game. It also prolongs the gameplay. As a toy, *Tower of Goo* grows stale, while *World of Goo* constantly offers new challenges.

Creating multiple levels and new challenges means, of course, more design work for the game designers. Part of the attraction of physics games is the promise of

FIGURE
11.12

In each level, players must move a specific number of goo balls into the pipe at the top of the game area. (Reproduced by permission of 2DBOY, LLC)

FIGURE
11.13

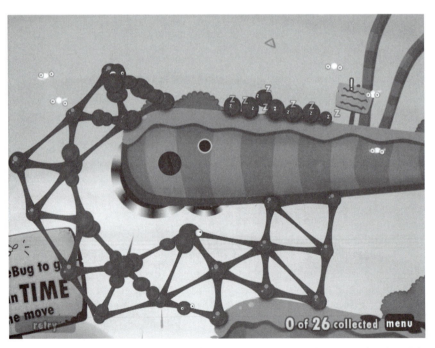

The player must build a structure from the starting point on the lower ledge around the spinning wheels up to the goo balls on the upper ledge. (Reproduced by permission of 2DBOY, LLC)

creating a system that will not require much level design. You create a rich system and players interact with that system, finding new challenges and ways to play with the game. This may work for short games like *Paper Toss*, but to eke extended gameplay out of the game, the designer needs to create a level structure that offers a sense of progression and increasing challenge. You can't rely on players to simply want to better their own score. Many will find that once they've won, they're done.

Peggle: Balancing Mystery and Legibility

Physics-based games can also be very frustrating. The murkiness of how objects will behave once launched into the system can make games with complicated physics feel punishing and even a little unfair. Designers and programmers should take heed when they craft the physics engine that supports play. If the system is too realistic or too opaque, players can quickly grow frustrated.

The game *Peggle* is a cross between pachinko and a shooting game like *Snood* (Figure 11.14). In the game, designed by Sukhbir Sidhu and Brian Rothstein for PopCap, the player confronts a series of colored pegs. To pass the level, the player must clear all of the orange pegs by hitting them with a ball launched from a cannon at the top of the game area.

FIGURE
11.14

Peggle provides an arrow that shows how the ball will fly to the first peg. This important bit of information makes the play much clearer. (Reproduced by permission of PopCap Games)

Peggle has the potential to be very frustrating to players. The gameplay is centered almost entirely around a bouncing ball careening between pegs. The ball bounces off the first peg and then a second and then a third, changing course with each bounce. It's almost impossible to tell where the ball will go beyond the second, or maybe the third, bounce, if the path is very clear. After the initial collision, the physics of the game take over and rattle the ball around among the pegs. The ensuing random-ness stands as a pleasing counterpoint to the straight, legible flight of the player's initial shot. But *Peggle* avoids frustrating the player through a very clever and simple design decision. You can very clearly see where the ball will land on the first bounce. The game even gives you a dashed arrow indicating the trajectory of the ball, show-ing how it will fly and the arc that gravity will impose on it (Figure 11.15). The first

FIGURE
11.15

On longer shots the dashed arrow may not reach all of the way, but the player quickly realizes the ball will basically go wherever your mouse arrow points. The arc of the ball is subtle and essentially equates to a straight line. (Reproduced by permission of PopCap Games)

power-up you earn even reveals the exact direction and arc of the ball after its first bounce (Figure 11.16). With this one piece of information, the designers wipe away the need to learn and internalize the physics of the system. Unlike *Bow Man 2*, you don't need to intuit the trajectory of the ball. The game tells you.

FIGURE
11.16

The first power-up shows you exactly where the ball will go after the first bounce. The arc is much greater on the bounces than it is on the shot. (Reproduced by permission of PopCap Games)

Handing over the key information about the physics of the system would seem to rob the player of the challenge of learning and mastering the system of physics in the game. But, in the case of *Peggle*, this turns out to be a good move. After the first bounce or two, the game devolves into randomness. Since the game requires clearing a number of pegs with a limited set of balls, obfuscating the trajectory of the ball would have only led to a lot of misses and frustration. Since the moments after the launch are largely random, having more transparency upfront gives you greater control and increases the legibility of the system. Showing the arc of the flight enables you to read, parse and understand the physics of the game before the output devolves into random noise. You get to make one clear and concise move that is followed by the variable output of a ball bouncing betwixt a series of pegs.

Peggle splits the difference between a physics game with a system of unclear, noisy outcomes and the clear and concise systems more typical of casual games. The game offers the player clear and concise choices about where to shoot. Once that move has been made, players can enjoy the unpredictable outcomes associated with physics games.

Summary

Physics-based games tap into our natural desire to explore the world around us through play. We get to poke and prod at a system, bouncing, tossing and stacking pieces to see what will happen. Turns out this poking and prodding generally translates well to video games. Bouncing a real ball is fun and so is bouncing a virtual ball. The laws of physics give game designers a familiar set of rules from which they can build a game. Basing your game on physics gives you a head start in designing a dynamic system.

But the opaqueness of most physics systems has drawbacks. Very often physics systems are not clearly legible. And unless they allow for sufficient experimentation to begin understanding the system, players can grow frustrated. Moves don't have the clear, definite outcomes you see in other casual games like *Bejeweled* or *Diner Dash*. This can be off-putting for some casual players who want a system they can interact with quickly and be certain of their results. If the game models physics too closely, it can feel punishing. Designers should pick the elements of physics most salient to their game system and emulate those. They should also remember they have free rein to improve these physical laws. If the game is more fun when you can jump higher, then turn gravity down. The limitations of physics games can be overcome by balancing legibility and opaqueness, as well as complexity and simplicity.

CHAPTER TWELVE

Socializing

Games evolve to meet new technologies and new demands from players. Console games had followed a path towards increasingly focused hardcore play for years, as each generation of consoles increased computing power and the potential to render more and more detailed graphics. Then the Wii came along and helped open up consoles to casual gamers, who had previously shied away from expensive hardware and the traditional hardcore games found on them. The Wii introduced physical play into the living room with video games like *Wii Tennis*.

The last decade has also seen great improvements in networking capabilities, leading to more online multiplayer play. Through massively multiplayer games like *World of Warcraft* and systems like Xbox Live, it has become increasingly easy to play with your friends even when they live thousands of miles away. Some people now view the campaign or story mode of games like *Halo 3* as simple warm-up to the multiplayer battles enabled by networked play. In fact, multiplayer has become such a dominant part of video games that some games can't be played alone. Playing Valve's *Team Fortress* demands you play online with others.

And while online play of games like *Halo* and MMOs like *World of Warcraft* have traditionally been dominated by dedicated hardcore players, these technologies are also opening up new gameplay possibilities to casual game designers as well. Over the last several years, a number of casual MMOs and virtual worlds have begun to crop up, from *Puzzle Pirates* to *Maple Story*. And even more recently, the gaming industry has seen an explosion of interest both from designers and players in social networks like Facebook, MySpace and Bebo. These social networks already boast millions of users looking for quick bursts of fun and play to accompany their daily activity on the sites. They aren't necessarily looking to jump into a full virtual world or to dedicate hours of time to killing rats and leveling up an ogre. Instead, these users are seeking shorter, more casual gameplay experiences of the sort we've been discussing.

Many developers and investors now view social network gaming as the future of the casual game industry. There is a lot of hyperbole around social networks and gaming. But they do represent a tremendous opportunity for developers. Sites like Facebook deliver huge audiences of potential players. The social networking components also provide great tools to spread games virally. Games on these networks can quickly attract tens of thousands of users through word of mouth, now known

as the Friend Invite. The games that work the best in the context of social networks adapt their gameplay to user behavior patterns and social milieu of the site.

Fortunately, casual gameplay integrates very well into social network use. Mostly because the usage of social networks greatly resembles casual gameplay. Most people probably don't sit down with the intention of spending the next several hours perusing Facebook. It just sort of happens. You have a few minutes to kill at work so you log in to read your news feed. You scan the short entries for a few minutes; a link to a new photo album catches your eye and next thing you know you've been looking at Facebook for 45 minutes. For many users, the Internet collapses down to a site like Facebook. It has all of the info you really want—updates on friends, baby pictures and now games—to kill the time when you've already looked at those pictures from your nephew's first birthday party 23 times. Many of the games ported over to Facebook are simple single-player Web games. But the games that work best in this new networked world find interesting ways to take advantage of not just the audience available on Facebook, but also the potential for new social interactions.

So is social play the future of games? Well, that seems like a ridiculous statement given that games have always been social activities. We have always played in groups. Card games and board games are, by definition, social. Before you can even play, you must gather other players to join the game.

If anything, video games represent an anomaly among games. They allowed for individual play because the processor essentially took on the role of the other player. The computer provided the challenge that opponents usually do. This was a big advantage when your friend had to go home for dinner, but you still wanted to keep playing *NHL '96*. The computer could keep playing with you. But, with all due respect to Deep Blue and the super-powered game playing artificial intelligences out there, computers generally make less interesting opponents than other humans. Most AIs perform in relatively scripted and predictable patterns. So once you learn an enemy's patterns, it becomes fairly easy to defeat most game AIs. Humans, with all of their irrationality and creative problem-solving, make much more interesting opponents. Each new player you face brings a slightly different style and approach to a game. That's why most people play through a game like *Halo 2* once, but will spend countless more hours on multiplayer maps that allow you to interact with other real players. Networking technology is enabling games to return to a more natural social multiplayer state.

Games are inherently social. Games take shape and exist in the space between players. They are defined by the interactions between individuals. The feints, parries and thrusts of two game players are like a conversation. Mattia Romeo, the designer of *Top Chef*, said of multiplayer games, "You know how Clauswitz said war is politics by other means? Well games are like conversation by other means." In the give and take of the play, we have a kind of dialog or conversation with another player. And, as with most conversation, what's important isn't necessarily the information that's conveyed, but the enjoyment of the interaction.

Other players are the content of the game. Playing with others provides an ever-refreshing set of content. Tiring of a game? Think you have the entire strategy down

pat? Just play the game with someone new and you have an entirely new challenge ahead of you. This goes for everything from head-to-head play to cooperative play.

The reinvigoration of social gaming opens up new avenues of play for developers. Not only are sites like Facebook drawing in new players, expanding the pool of people playing games, but they are also creating the possibility of new mechanics. Traditional social play revolved around groups of individuals playing against one another or several teams engaging in competition. But the Internet allows for radical new alignments. The Internet enables not just one-to-one and one-to-many dialogs, but many-to-many conversations. You are no longer limited to team play to get the benefits of social play. Social networks provide interesting new social alignments from networks to crowds, both active and passive. Taking advantage of these social alignments requires game designers to think innovatively about how to structure their mechanics. Quite likely, they will require designers to invent entirely new mechanics.

But before jumping to new social milieus, it behooves designers to look at some of the more traditional ways games engage us socially. After all, social games have as much to do with people playing them as they do with the mechanics and content of the game. So understanding how people react to each other in games is of the utmost importance.

Apples to Apples: Reading People, Not the Game

Apples to Apples is a very thin game. And a very popular one. It relies almost entirely on the subjective opinions of players. And these aren't even the subjective-yet-structured opinions that judges hand out in sports like figure skating. The opinions of players don't need to be backed up or justified in any way. At first glance, you would think this subjective judging mechanic would cause the game to break down. But through a combination of clever mechanics and the general generosity of players, the game works.

In 1998, Wisconsin-based game maker Out of the Box Publishing acquired the rights to *Apples to Apples* from the original creator Matthew Kirby. Out of the Box focuses on publishing simple, yet clever party, card and board games. They keep the games simple and straightforward enough that they can be learned in minutes and play can be completed in less than an hour. This gives many of their games a very loose casual feel. Out of the Box published *Apples to Apples* for a number of years before selling the license to Mattel. Over the years *Apples to Apples* has found wide popularity as a party game, selling more than three million copies.

There are two decks of cards in *Apples to Apples*: nouns and adjectives. At the beginning of the game, each player is dealt a hand of seven red noun cards. Each card has a noun printed on it, ranging from famous people to places to things. The players hold these cards in their hands, keeping them secret from the other players. One player is designated the judge for the first round and draws a green card from the adjectives deck and places it face up on the table for all the other players to see. Then each player at the table picks one noun card from their hand and places it face

FIGURE
12.1

The judge reads through all of the Red Apple Noun cards players submitted and chooses the card he feels best matches the Green Apple Card.

down on the table. The judge picks up the noun cards, shuffles them and then reads through them. From this stack of nouns, the judge must pick a noun they think matches the adjective. So, for example, the green adjective card the judge turns over might say "Fragrant" while you hold in your hands cards like "My Family," "Magic Tricks," "Bart Simpson" and "The Internet," You must scan your limited option of cards and decide which of your nouns the judge is most likely to associate with the adjective "Fragrant" and play that card.

How the judge decides on a match is entirely up to them. The combination might have elicited a laugh, titillated the group or even offended another player. It's entirely up to the judge. The player who played the chosen red apple card wins the round. They are given the green apple card to mark their progress. All players draw a red apple noun card to replenish their hand. The player to the left of the judge becomes the judge for the next round and the cycle begins again. The first player to collect a designated number of green adjective cards wins. When you play with more people, you have to collect fewer cards so the game doesn't bog down too much.

Party games need to be casual. The setting and number of players involved demand simple rules that can be easily communicated. With a group of 10 people sitting around, all half paying attention, some people are bound to check out during the process of explaining the rules. So the rules need to be explained quickly and involve as few exceptions as possible. The design of *Apples to Apples* epitomizes this ethos. The rules are simple and straightforward. The official rules for *Apples to Apples* lay out the entire play of the game in seven short rules. There are no confusing exceptions that begin with "But if ..." As a result, *Apples to Apples* takes only a minute to learn to play.

It is interesting to watch the reactions of first-time players. Those expecting a more formal game are inevitably surprised and sometimes frustrated with the arbitrary nature of the judging combined with the random cards you are dealt. These players often complain that the game lacks strategy. They point out that players are dealt a hand of cards which they are largely stuck with. They only discard and replace one card at a time, making it hard to get new cards if they feel the ones they have are not interesting. Unlike a game like poker, where the players can discard and draw new cards to hopefully replenish their hand with more useful cards, *Apples to Apples* has no such valve. This leaves players with few options for strategy in managing their card stock.

The randomness of the deal is compounded by the arbitrariness of the judge's choices. Since the player can choose based on any criteria, some players believe they can just throw down any random card and stand about as good a chance at winning the round as if they carefully deliberated their choice. This attitude ignores the actual strategy in the game. The game offers little strategy in the form of deck management. Instead, all of the strategy is bound up in how well you can read and anticipate the associations other players would like to make. This game is explicitly social. There's nothing to figure out about the game system. The only thing to figure out is your fellow players—their personalities, their likes and dislikes, what they think is funny. The formal game system is thin, but the social elements are complex.

The thinness of the formal system can put a strain on the game. Players must be willing to buy into the game and open up to the social interaction. All party games live and die on the willingness of players to give themselves over to the game. This problem is less pronounced in more formal games, where a complex set of rules dictate and control the interaction. A game like checkers doesn't rely on the players' willingness to get into the game. The rules prescribe exactly how pieces should move and where they land. Taking another player's checker is not open to interpretation. If you jump the piece, you get to remove it. But a less formal game like *Apples to Apples* hands the reins controlling the proceedings over to the player, saying, "How will you know which card is right? Just pick one that feels right to you."

If players are unwilling to pick up those reins, then the game flags. Along with the rules, the game provides Playing Tips, which are possibly more crucial to the success of the game than the formal rules. These tips read:[1]

- It's OK to play a red apple card that isn't a perfect fit. Judges will often pick the most creative, humorous or interesting response.

- Lobbying and "table talk" are encouraged! Players can comment on cards and try to convince the judge to pick a particular card—either their own or a favorite choice.

- Playing red apple cards that appeal to the judge can improve your chances of winning. This is often called "playing to the judge."

[1] *Apples to Apples*, Rule Sheet, 2007. Mattel

- Red apple cards that begin with "My" should be read from the judge's point of view. For example, when the judge reads "My Love Life," it should be assumed that it is the judge's love life that is being described by the word on the green apple card.

As these tips make clear, players must be willing to perform a bit. They must enact the game. The most compelling games of *Apples to Apples* occur when players buy into the game and the judges make a production of choosing the winning card, talking out their rationalization and building up the drama to their final selection. This light performative element lends the game more drama. It also pulls reluctant players into the game. Like any good conversation, *Apples to Apples* relies on the participants to talk and engage.

Including the Playing Tips helps illuminate the social play involved in the game. When designing a social game, foregrounding the social elements can be very important. Many players tend to think of games as strictly formal. They approach the game with a mentality that they will burrow down into the ruleset and figure out how to win. In games that are explicitly social, they can't do this. As with *Apples to Apples*, there may not be much to burrow into. And if you do, you will miss the social cues from other players. Catching and understanding these cues is essential to winning the game.

Once players begin to engage with the system, they eventually see that the game is not entirely random. You can be good at *Apples to Apples*. You just need to develop a sense of how the mechanics of the game, namely pairing the noun and adjective, interacts with the personalities of the players. As opposed to pursuing strategies that you can control, you try to read people and guess what they would like to hear. In this way, *Apples to Apples* really begins to feel like an extension of conversation.

Rock Band: Becoming a Band

Few games in the last several years have done as much to change the image of video games as *Rock Band*. The game explodes the image of video games as a solitary pursuit and brings video game playing squarely into the public and performative arena. By combining gameplay with karaoke and deep-seated rock star fantasies, Harmonix\created a game which, at times, feels more like a phenomenon than a simple video game. The game captured the public imagination. How has this game with relatively hardcore elements and gameplay that requires four people captured such wide attention? Why will your mom play this game and not *Ghost Recon*? Because the game exemplifies casual game design philosophy despite boasting some relatively hardcore play patterns. Then it situates that casual game play in a social setting that amplifies the fun of the game. No knock on *Guitar Hero*, but it is substantially more fun to rock out as a full band than as a loan guitarist.

Harmonix has been making music software since 1995. The company was founded by Alex Rigopulos and Eran Egozy. The two met while working at MIT Media Lab. They initially focused on building tools that provided users alternative

controllers to create music, using inputs like joysticks and full body gestures. Eventually the company regrouped and decided to focus on designing music-based video games. In 2001, Harmonix released *FreQuency* for the PlayStation 2. With this game, Harmonix began to formulate the mechanics that would later come to inform *Guitar Hero* and *Rock Band*. In *FreQuency*, the player travels down an octagonal tube (Figure 12.2). Each wall contains a musical track. Each track in turn contains sequences of notes. You play the game and turn on the music by hitting buttons that correspond with the notes. Despite rave critical reviews, the game never caught on commercially. The game was quite hard and mainly featured music by underground electronic artists.

FIGURE
12.2

FreQuency, Harmonix's first major stab at a music game, couched music playing in an abstract space. Players activated tracks by hitting notes in an octagonal tube. (© Sony)

In 2003, Harmonix released the follow-up *Amplitude*, which simplified the gameplay and featured more mainstream music (Figure 12.3). *Amplitude* reduced the maximum tracks the player must manage to six and gave the player better control of the ship. Looking at the screen for *Amplitude*, you can see the basic mechanic of *Guitar Hero* taking shape. Notes stream down a rail. You must "play" those notes by hitting a button as you pass over it. Of course you're "playing" music with a ship called a Beat Blaster. The game—while fun and definitely entrancing—still feels divorced from music playing, as we commonly think of it. You do turn on the tracks, from percussion to synth to vocals, by successfully hitting the notes on each track, in a sense creating the full song and playing the track. But the gameplay doesn't map to any traditional notion of how one plays music. In fact, *Amplitude* looks more like the futuristic racing game *WipeOut* than playing music. The limited

FIGURE
12.3

Amplitude simplified the gameplay of *FreQuency* and introduced a soundtrack with more mainstream music. The player guides the Beat Blaster ship along a track, hitting combinations of notes in time with the music. (© Sony)

FIGURE
12.4

In this screen from *Guitar Hero 5*, the music playing has been streamlined from *Amplitude*. You no longer have to navigate among tracks. In this screen two players play side-by-side. You simply hit colored buttons that match the colored notes in time with the music. The game collapses to a fast-paced game of Simon Says. (© 2009 Activision Publishing, Inc. All rights reserved)

success of the game probably stems from the fact that it doesn't really match our expectations of playing music.

Then Harmonix partnered with Red Octane to develop *Guitar Hero*. The game was directly inspired by *GuitarFreaks*, an arcade game popular in Japan. *Guitar Hero* further simplifies the tube of oncoming notes, making it into a straight line with a series of notes streaming down that the player must hit by pressing corresponding buttons. The game essentially boils down to a fast-paced game of Simon Says. Harmonix also replaced the abstract graphics of *FreQuency* and *Amplitude* with animations of musicians on stage at rock concerts. The designers were bringing the game closer to our expectations of playing rock music.

But the controller is really the key. That chintzy plastic guitar is what makes the whole game work. Rob Kay, who led the design of *Guitar Hero*, said, "The controller really was the kind of magic sauce for what we wanted to do. It's very difficult to make games attractive and accessible, and I'm sure that 90 percent of what draws people into *Guitar Hero* is that plastic guitar. They instantly say, 'I get it! I pretend to be a guitarist!'"[2] The guitar is what makes the whole game understandable for people. You could play *Guitar Hero* with a controller, punching buttons to match the beats, but it wouldn't be as fun. You would lose the fantasy of being a rock guitarist. You'd simply be matching beats in a video game. But because the controller takes the shape of a guitar, you can suddenly imagine you're the equivalent of Eddie Van Halen or Slash from Guns N' Roses, rocking out before a stadium of thousands.

This bit of theater is amplified even more with *Rock Band*. *Rock Band* allows you to share the fantasy of being a rock star with your friends, making it even more powerful. *Rock Band* plays on the commonly shared and recognizable images and fantasies of being a rock star. MTV has made sure we're all familiar with the tropes and poses of rock. *Rock Band* takes those images of musicians performing in music videos and stadium-filled concerts and gives the player the chance to enact them. *Rock Band* and *Guitar Hero* tap into the same impulse that makes us play air guitar, wildly strumming back and forth when we hear a song we like. By giving you a guitar and a goal, the game gives further license to that impulse and directs you to fully enact it. The game practically begs you and your friends to strut and pose like rock stars. Shoving all of the players into close proximity and facing them towards the screen and a common goal saves all of the players any embarrassment that might stem from rocking out on a plastic guitar or rubber drums. Instead, the proximity, common fantasy and group performance bring everyone into a shared social space.

Rock Band takes the basic gameplay of *Guitar Hero* and expands it to include bass, drum and vocals. Each of these parts of the song is represented by a separate track of scrolling "notes." For the bass, drums and guitar tracks, colored notes scroll vertically down the screen. Each controller has correspondingly colored buttons which must be pressed in time with the music. On the guitar, this means holding

[2]Inside Game Design: Harmonix Music Systems, Gamasutra, 2007, www.gamasutra.com/view/feature/2801/book_excerpt_inside_game_design_.php?page=2

FIGURE
12.5

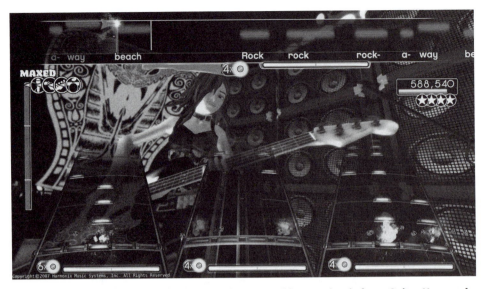

Rock Band uses the same basic Simon Says beat matching mechanic from *Guitar Hero* and expands it to cover guitar, bass, drums and vocals. The vocal track scrolls along the top of the screen. Players must match the length and relative pitch of each lyric. (© Harmonix)

down the corresponding colored fret buttons and simultaneously flicking the strum button. On the drums, the player must strike the matching drum pad in time with the music. Vocals use a mechanic familiar to *Karaoke Revolution* players. The vocals scroll along a horizontal track at the top of the screen. Lyrics appear beneath green bars which indicate the original pitch of the vocal. The player must match the timing of the lyrics and the relative pitch.

The performance of each player is tracked on a meter to the left of the screen. Miss too many notes in a row and that player starts slipping down the performance meter. Hit the bottom of the meter and the player fails out of the song. If the whole band slips to the bottom they lose the song and must start again.

Each player also has an Overdrive meter which they fill by hitting every note in a specific series. Once players fill their Overdrive meter at least halfway they can activate Overdrive, which earns them bonus points and boosts the entire band's performance meter.

The game forces each player to engage in their own action and to pay close attention to his or her own track. Hitting each of the notes as they quickly stream down the screen can be very consuming, forcing players to pay close attention to just their part. The attention demanded by each track could very easily reduce the feeling of social gameplay into an instance of four people playing individual games side by side. Yet each player's performance affects the entire band. The social element of the game play is brought out by the context of everyone playing the same song simultaneously as a group. The game casts the players as a band, gives each

player a part to fulfill and then ties the play together through the music. The game breeds you into a focused team. The game creates a social environment that makes you really feel like you're in a band when you play. The band uses several simple mechanics to reinforce the team/band feeling.

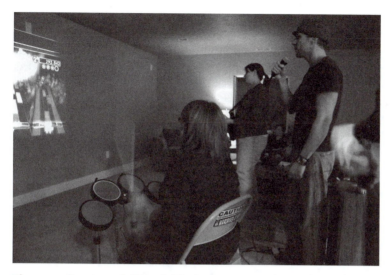

FIGURE
12.6

Players rock out as a full band. Playing as a group draws players into the fantasy of being a rock star and creates a feeling of kinship. (Photo from Flickr by brettneilson)

When a player fails out of a song, they start to drag down the rest of the players, imperiling the entire band. But another player can bring the failed player back to life by triggering Overdrive. This gives players a way to look out for one another and help each other out. Players can also increase the band's score by coordinating when they trigger their Overdrive bonuses. Players can save each other or help each other pass particularly tricky parts of songs.

A causal evening of *Rock Band* with friends can be a gateway to hardcore play. Unlike most casual games, *Rock Band* demands players perform the same levels multiple times, perfecting them and raising their score. For the obsessive, this can lead to hours of practicing a particular song to play it perfectly. Once they get into *Rock Band*, players can exhibit very hardcore behavior, repeating songs over and over until they perfect them. But most players experience the game socially in a more casual manner.

What to Wear: Tapping the Wisdom of Crowds

If the initial history of video games limited social gameplay to the time when your mom allowed you to have friends over to hang out in the living room and play, then the Internet has radically redefined the living room. Now you can play with

225

your friends at any time. Never has gaming been a more aggressively social activity. From massively multiplayer games like *World of Warcraft* to match finding on Xbox Live, the Internet allows us to play together all of the time.

However, much of the social interaction of gameplay still revolves around small groups. You pop *Splinter Cell* into your Xbox, log in and play through a level with your brother. Or perhaps you join a squad of 16 people in *Halo 3* and vie for control of a gameboard. These groups still look like traditional social gameplay. They resemble the numbers of people you would gather to play a game of pick-up soccer. Raids in *World of Warcraft* enlarge the group of players on a single mission to around 40. As the groups get bigger, new coordination problems arise for players. How do you communicate and act in concert with 40 other players? One answer is a lot of screaming.

Social networking platforms like Facebook alter the playing field, literally. They exponentially expand the number of people you can interact and play with. Boasting more than 300 millions users around the world, the site gives game designers an

FIGURE
12.7

The play of *What to Wear* revolves around creating an outfit for the daily contest and voting on outfits entered in yesterday's contest. (Reproduced by permission of Large Animal Games)

entirely different scale on which to design social games. These networks expand the scale in terms of players and time, stretching gameplay over extended periods of time. And while no game will ever capture all 300 million users, it's entirely possible to attract tens of thousands or even millions of users.

Sites like Facebook also offer particular challenges to users. Most users don't have Facebook open all day. Instead they check it once or twice a day or perhaps only several times per week. And when users do visit Facebook, a number of applications, status updates and baby photos all compete for their attention. And perhaps most crucially, you and your friends all visit Facebook at different times throughout the day. You have no guarantee that your friends will be available to play at the same time you want to. In order to integrate play with normal usage patterns on social networks, designers have found it advantageous to create games that revolve around asynchronous gameplay. Asynchronous games allow you to make a move

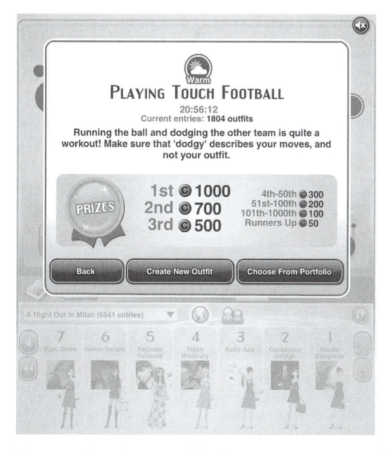

FIGURE
12.8

Before you start creating your outfit for the contest you are given some basic information about the contest including the weather and prizes for where you place. (Reproduced by permission of Large Animal Games)

and leave the game. Another player can check in later and make moves, even if you're not present. This allows the game to spread over days, weeks, even months, as opposed to games which require both players to be continuously present, which typically top out at a few hours. This concept is not new. Correspondence chess, for example, revolves around asynchronous gameplay.

Over the last several years Facebook games have become all the rage. Facebook gives developers access to a large audience looking for something to do. Companies like Zynga and Playfish have built hugely successful companies building games for Facebook and other social networks on the backs of traditional multiplayer games like Poker.

Designing for Facebook allows game designers to create games that create new forms of social play. A number of games from *Mob Wars* to *Vampires* use the player's social network to build gangs and clans. They also use your friends as opportunities to score points.

A game like *What to Wear* makes clever use of the aggregate opinions of players to create a judging system for the game. By using a large pool of people, *What*

FIGURE
12.9

As you create your outfit, you must pay attention to the total cost of your outfit. You have a limited number of credits for purchasing clothes. You earn credits by checking in every day and voting on the outfits others create. When you're low on credits, you can always fall back on items already in your closet. (Reproduced by permission of Large Animal Games)

to Wear can emulate the way popular opinion affects fashion. With thousands of active players each submitting outfits and then voting on the outfits other players create, the game really feels like a fashion show.

What to Wear was created by Large Animal, a New York-based game developer. Over the years, Large Animal produced a range of different casual games, from Web games to PC downloadables. Recently they have focused on creating games for social networks like Facebook, Bebo and MySpace. Before creating *What to Wear*, Large Animal released several other social network games, including *Bumper Stars*, *Lucky Strike* and *Bananagrams*. These were all good games, but they felt like fairly straightforward Web games. They used mechanics like bowling and pool to deliver a contained game experience. In *Bumper Stars*, you shoot a ball around a small game area, bouncing off bumpers and picking up objects to score points. The game is for a single player. The social aspect is limited to high scores and other small cosmetic touches. But with *What to Wear*, Large Animal has made a game which truly takes advantage of the social landscape of Facebook. In many ways, a game like *What to Wear*, designed by Wade Tinney and Daisy Pilbrow, along with design contributions from the entire development team, can only be played on a social network like Facebook. This game could not exist without the social elements. They are integral to the game system and play. To work properly, it requires a large pool of players both contributing content and serving as judges for one another.

The core gameplay revolves around a daily contest and involves two activities, making an outfit and voting on the outfits other users have created. Each day the game introduces a new contest that players must design outfits around. Themes for the contests range from "A Housewarming Party" to "A Speed Dating Party" to "Chilling at the Mall." You are given a brief description of the style challenge and a temperature forecast. Then you can dive into the clothes, picking items from the shop and the closet. At the beginning of the game, you are given a bunch of initial credits. You must manage this reserve of credits, as each item in the shop costs credits. And just like in real life, the really hot clothes cost the most. Once you're satisfied with the outfit you've created, you save it and submit it to the contest. Each contest lasts 24 hours, giving you time to check in at some point during the day and make an outfit.

Once you have finished making your outfit, you can vote on the outfits that were submitted in the previous day's contest. The game presents you with two random outfits and asks you to say which you think matches the theme best. You can apply whatever criteria you like, but you must choose between the two outfits, and you must choose the entire outfit. You can't say, "Love the sweater, hate the shoes." You have to take the ensemble as a whole. This keeps the voting simple and straightforward, enabling you to churn through many outfits and cast dozens of votes. In five minutes, it's possible to look at dozens of outfits, each one slightly different and possessing its own character. In this way, the game makes excellent use the combinatorial possibilities of clothing items. Building an outfit takes time, as you want to pick the right items for each layer. But judging an outfit takes only a second.

FIGURE
12.10

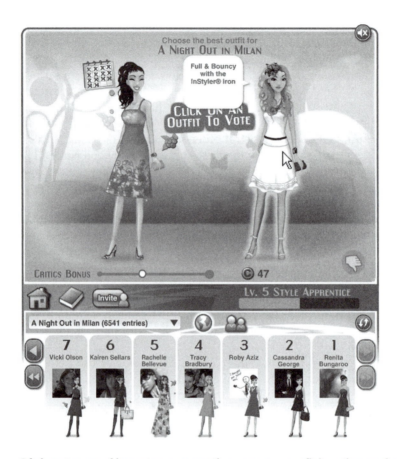

Of almost as equal importance as creating your own outfit is voting on the outfits other players have created. Player votes provide the engine that powers the game's scoring system. (Reproduced by permission of Large Animal Games)

Best of all, the judge is never wrong. The voting mirrors the choice made by the judge in *Apples to Apples*. But in the case of *What to Wear*, you have thousands of judges, each applying their own sense of style to the other outfits. The game tallies the votes for all of the outfits and the one with the most votes wins. *What to Wear* encourages you to vote for more outfits by rewarding you with credits and Style Points for each vote. The more credits you have, the more clothes you can buy in the shop. In typical role-playing game fashion, earning Style Points levels you up, which in turn rewards you with new clothing items. The designers know that if players don't vote, the game won't work. So they highly incentivize you to spend time reviewing outfits, by making it both easy and lucrative. Plus applying your judgment is fun. It's fun to look at clothes and say, "That's hot! That's not!"

FIGURE
12.11

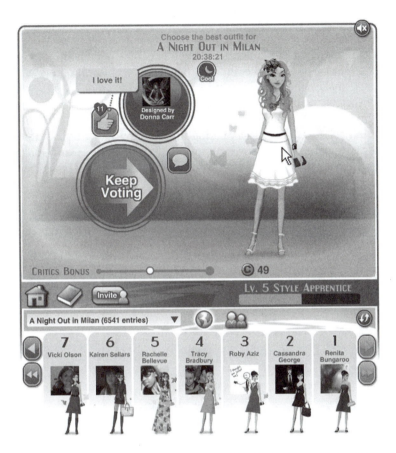

After you vote on another player's outfit, the game gives you the chance to give them an extra thumbs up, earning that player Style Points. In this way, the game encourages a very light, but effective, social interaction with other players. At the bottom you can see the outfits currently leading the voting. All of this contributes to the feeling of fashion and collective taste. (Reproduced by permission of Large Animal Games)

In addition to these basic mechanics, some additional mechanics encourage more social interaction. You can send other players' thumbs up for outfits you really like. This sends the players a message and awards them bonus credits. You can also peruse the portfolio of outfits other players have created, giving you a better sense of other players' styles as well as new fashion ideas. This breaks down social barriers. It feels much easier to interact with players because you are all trying to accomplish the same goal, while in other games you are direct competition. It does not hurt you to appreciate or praise the work of others. Quite to the contrary, you benefit from it. This creates a positive social environment that draws out small simple moments of interaction between players.

The more you play *What to Wear*, the more you develop a sense for the taste of the other players. You begin to realize that part of picking out an outfit is assembling a look and using items you think other people will like. Like real fashion, picking out an outfit is one part what you like and one part what you think others will like. You must not only make what you like, but what you think other players will find hot. Through the clever combination of creating your own outfits and being forced to sit in judgment of other players' outfits, the game creates a system that simulates the social milieu of fashion. By exploring the different looks others have created, you can begin to formulate guesses about what combinations and looks will earn more votes from the group in future contests. Like *Apples to Apples*, you learn to try and read the crowd.

FIGURE
12.12

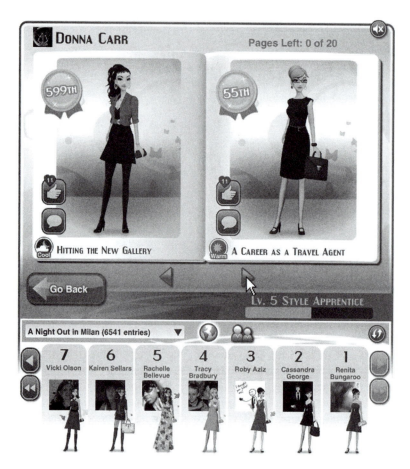

You can even drill down and look at the other outfits players have created and saved to their portfolio. (Reproduced by permission of Large Animal Games)

Using other players to judge outfits is a brilliant use of the social milieu of Facebook. The game solves the subjective judging issue that we encountered in *Jojo's Fashion Show* and *Top Chef*. In *Jojo's Fashion Show*, I created a system of attributes to try to emulate the way people perceived clothes. This worked well in the single-player environment of the PC downloadable game and allowed the player a fair amount of leeway to improvise. However, it represented a single unchanging vision of fashion. Because *What to Wear* can tap into the ever-shifting tastes and opinions of thousands of players, the system of fashion it presents becomes much more dynamic. It can adapt and respond over time. The game uses the collective opinions of the crowd to define style.

What to Wear makes full use of the new social dynamics available to game designers. In some ways, it takes a simple model similar to *Apples to Apples* and invites thousands of people to sit around the table and play together. It doesn't force you into direct interaction with other players. Instead it smartly uses the crowd as content generators and background noise for each other. You feel like you're playing in a social milieu even though you rarely talk or message with other players. Instead, you judge their clothes and they judge yours. This gives you the feeling of community and interaction.

What to Wear realizes style is ambiguous and subjective. So it's best left up to the people to judge and decide.

Summary

What to Wear points towards the interesting future possibilities of casual games. It truly taps the social potential of Facebook precisely by avoiding group and team play. This works great for casual players because it doesn't impose the heavy burden of group coordination on players. You don't have to organize a specific time to meet and play together. You don't have to coordinate appropriate moves with other players. You don't have to yell at anyone for making a silly move, nor worry about attracting the fury of some alpha player for making a bad move. Other players are necessary in your experience, but they aren't integral. All of this makes the game work well for casual players who want to play when they want to play. And now they have people to play with. Loads of them.

Not all games need to include massive numbers of players to have interesting social effects. Simple games like *Apples to Apples* that are structured to spark conversation can lead to interesting interactions between players. But then so can more formal games like poker. None of the rules of poker try and reveal the tastes or personalities of the players. But as any experienced poker player will tell you, people's personalities reveal themselves during play. From formal to informal systems games put players into dialogue with one another. They give players tools with which to prod and poke at each other and the chance to observe the results. Each new player injects new life into the game as you learn their tells and personal strategies.

The chance to interact, explore and have fun together amplifies the engagement of a game. Suddenly playing, performing well and winning carry deeper meaning. You aren't simply vying to best the game system; you are playing to beat someone else. Or perhaps you are working together, forming bonds as a team or band. In both instances, playing with someone else gives the play context outside of the game. It's not simply between you and the game system anymore. Now it involves bragging rights and social status. Tapping into social status outside the game gives game designers powerful tools to increase engagement within the game. After all, winning a single-player game feels like an accomplishment; beating your friends feels like a triumph.

Index